HISTORIC PHOTOS OF
TAMPA

TEXT AND CAPTIONS BY RALPH BROWER

TURNER
PUBLISHING COMPANY

The Platt Street Drawbridge is raised as a vessel enters the Hillsborough River. The smoke stacks of Tampa Electric Company's Hyde Park plant rise on the left of the scene. This 1926 photo was shot from the Tampa Municipal Hospital that was under construction on Davis Islands.

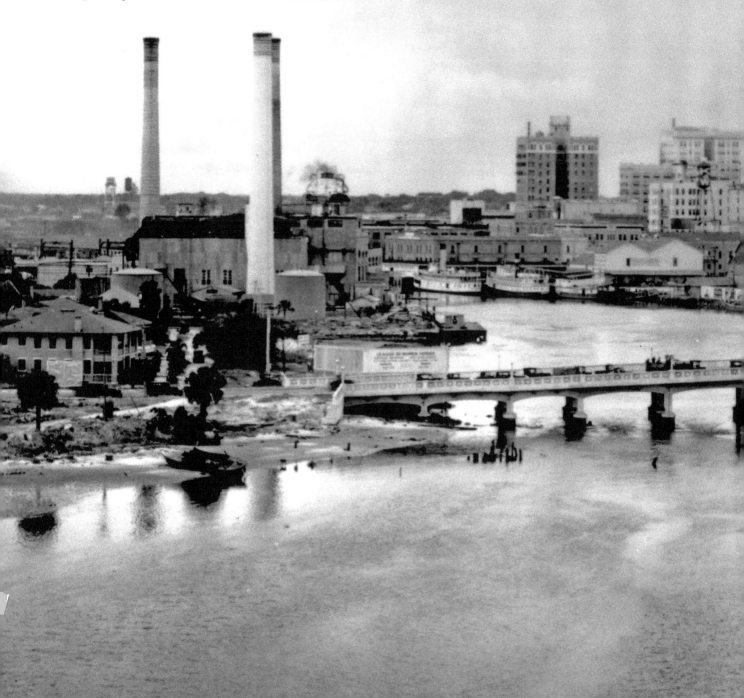

HISTORIC PHOTOS OF
TAMPA

Turner Publishing Company
www.turnerpublishing.com

Historic Photos of Tampa

Copyright © 2006 Turner Publishing Company

Library of Congress Control Number: 2006933648

ISBN-10: 1-59652-293-3
ISBN-13: 978-1-59652-293-0

ISBN 978-1-68336-920-2 (hc)

CONTENTS

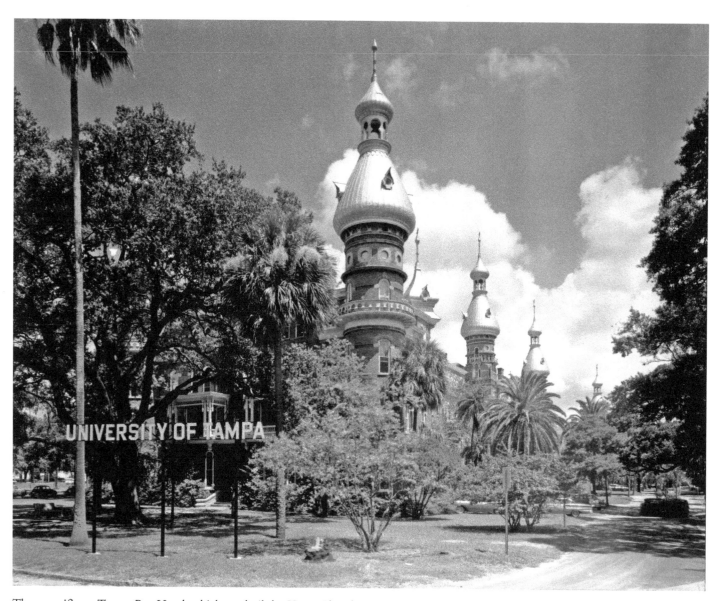

The magnificent Tampa Bay Hotel, which was built by Henry Plant between 1888 until 1891 at a cost of $3 million, was acquired by the City of Tampa in 1905 for $125,000. It stood mostly unused for nearly 30 years before the buildings and grounds were leased to the University of Tampa in 1933. Seen here in 1959, this is the entrance to the campus from Hyde Park Avenue.

ACKNOWLEDGMENTS

We would like to express our gratitude to Susan Brower for providing research assistance to the author and contributing support throughout the project.

We would also like to thank the following individuals and organizations for their valuable contributions and assistance in making this work possible:

Otis Anthony, Salatha Bagley, Canter Brown, Jr., Donald L. Chamberlain, Karl H. Grismer, Charles E. Harner, Charles E. Harrison, the Hillsborough County Planning Commission, Robert J. Kaiser, Karen McClure, Gary R. Mormino, Anthony P. Pizzo, R. L. Polk's City Directory of Tampa, George E. Pozzetta, *The St. Petersburg Times*, Bob Baggett Photography, and Tampa-Hillsborough County Public Library.

PREFACE

Tampa has thousands of historic photographs that reside in archives, both locally and nationally. This book began with the observation that, while those photographs are of great interest to many, they are not always easily accessible. During a time when Tampa is looking ahead and evaluating its future course, many people are asking, "How do we treat the past?" These decisions affect every aspect of the city—architecture, public spaces, commerce, tourism, recreation, and infrastructure—and these, in turn, affect the way that people live their lives. This book seeks to provide easy access to a valuable, objective look into Tampa's history.

The power of photographic images is that they are less subjective than words in their treatment of history. Although the photographer can make decisions regarding subject matter and how to capture and present it, photographs do not provide the breadth of interpretation that text does. For this reason, they offer an original, untainted perspective that allows the viewer to interpret and observe.

This project represents countless hours of research and review. The researchers and author have reviewed thousands of photographs in numerous archives. We greatly appreciate the generous assistance of the archivists listed in the acknowledgments of this work, without whom this project could not have been completed.

The goal in publishing this work is to provide broader access to a set of extraordinary photographs that seek to inspire, provide perspective, and evoke insight that might assist people who are responsible for determining Tampa's future. In addition, the book seeks to preserve the past with adequate respect and reverence.

The photographs selected have been reproduced using multiple colors of ink to provide depth to the images. With the exception of touching up imperfections caused by the damage of time, no other changes have been made. The focus and clarity of many images is limited to the technology and the ability of the photographer at the time they were taken.

The work is divided into eras. Beginning with some of the earliest known photographs of Tampa, the first section records photographs from the 1870s through the end of the nineteenth century. The second section spans

he beginning of the twentieth century to the end of World War I. Section three moves from the 1920s to World War II. And finally, Section four covers World War II to the 1960s.

In each of these sections we have made an effort to capture various aspects of life through our selection of photographs. People, commerce, transportation, infrastructure, religious institutions, educational institutions, and scenes of natural beauty have been included to provide a broad perspective.

It is the publisher's hope that in utilizing this work, long-time residents will learn something new and that new residents will gain a perspective on where Tampa has been, so that each can contribute to its future.

Todd Bottorff, Publisher

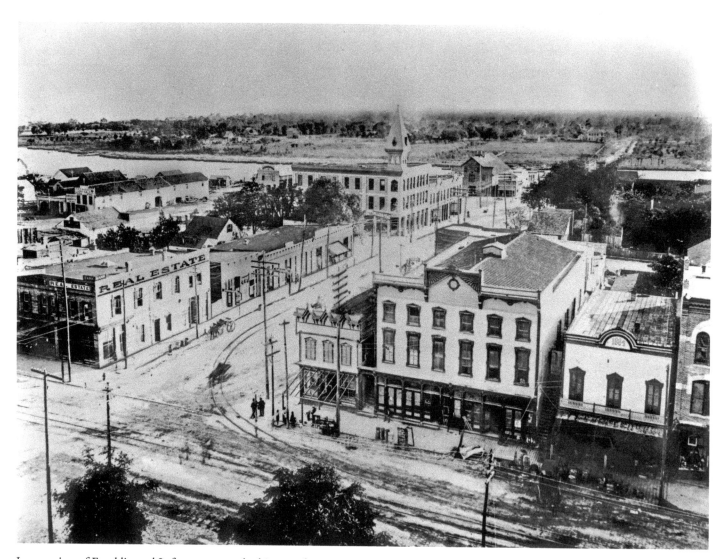

Intersection of Franklin and Lafayette streets, looking southwest across river toward the area that will be developed into Hyde Park

The Beginnings of Cigar City to the Turn of the Century

1880–1899

Although the village of Tampa had existed for hundreds of years, it wasn't until the establishment of Fort Brooke in 1824 that true development began. Fifty-nine years later the retiring military post was opened for homesteading. The edges of the city were defined to the north by Tyler Street, by Whiting Street to the south, by East Street to that side, and to the west by the Hillsborough River.

The census of 1880 showed Tampa with a mere 720 residents. The majority were whites, but more than a third were freed slaves. The cornerstone moment for the city occurred in 1884 when transportation magnate Henry B. Plant decided to connect Jacksonville to Tampa by rail.

Just two years later, Plant's railroads, the developing port, and the area's humidity which functioned as a natural humidor, lured the cigar industry up from Key West where labor unrest had hindered production. The land northeast of Tampa was developed as a factory town called Ybor City. Vincente Martínez Ybor and Ignacio Haya were the first to open their factories. By 1899 there were 4,000 Cubans living in Ybor City and in another development called West Tampa.

An 1896 Spanish embargo on shipments of tobacco from Cuba to the United States threatened to cripple Tampa's main industry. In response, Henry Plant sent his two fastest steamers, the S.S. Mascotte and S.S. Olivette, to run the blockade. With the aid of the Cuban farmers, both ships were loaded with enough tobacco for an entire year's cigar production in Tampa. The Mascotte is honored on Tampa's city seal.

By the mid-1880s Tampa was a stop-over point for tourists who rode the railways south to board pleasure cruises to the Caribbean and Central and South America. As an accommodation to his wealthy patrons, Henry Plant built the opulent, Moorish-styled Tampa Bay Hotel on the western bank of the Hillsborough River. For passage from the city across to the hotel, Plant persuaded the government and corporate donors to construct the Lafayette Street Bridge.

It was among the cigar factory workers of Tampa that the famed poet, orator, and political revolutionary, José Martí, delivered passionate speeches which incited cries of "Cuba Libre" as well as donations of arms and cash in the Cuban struggle for independence. Tampa was also the assembly and debarkation site for the U.S. Troops who invaded Cuba and helped its people defeat the Spanish for control of the island nation.

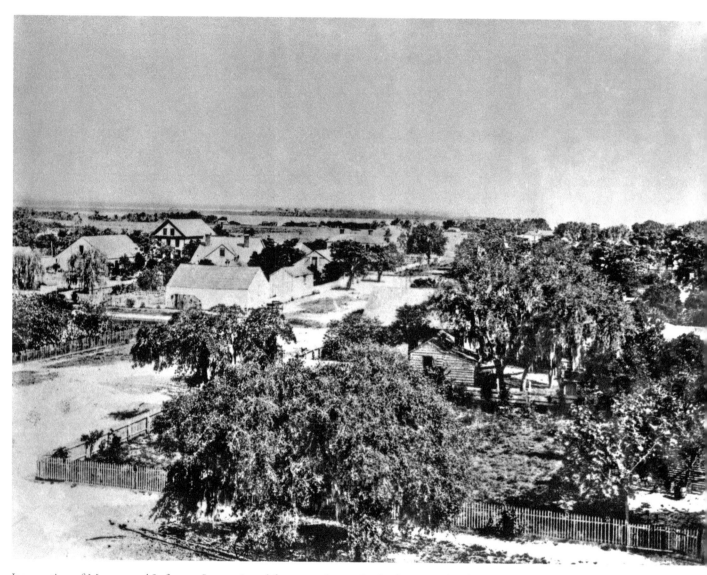

Intersection of Monroe and Lafayette Streets viewed from courthouse. In the foreground is the "Hanging Tree" reputedly used in lynchings. Monroe Street was renamed Florida Avenue and Lafayette Street is now John F. Kennedy Boulevard. (1882)

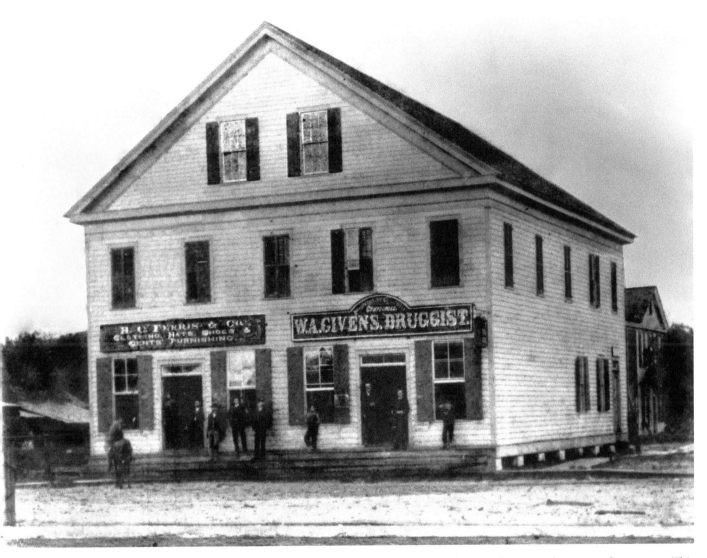

In the early years of Tampa, Washington Street was the center of commerce. This photo from 1881 shows the Mercantile Building which housed W.A. Givens drug store and H.C. Ferris & Company dry goods store.

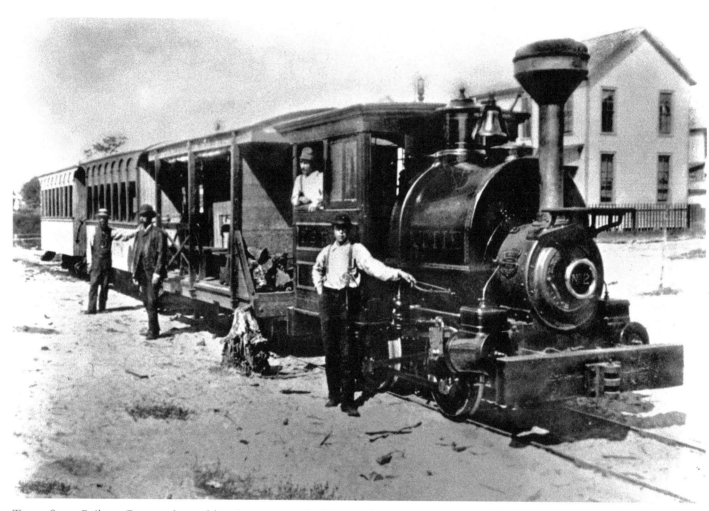

Tampa Street Railway Company's wood-burning steam engine No. 2 with passenger cars in tow and employees ready to receive patrons. (1886)

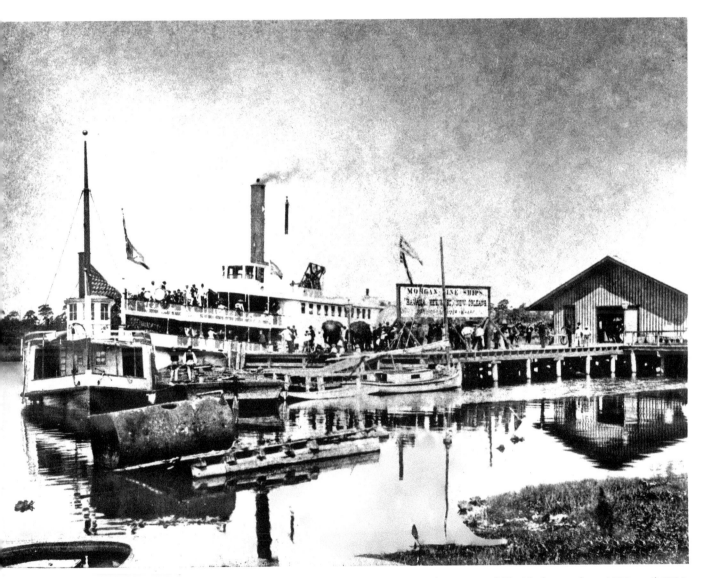

The paddle-wheel steamer "Erie" of the Morgan Line served west central Florida from at least 1880 until 1890.
Maritime records show her with ports of call in Clearwater, Safety Harbor, St. Petersburg, Cedar Key, and, of course,
Tampa. She is pictured here at the Morgan Line dock at the foot of Lafayette Street. (1885)

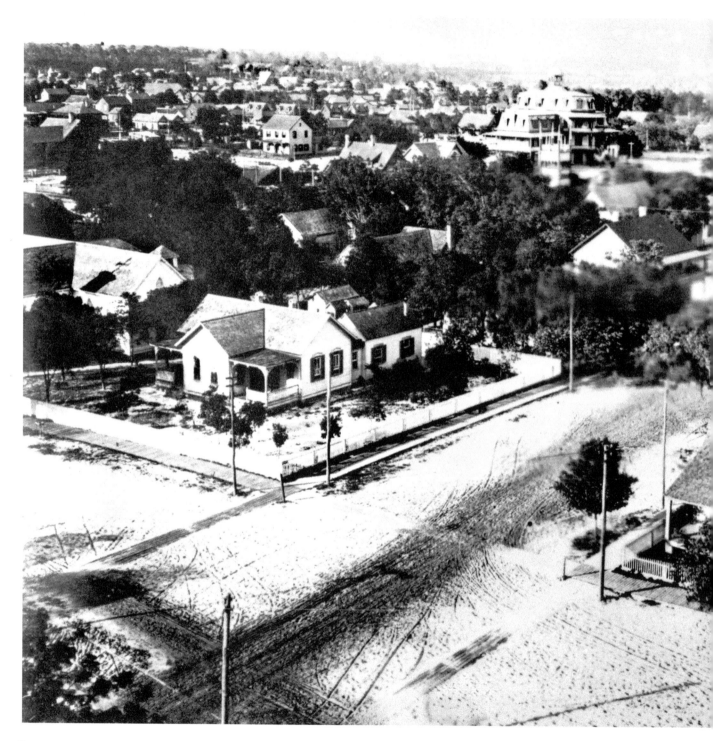

The view in 1886 from the roof of the Hillsborough County Courthouse of the intersection of Monroe and Madison Streets. Monroe became Florida Avenue. Notice that the city is heavily residential in this era; later all of the original city will be developed commercially.

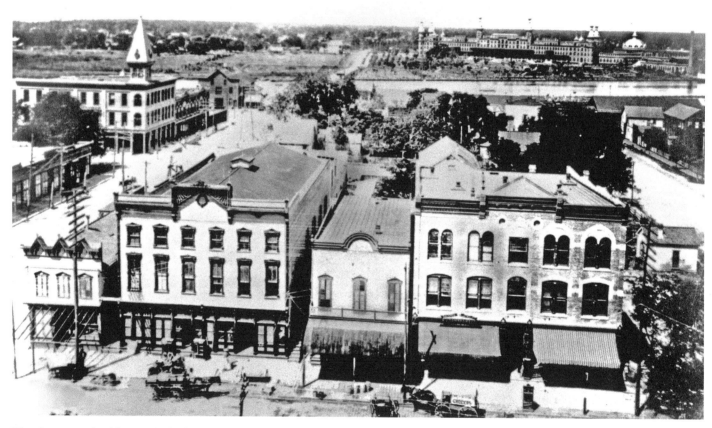

The three-story building with the first floor windows exposed is the Branch Opera House on Franklin Street which runs left to right at the bottom of this photo. Lafayette is the intersecting street that is visible to the left. The building with the spire on Lafayette is the hardware store of Knight and Wall. The Tampa Bay Hotel can be seen near the horizon.

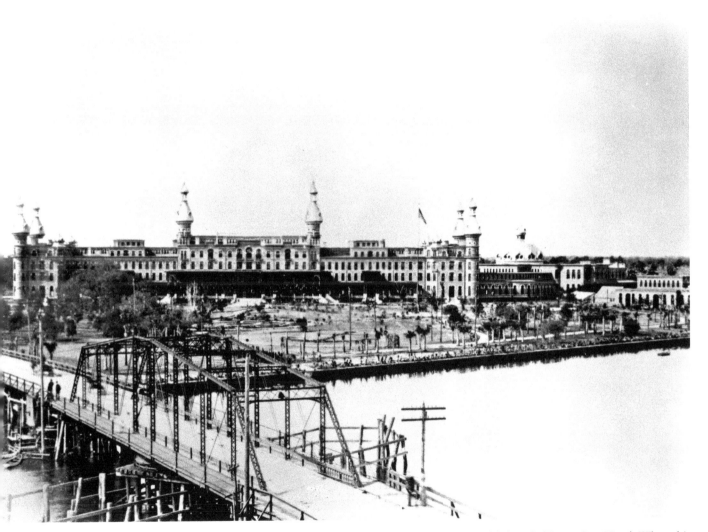

The new Lafayette Street Bridge forged the Hillsborough River and led to the Tampa Bay Hotel. When this photo was taken, in 1890, the hotel construction had been completed but was not yet receiving guests. The Plants were still scouring Europe for furnishing; the hotel did not open until the following year.

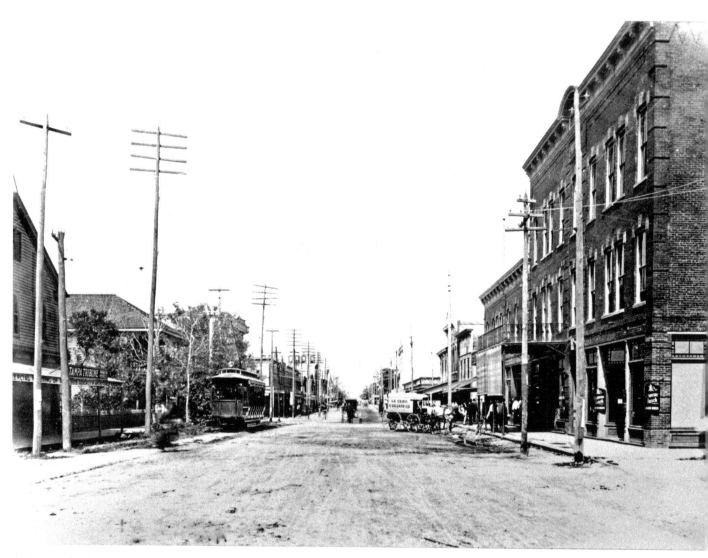

A view up the dirt road of Franklin Street, seen from Washington Street. A trolley is on the far left of the road and horse drawn carriages are center and right.

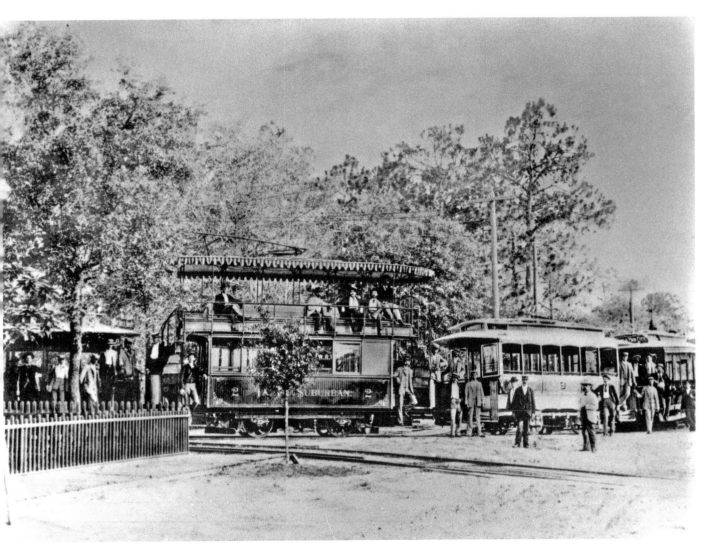

Passenger service aboard regular and double-decker street cars of the Tampa Suburban Company. This train is on the Ballast Point route.

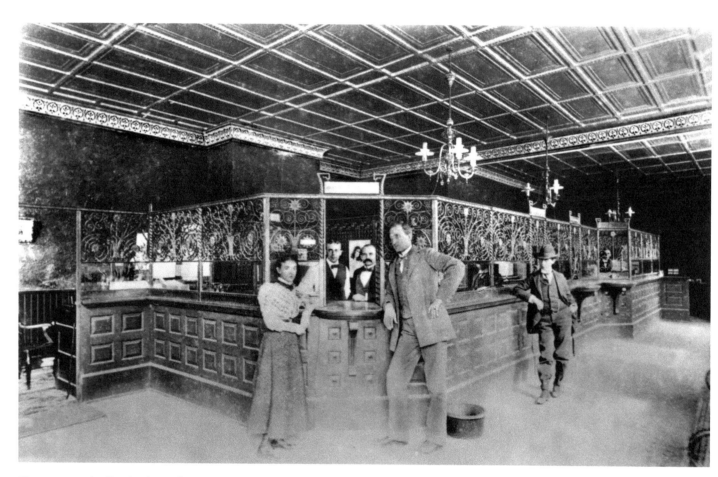

Customers and tellers in the Exchange National Bank. The bank, situated at the corner of Franklin and Twiggs Streets, was founded in 1893 by John Trice, Edward Manrara and Peter O. Knight. Co-founder Knight had his law office on the second floor of this building.

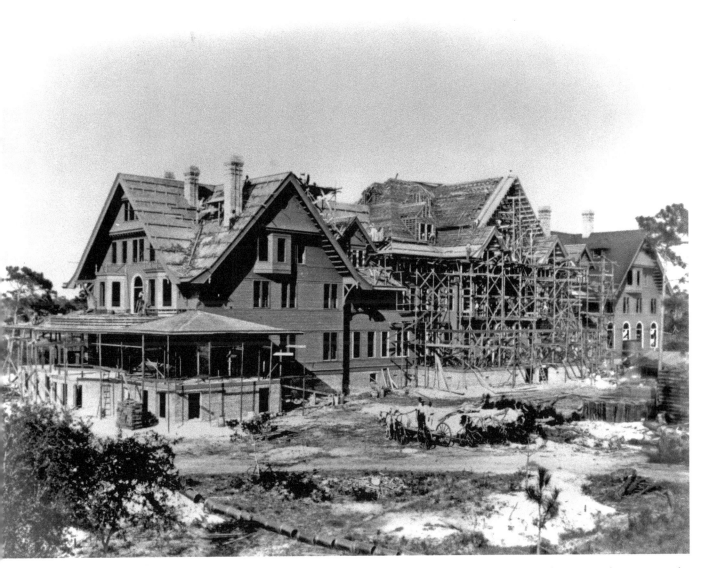

The Belleview Hotel under construction in 1896. The hotel, built by Henry B. Plant, opened in 1897 on the Clearwater Harbor in Belleair, Florida, accessible from Tampa by railroad. The hotel was purchased from the Plant family in 1920 by the Bowman-Biltmore Hotel Corporation and was renamed the Belleview-Biltmore Hotel.

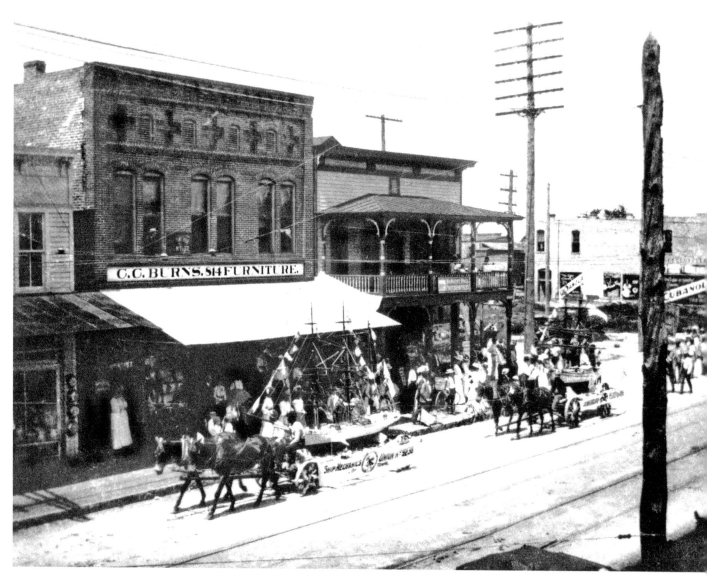

A parade running down Franklin Street in front of Burgert Brothers Photography and the C.C. Burns Furniture Store. The nearest float, a three-masted ship, was sponsored by the Ship Mechanic's Union.

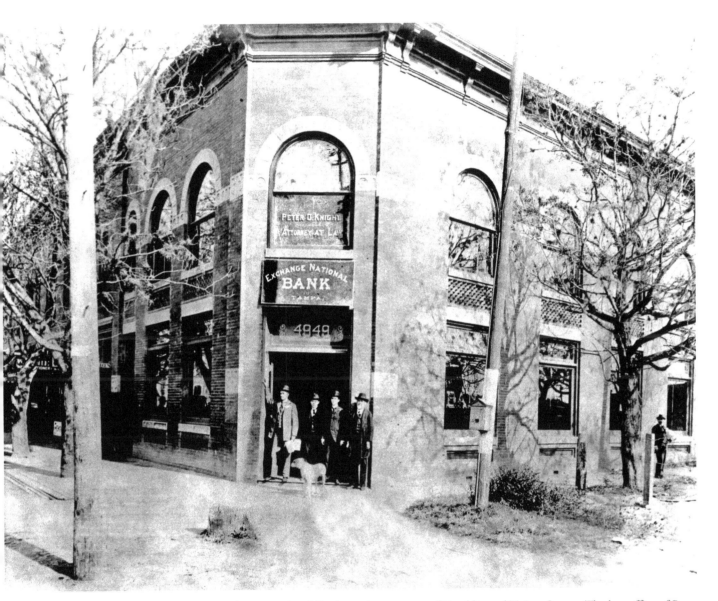

Exchange National Bank northeast corner of Franklin and Twiggs Streets. The law office of Peter O. Knight, a major investor in the bank, has his office on second floor, above the open doorway where the bank's employees are standing. (1899)

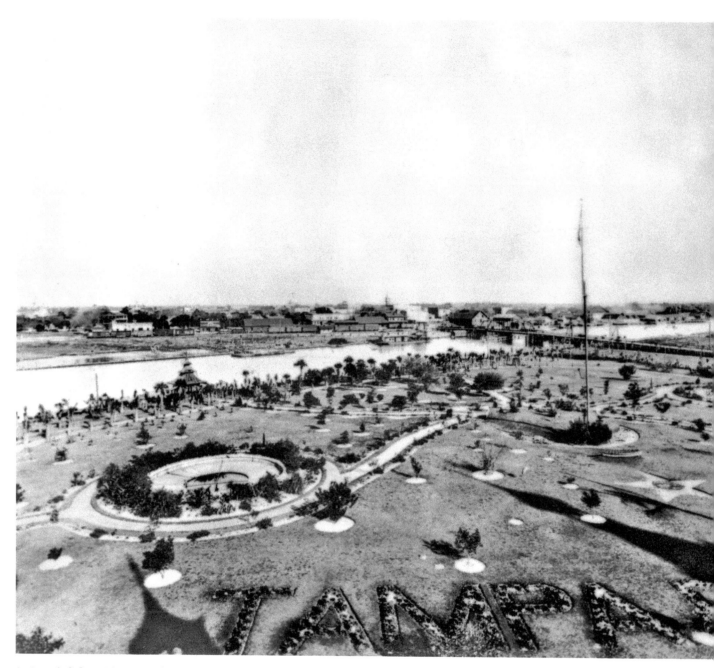

A view aloft from Henry B. Plant's Tampa Bay Hotel, looking across the landscaped grounds and southeast across the Hillsborough River toward Tampa. The span over the river is the Lafayette Street Bridge.

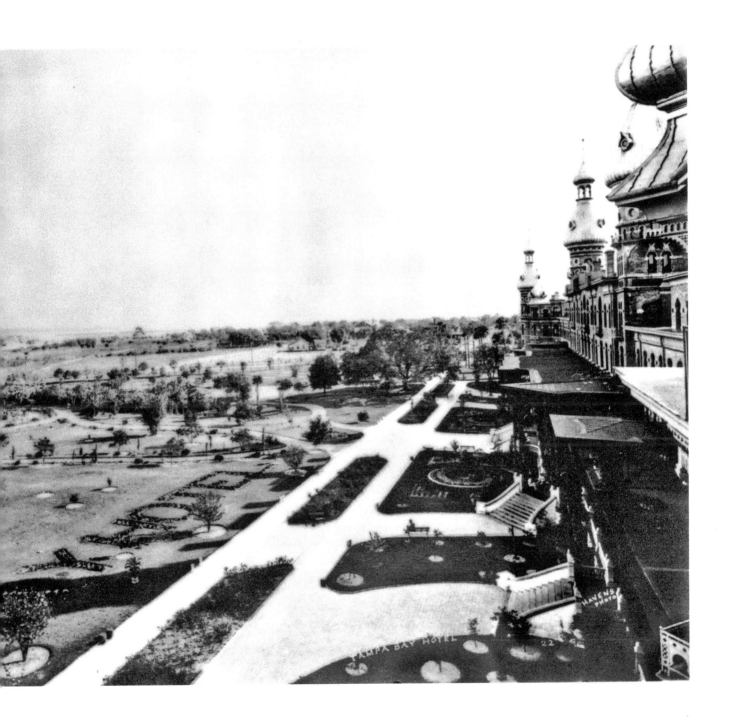

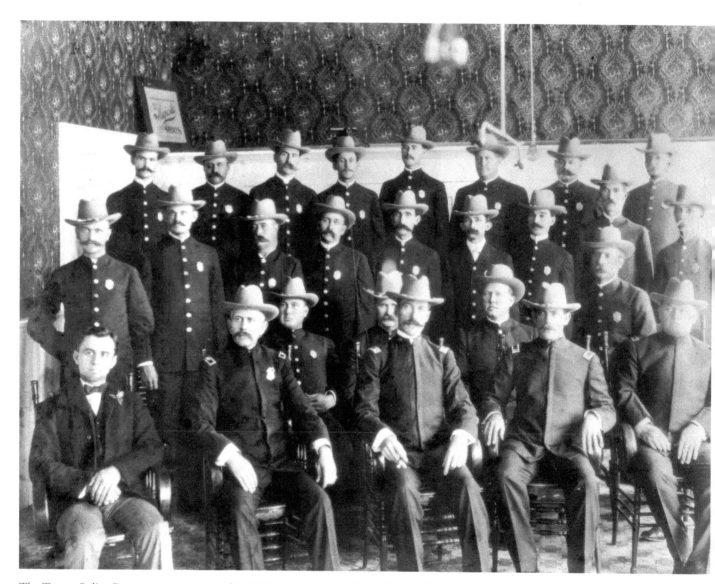

The Tampa Police Department was created in 1886, replacing the office of City Marshall. This is a group portrait of uniformed officers. Chief of Police, J.C. Jones, is second from the left in the front row. Over the years their headquarters would be in various places around the downtown area. In 1915 the police moved out of City Hall and into a building at the corner of Florida Avenue and Jackson Street. They would stay there until 1961 when a new building was constructed at Tampa Street and Henderson Avenue.

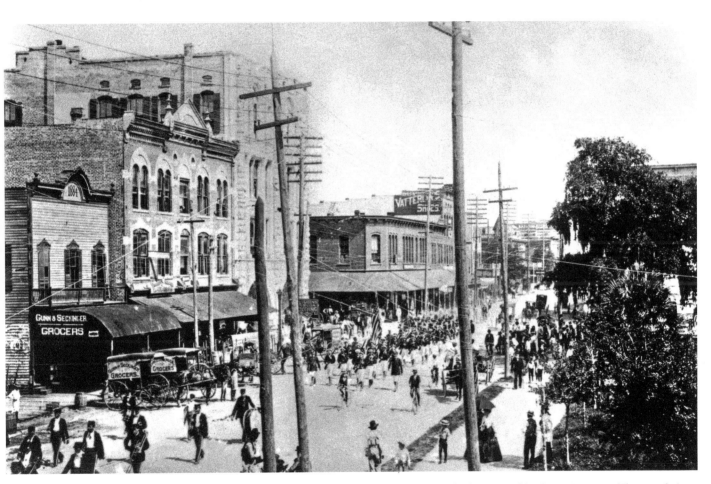

Spectators look on as a band and soldiers parade down Franklin Street in 1897. The parade is to support the U.S. involvement in the Spanish-American War.

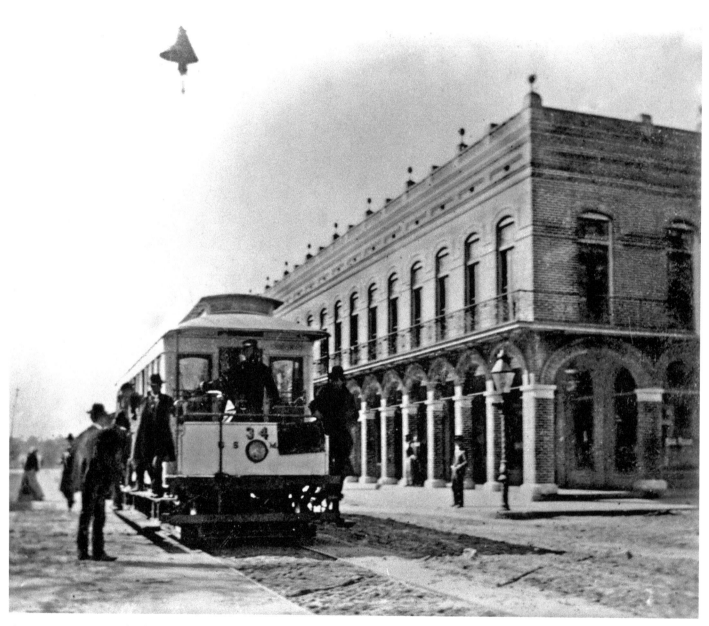

A streetcar runs on tracks down the unpaved Ninth Avenue past Ybor City's El Pasaje Hotel & Restaurant. El Pasaje means, "the passage." The colonnade, or columned walkway, creates a passageway along the street level and gives the building its name.

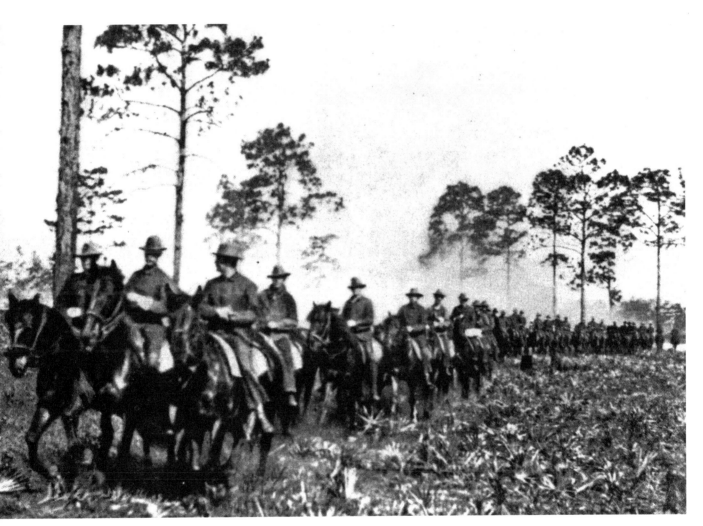

The US Army staged in Tampa for the invasion of Cuba during the Spanish-American War.
Pictured here is the Calvary on horseback riding in a bathing parade to Port Tampa City on the
southern end of the peninsula. A bathing parade is a procession to a body of water for bathing,
meaning either swimming or cleansing.

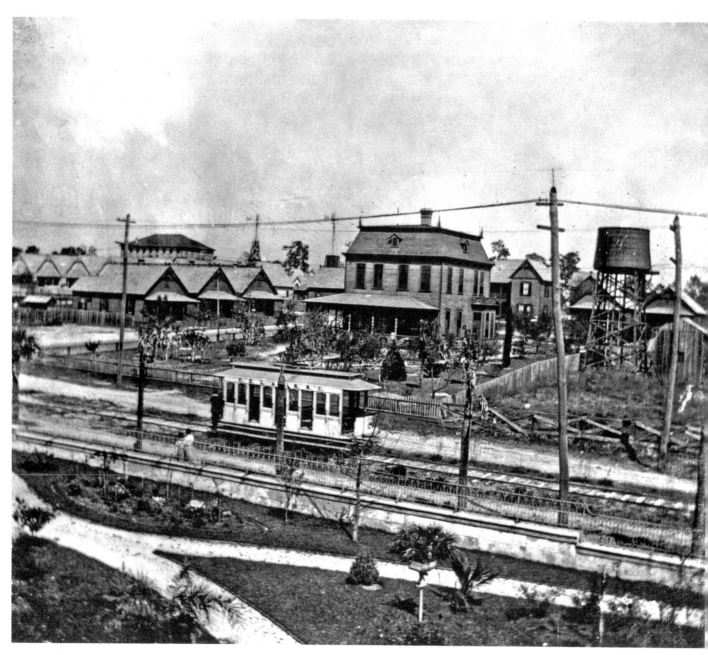

One of the CEL & PRR Co. streetcars in front of the home of José Arango, owner of Arango Cigar Company, known for its Julia Marlowe brand of cigars. His home was located at Twelfth Avenue and Twentieth Street. Arango also owned Arango and Arango Cigar Company.

The V M Ybor & Company Factory #1 on Fifteenth Street in Ybor City. This three-story brick building was one of the first two cigar factories in Tampa. The covered entry is one of the most famous sites from which José Martí addressed the factory workers while gathering support for the Cuban Revolution.

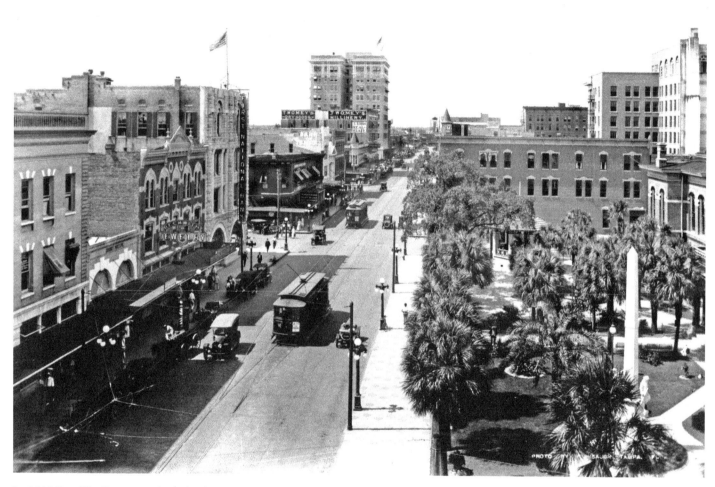

In 1915 Franklin Street was the hub of commerce. The Hillsborough County Courthouse with the Civil War Memorial is in the lower right of the frame. The First National Bank is across the street, flying the Stars and Stripes. The tall building further north on Franklin is the Citizen's Bank.

Tampa at the Commencement of the Twentieth Century

1900–1919

The new century brought population and geographic expansion to Tampa. In addition to the blossoming of Ybor City and the City of West Tampa, Hyde Park and Port Tampa City began to flourish. The turn-of-the-century populace swelled to nearly 16,000. Street rail lines, and later electric trolleys, reached the sprawled neighborhoods of the emerging manufacturing center.

By 1900 there were 129 cigar factories operating in Hillsborough County. Ethnic and racial groups were divided into realms with many of the factory workers residing in Ybor and West Tampa. The city proper, Hyde Park, and increasingly, the Interbay Peninsula, served as home to whites. African Americans, for the most part, lived in "the scrub" situated amid Tampa, Ybor, and West Tampa.

When Fort Brooke was decommissioned, both the white settlers and freed slaves were allowed to stake property claims. Among the best known and respected of the African American homesteaders were Benjamin and Fortune Taylor. Fortune Street, on the northern end of early Tampa, was named for Mrs. Taylor.

Several of Tampa's enduring landmarks were opened during these two decades: the state fairgrounds, adjacent the Tampa Bay Hotel, were opened in 1904; Ybor City's Columbia Restaurant debuted in 1905; and the development of Bayshore Boulevard was begun in 1907 as a scenic access to the Interbay Peninsula and the new collection of upper-class neighborhoods. The Palma Ceia Country Club opened in 1916.

The world's first regularly scheduled passenger air service was offered in 1914 on the St. Petersburg–Tampa Airboat Line. The inaugural flight was captained by Anthony "Tony" Jannus. The 18-mile trip took 23 minutes, a great advancement over the 160-mile trip around the top of Old Tampa Bay on the Tampa & Gulf Coast Railroad.

The cigar workers, merchants, and vendors of Ybor City and West Tampa were proud to be Americans and also proud of their origins in Cuba, Italy, or Spain. Their somewhat closed societies were microcosms of their old worlds and were reinforced through membership in organizations such as El Centro Español, L'Unione Italiana, El Circulo Cubano, and El Centro Asturiano de Tampa. These clubs and others provided fraternity among men with common ancestry. Some of them also offered a system of shared medical expenses and provided death benefits. The clubs could be quite elaborate; for example, the Centro Asturiano contained a cantina and cafe, billiards, a bowling alley, gymnasium, library, and theater.

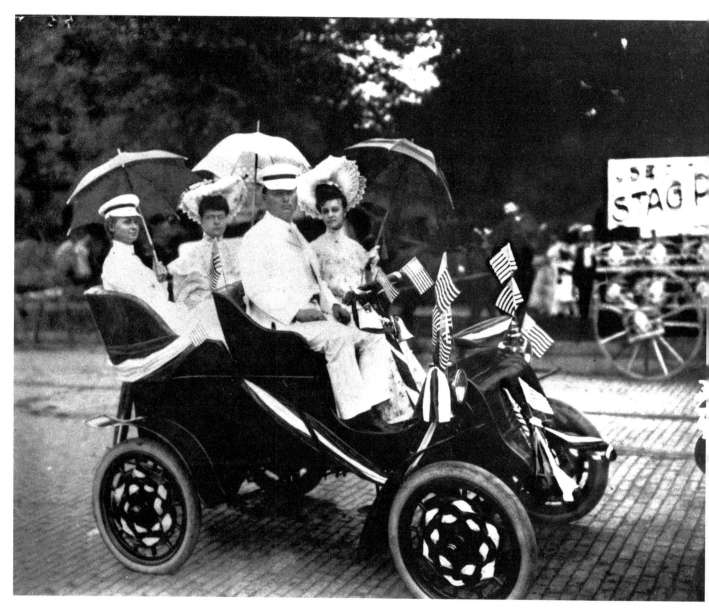

Two couples on parade in a decorated 1903 Cadillac automobile. The parade was a part of the festivities of the first Gasparilla Carnival, an annual event in which an honored local businessman assumed the role of the Spanish pirate, José Gaspar, to invade and capture the City of Tampa.

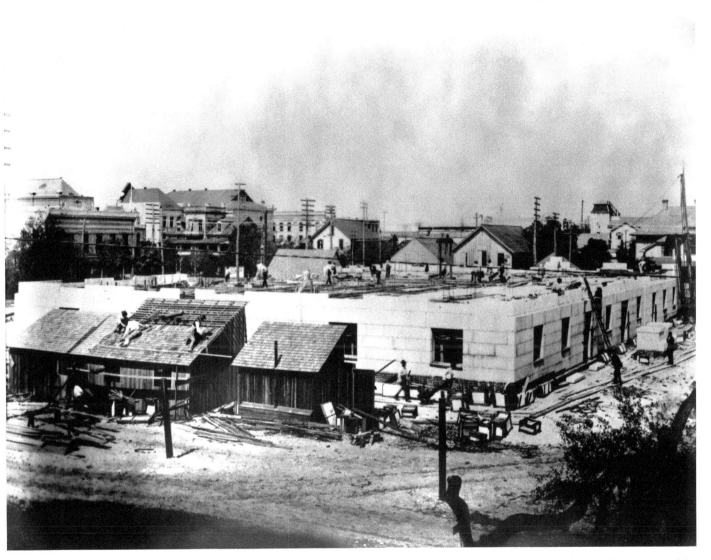

This photo was taken in March 1903 and charted the progress of the construction of the Federal Building at Marion and Zack Streets.

The first telephone operator for the Peninsular Telephone Company, Elsie Hart, is pictured at her work station in Clearwater, Florida. Peninsula Telephone was founded by William Brorein in 1901 and bought out the Bell Telephone operation in Tampa in 1906. Peninsula Telephone would later become General Telephone and then Verizon.

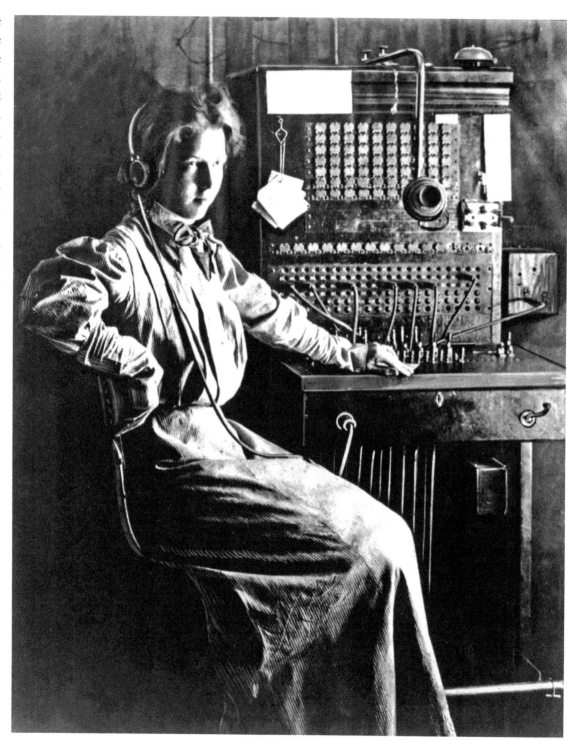

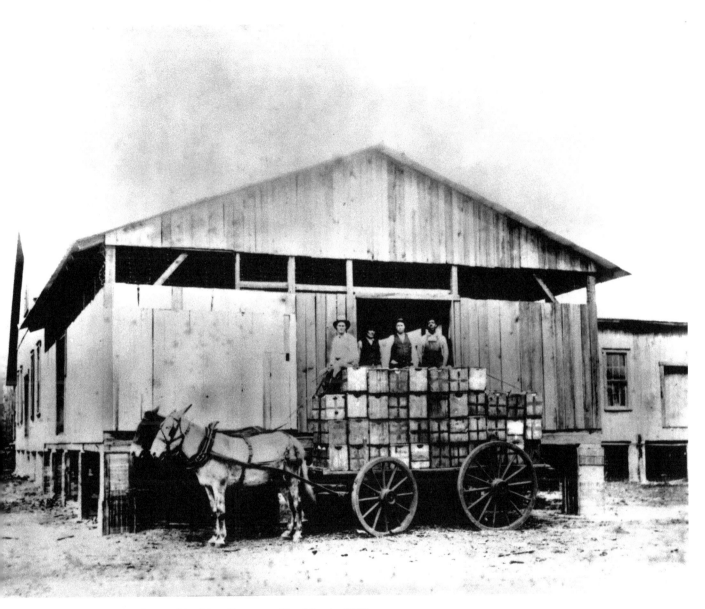

A group shot of employees of Lewis Trucking Company. Trucking in 1900
referred to a strong team of horses or donkeys and a wagon.

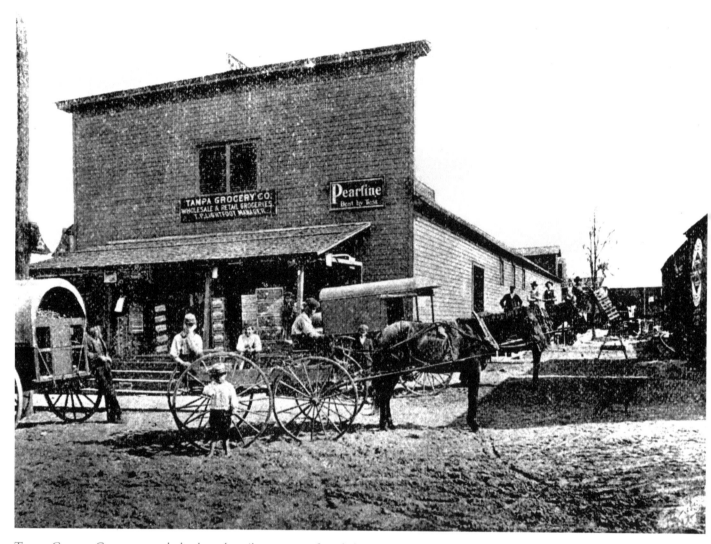

Tampa Grocery Company, a wholesale and retail grocer, was founded in 1896 by T.P Lightfoot. His original store was located on Sixteenth Street in Ybor City. Over time, Lightfoot would open as many as three more stores under the Tampa Grocery name.

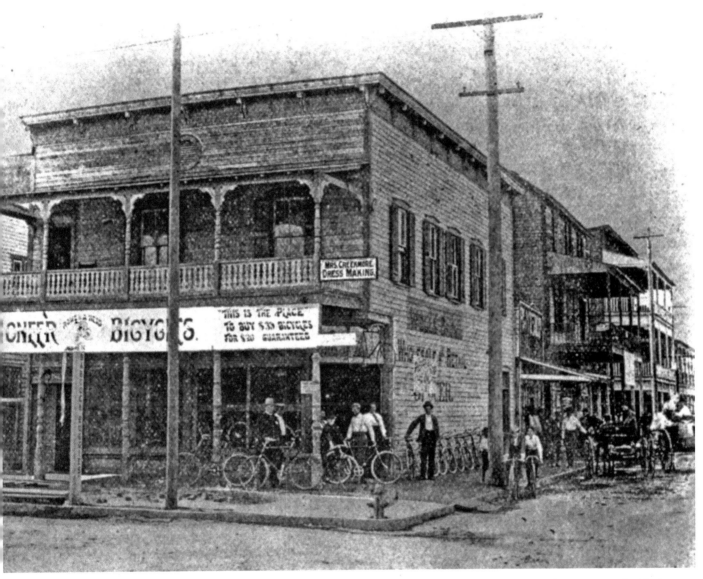

The W.J. Rowe Bicycle Emporium opened in 1898 on Florida Avenue. There one could buy bicycles and parts or have a bike repaired. It was also possible to rent bicycle wheels.

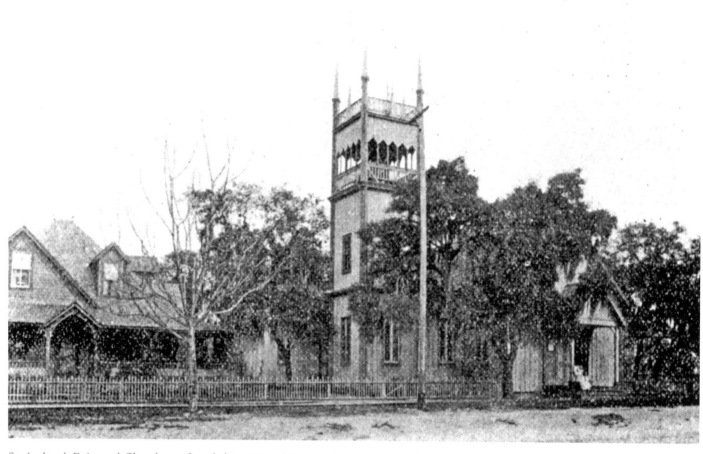

St. Andrew's Episcopal Church was founded in 1871. This wood-frame church and rectory were built at 505 Marion Street, at the corner of Madison Street. A new church of masonry construction was built on the same site circa 1919.

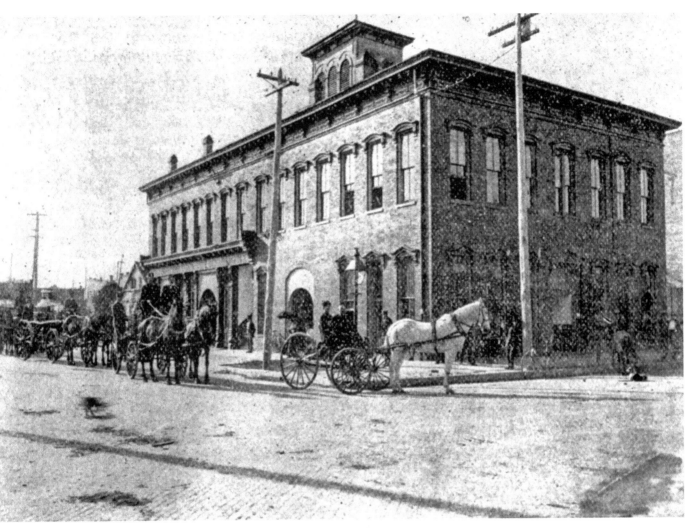

Horse drawn carriages in front of Tampa City Hall in 1900, a building that also housed the Tampa Police Department. This building would be replaced in 1915 by the more familiar building with it's clock tower named, "Hortense."

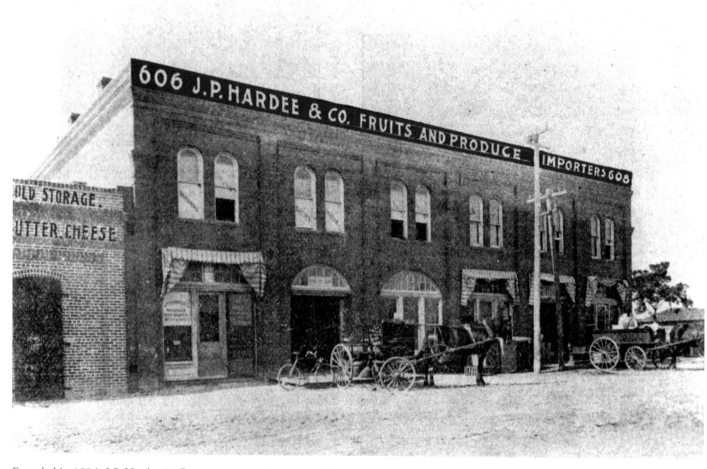

Founded in 1894, J.P. Hardee & Company was an importer of fruit, produce, poultry, eggs, and dairy products. Their trade reached the northern and eastern US and south to Cuba.

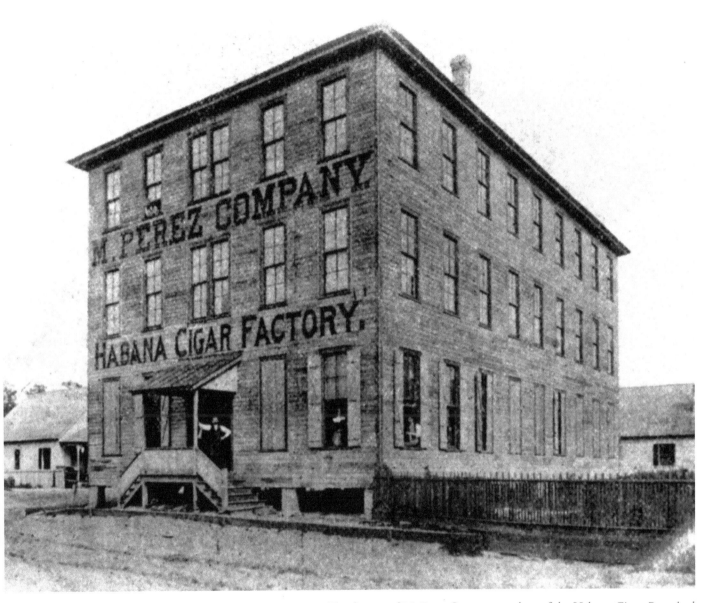

The factory of M. Perez Company, makers of the Habana Cigar. Perez had operations in Key West and followed makers, Ybor and Haya, to Tampa. This factory was located on Nineteenth Street in Ybor City.

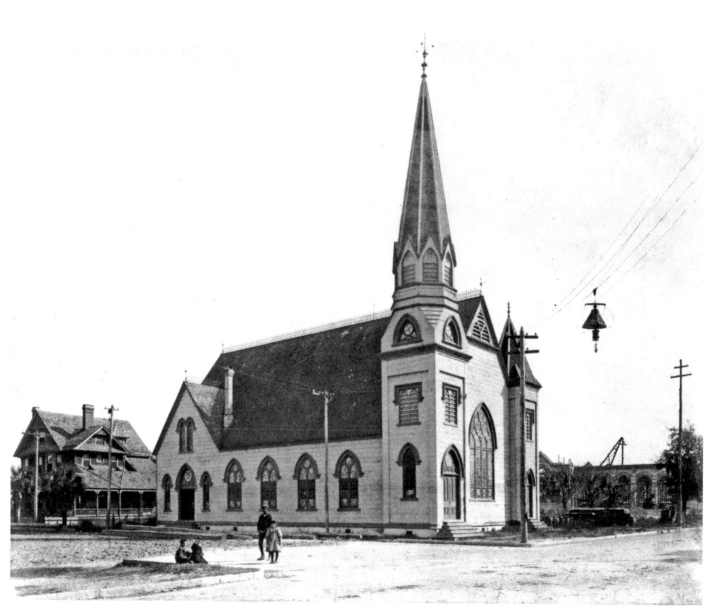

The First Presbyterian Church, located at Florida Avenue and Zack Street. This church is in the Victorian style with beautiful stained glass and high steeple.

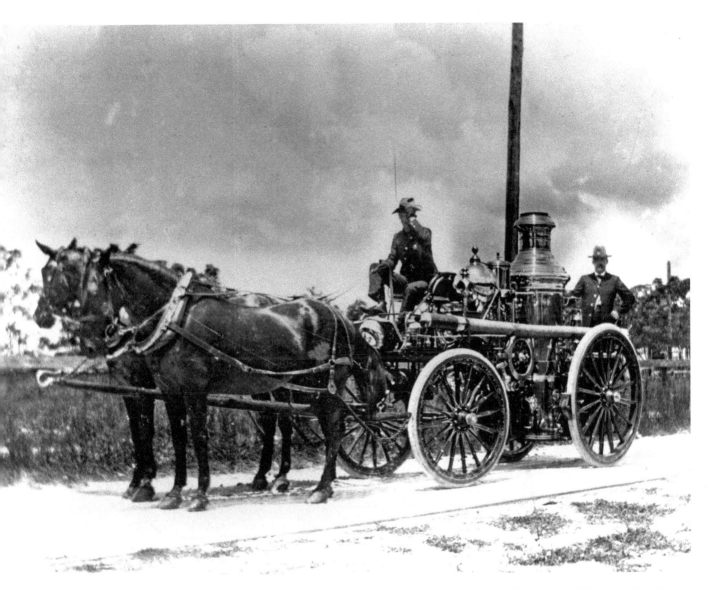

This photo, taken in 1905, is toward the end of the era of horse-drawn fire engines. With the technology to carry and pump greater amounts of water, came the need to motorize the fire engines because the horses could no longer effectively pull the load. Pictured here is a steam piston pumper made by the American LaFrance Fire Engine Company. This engine, named "Elmer Webb," was assigned to Station No. 4 in Ybor City.

This photograph from 1903 shows construction of the foundation of the Federal Building at Marion and Zack Streets. Beyond the construction site is the First Presbyterian Church. The De Soto Hotel is to the right of the church.

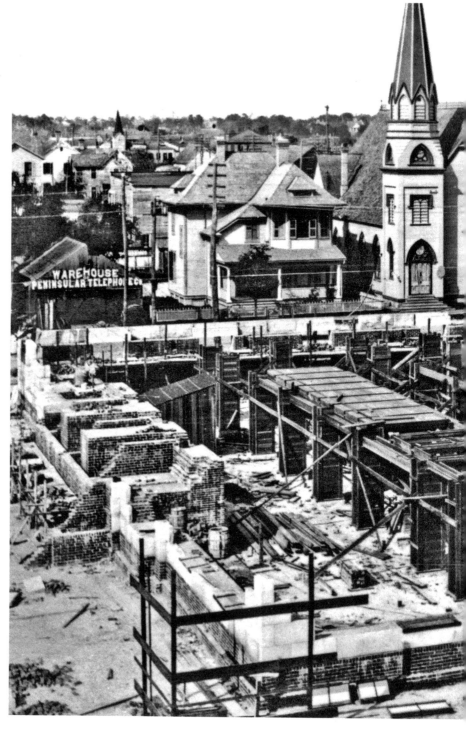

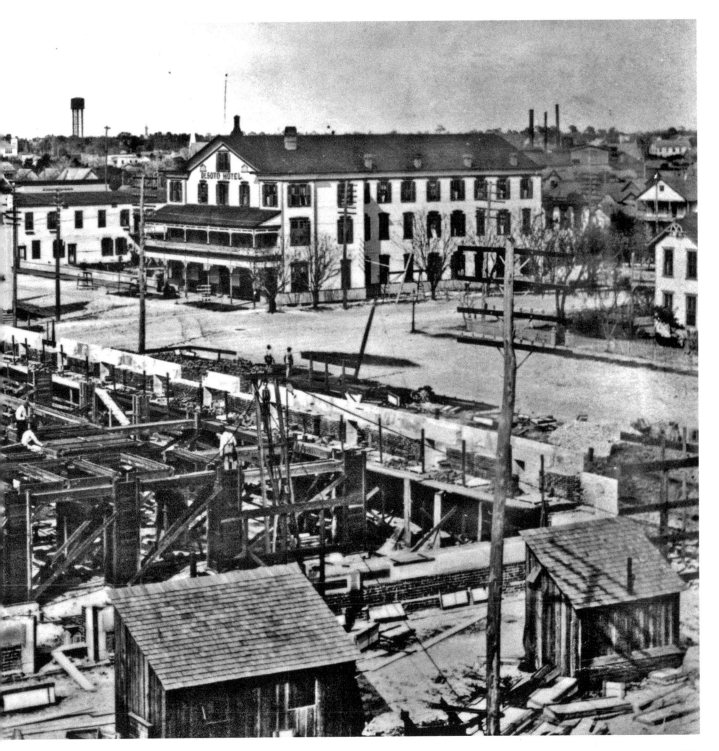

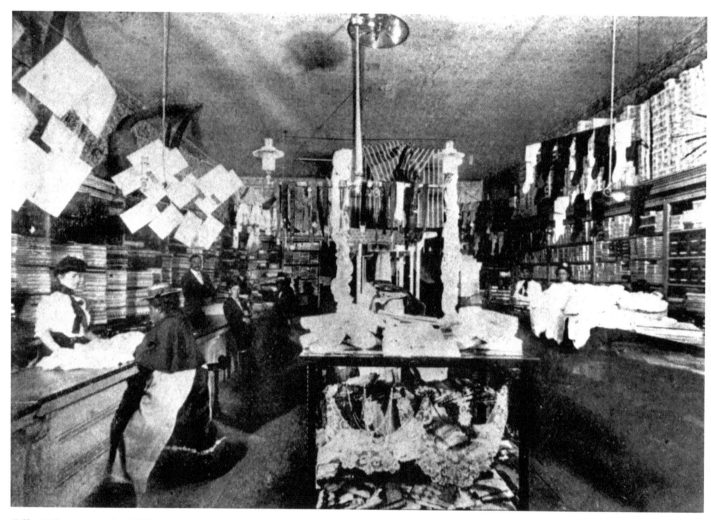

Offin Falk came to the US from Russia in 1889 and moved to Tampa in 1895. His original store was in Ybor City. In 1897 he moved his store to Franklin Street. Two years later he was joined in the business by his brother, Morris, under the name O. Falk and Brother Dry Goods and Millinery. In 1923 they built a three-story structure adjacent to their existing store.

William G. Brorein, the founder of Peninsula Telephone Company, deserves significant credit for success of the Carnival-style Gasparilla Festival. Pictured here is the royal court at the first Gasparilla coronation ball honoring the King of Gasparilla. The event was held at Tampa Bay Hotel in 1904.

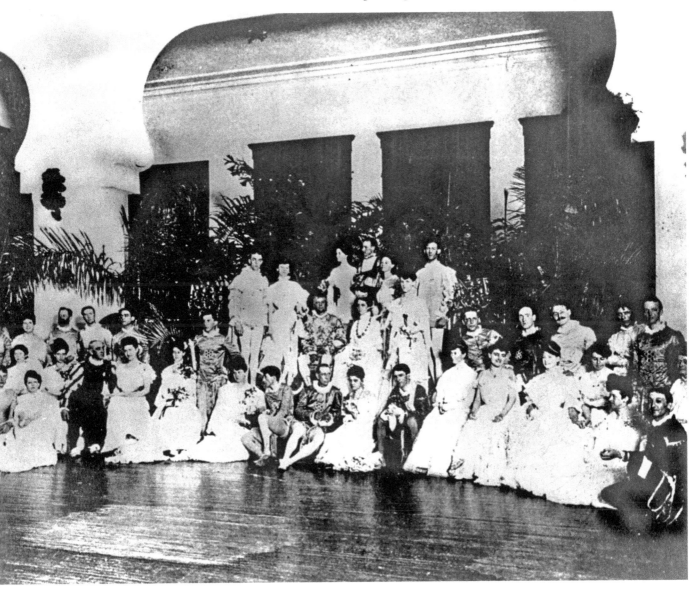

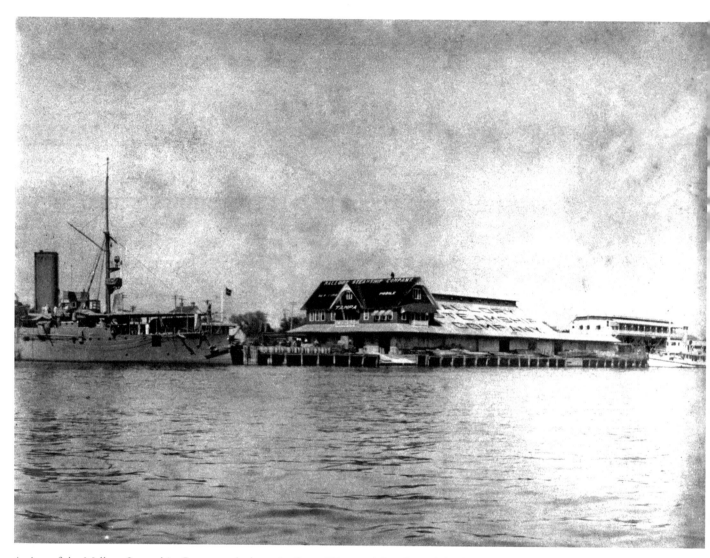

A view of the Mallory Steamship Company docks at the Port of Tampa. After channel dredging in 1908 that allowed large seagoing ships to dock in Tampa, the port became a part of the shipping circuit for Mallory and others. The routes of the Mallory line included ports of call in New York, Key West and Mobile.

From 1910, this is the Florida Citrus Exchange Building on Twiggs Street in Tampa. The brick building has a wooden porch and wide sidewalk.

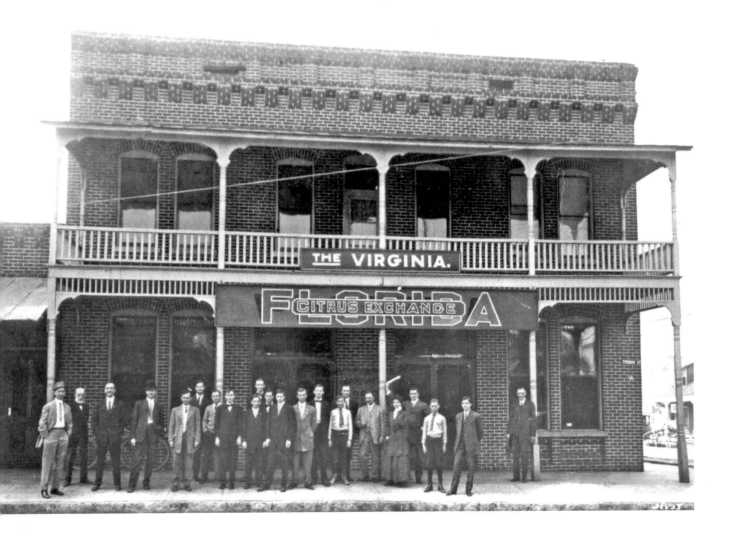

This second, sturdier version of the Lafayette Street Bridge was built in 1896. The road surface of the pictured bridge was wooden plank. The bridge also carried street rail tracks. Construction of the bridge precipitated growth west of the river. The third iteration of the bridge would be between 1912 and 1913. Circa 1910.

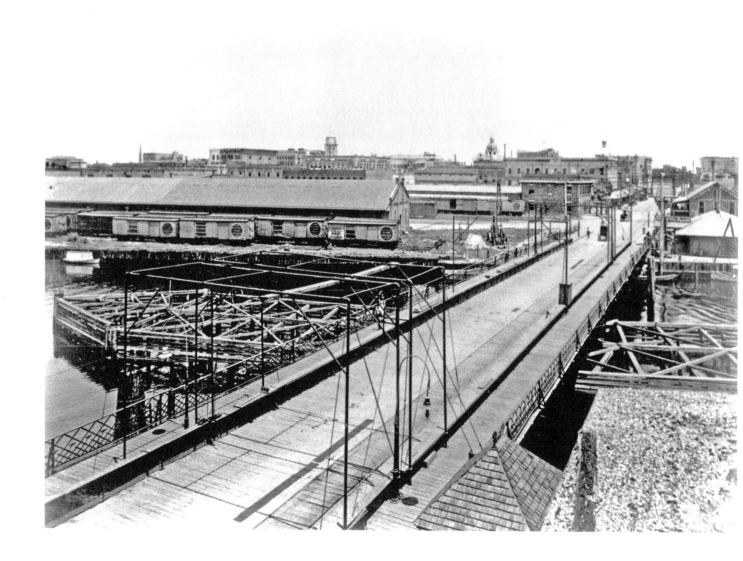

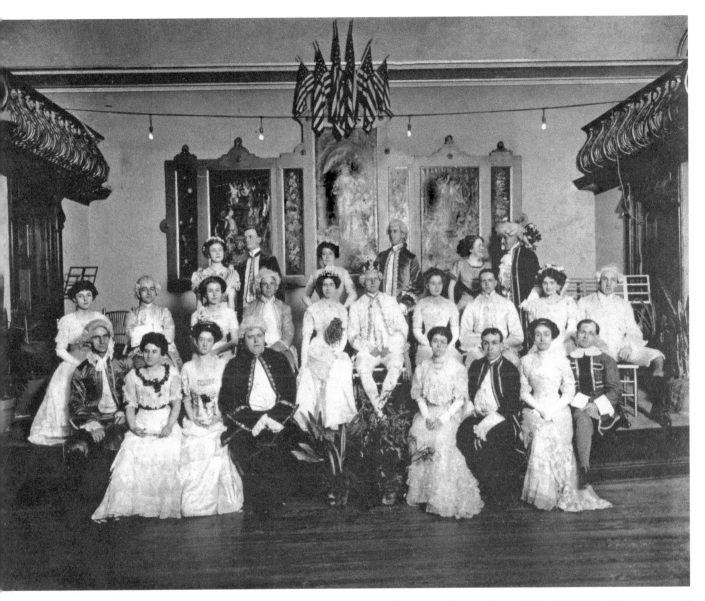

Ye Mystic Krewe of Gasparilla did not invade Tampa in the years from 1907 to 1909. The Krewe returned in 1910 as part of the Panama Canal Celebration which marked progress on canal construction and a Congressional joint resolution proclaiming Tampa as the nearest adequate port to the canal. The Gasparilla Carnival capped the festivities. The photo reveals the royal court with King Edward Hendry and Queen Kathleen Phillips seated in the center of the front row during the coronation ball at the Tampa Bay Hotel.

The street rail lines seen running east on Main Street and south down Howard Avenue in the City of West Tampa. West Tampa was the creation of immigrant Hugh Campbell Macfarlane. Development began in 1892. The photo was taken in 1911.

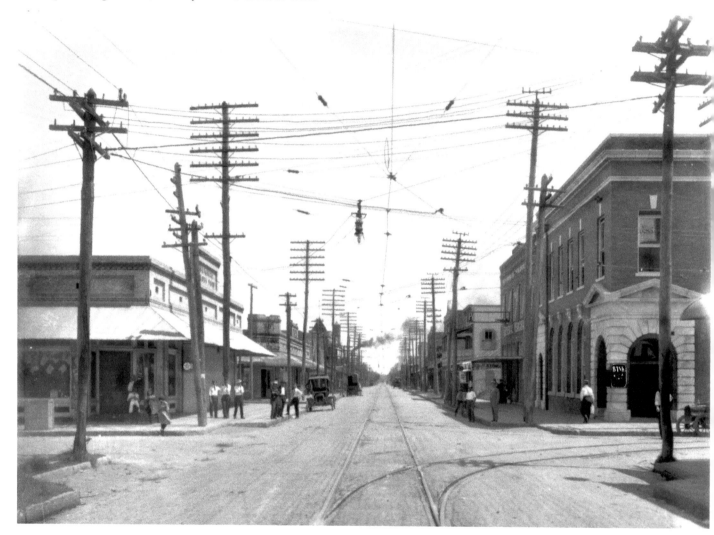

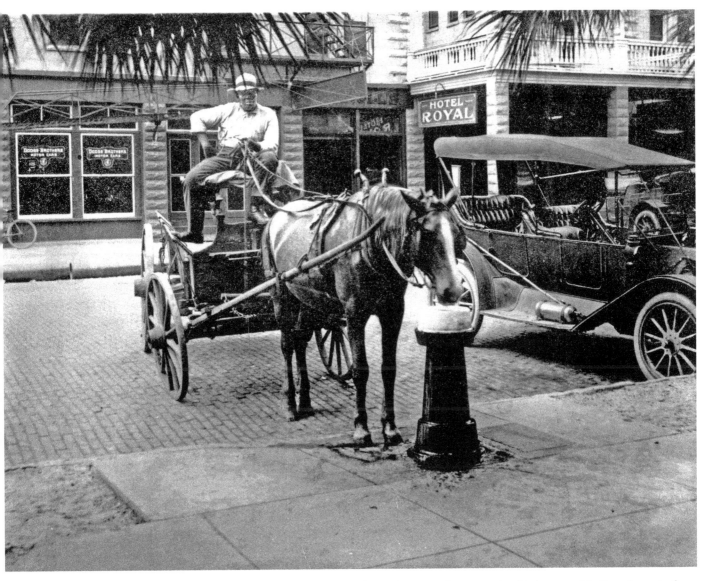

Man in a horse drawn carriage, watering his horse on Madison Street in front of Hillsborough County Courthouse.

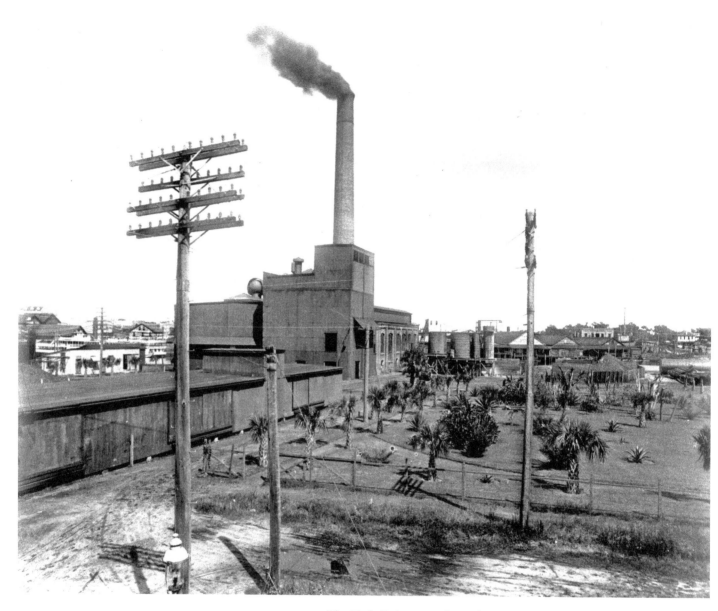

The Hyde Park power plant of Tampa Electric Company as seen from Parker Street. Beyond the grounds of the plant and across the river, buildings of the Port of Tampa are visible.

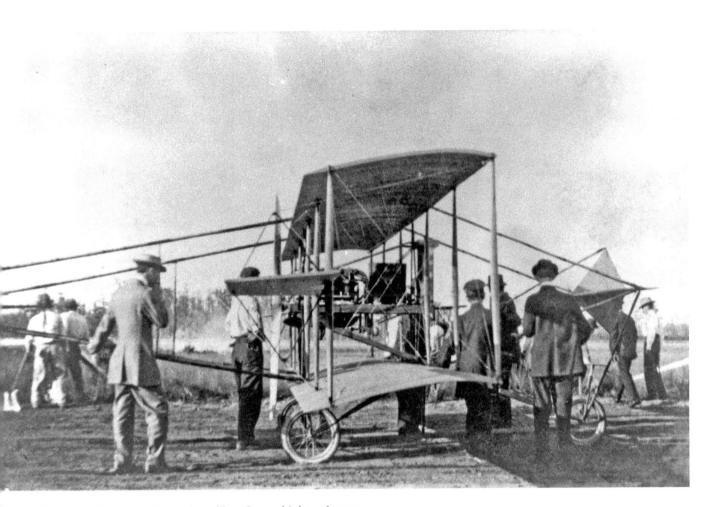

George S. Gandy with a group inspecting a Tony Jannus biplane. Jannus piloted the world's first scheduled passenger flights the same year as this photo was taken, 1914. Gandy was responsible for the first bridge across Old Tampa Bay.

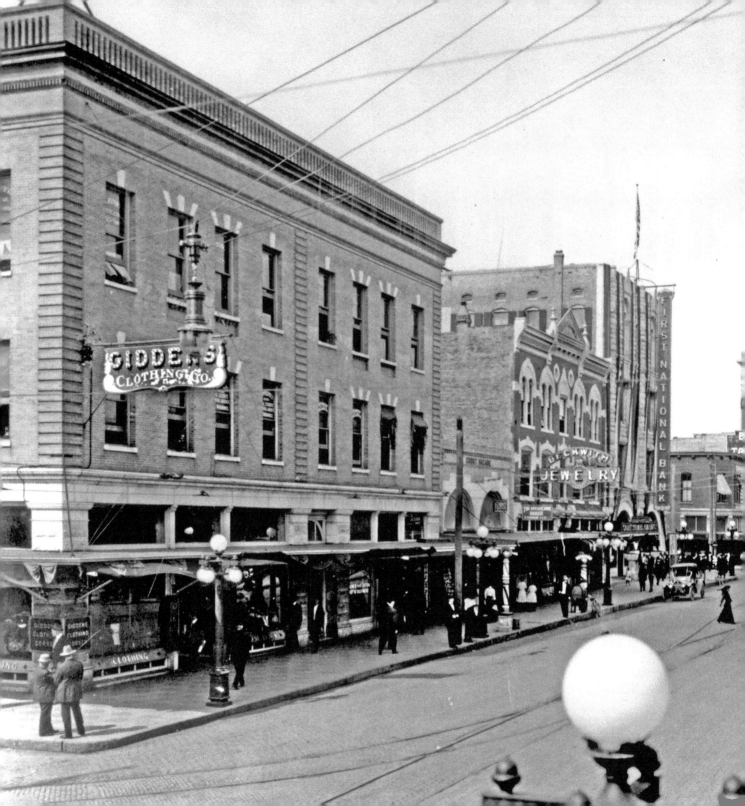

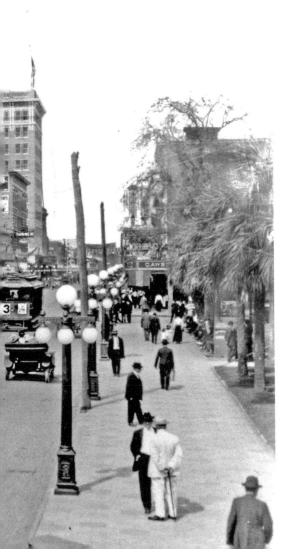

Gidden's Corner, across from the Hillsborough County Courthouse at Lafayette and Franklin Streets. The tall building toward the end of Franklin is the Citizen's Bank. (1912)

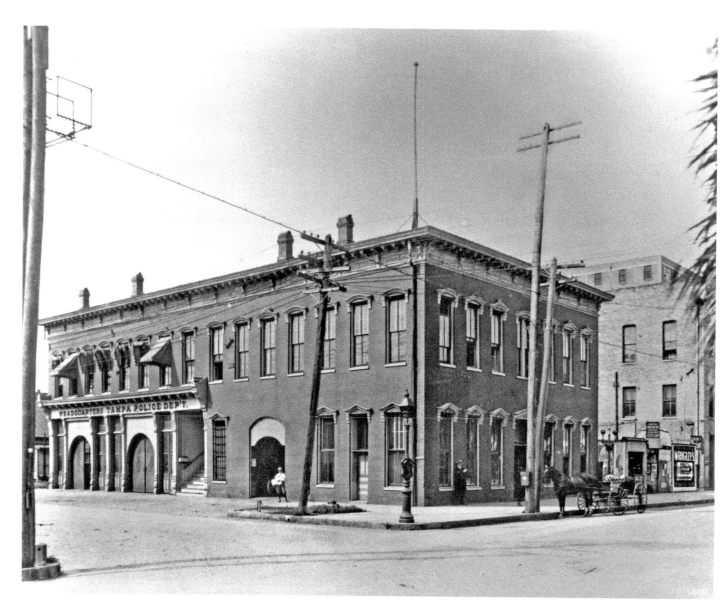

Before the beautiful City Hall building which features the clock tower, this
1914 photograph captures the two-story brick building which formerly
housed both City Hall and Police Headquarters.

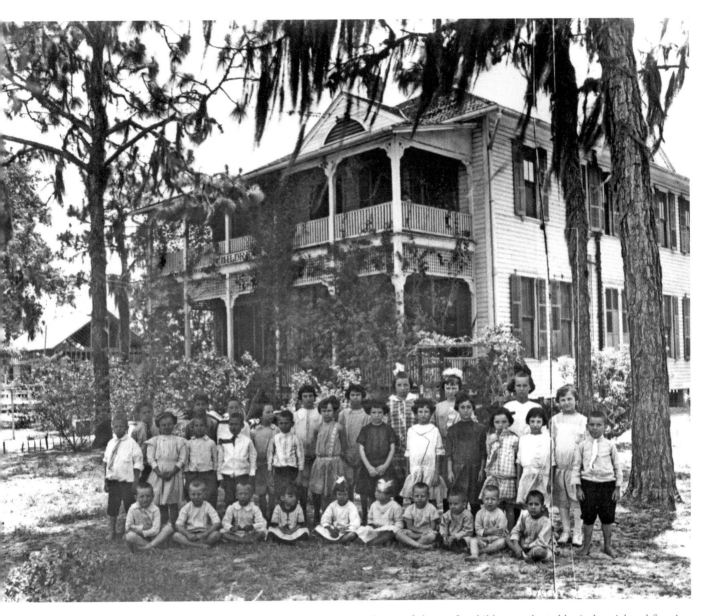

The Children's Home was created as a safe haven for children orphaned by industrial and farming accidents or disease. Photographed here is a group of young residents in front of the living facility on Florida Avenue between 26th Avenue and Emily Street. Note the number of children.

The Federal Building, with its ionic columns, sits on the city block that is bound by Florida Avenue, Twiggs, Marion, and Zack Streets. The building, seen here in 1915, was ringed in palm trees.

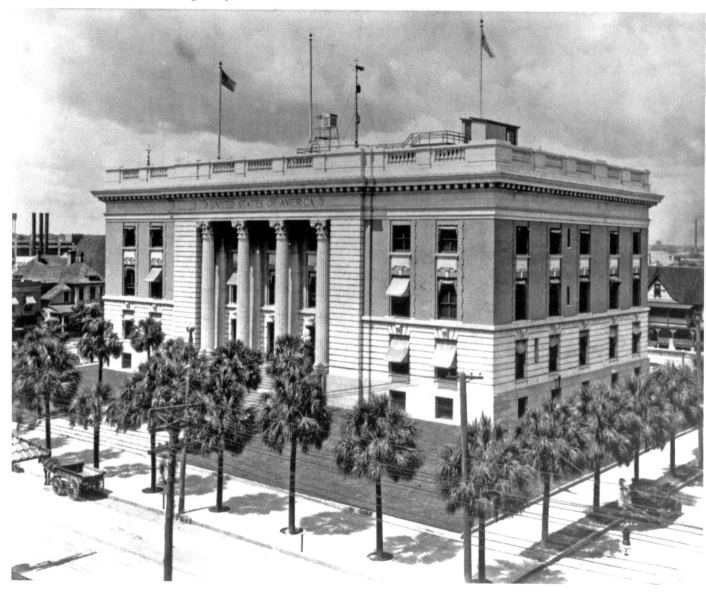

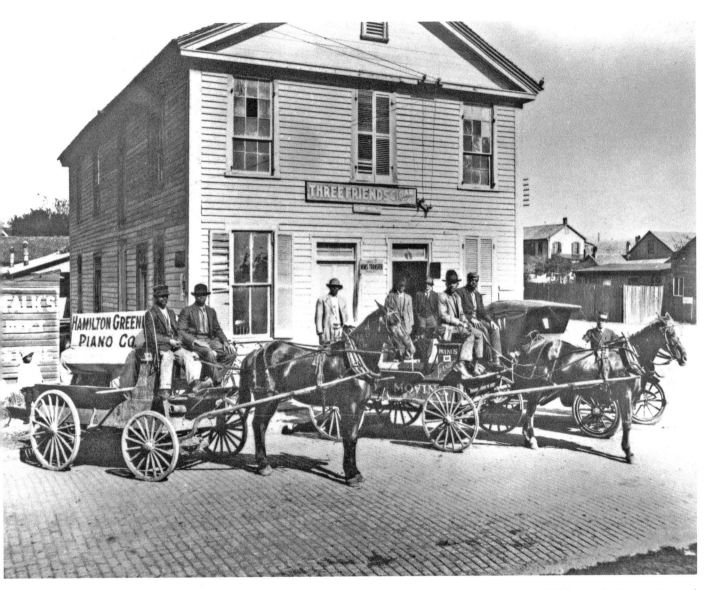

In 1915 there were over 100 cigar manufacturers in Hillsborough County. Pictured here are employees of Mims Transfer Company in front of the wood-frame factory of Three Friends Cigar Company on East Scott Street in Tampa.

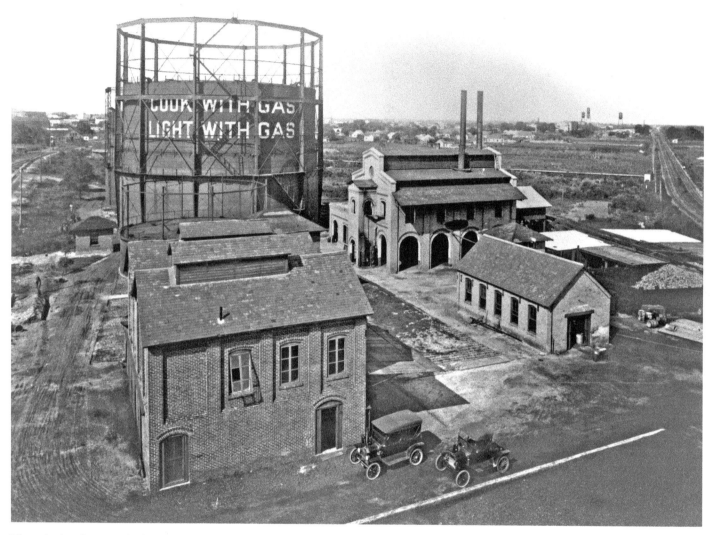

Though electric power had come to Tampa as early as the 1890s, gas power was a very reliable option for light and heat. The Tampa Gas Company was near Ybor Channel on Twelfth Street between First and Second Avenues in Ybor City. First Avenue was renamed Adamo Drive in honor of Dr Frank Adamo, a Tampa native who achieved worldwide acclaim for his treatment of gangrene.

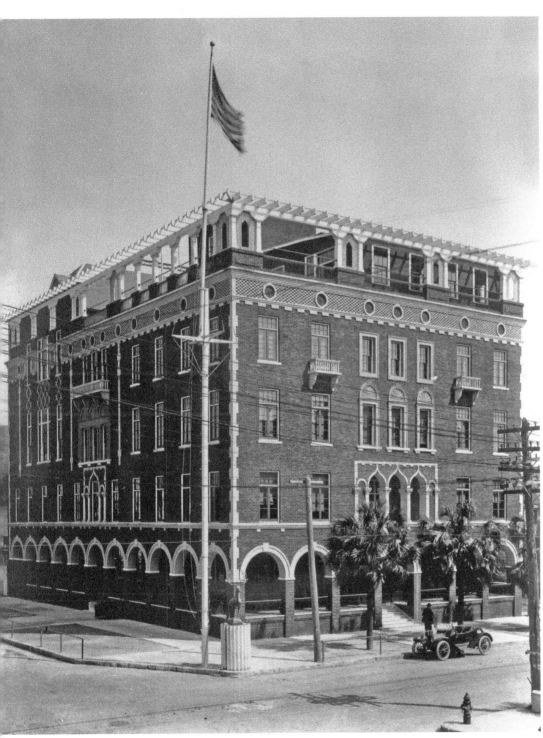

The Elk Club, Lodge 708, was located at the corner of Florida Avenue and Madison Street, was built of red brick and marble in 1913. This photo was taken two years after its completion.

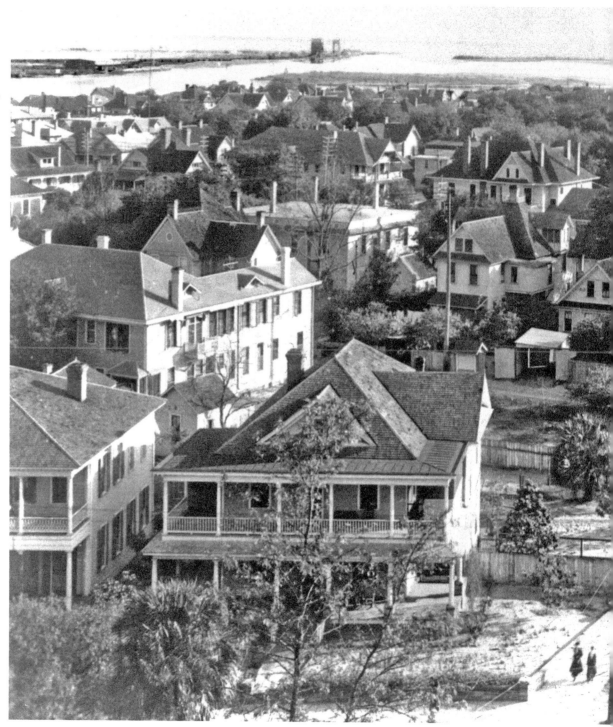

Street cars and pedestrian traffic along Hyde Park Avenue. This view, from the vantage point of the Tampa Bay Hotel, encompasses Hillsborough Bay and streets of fine residences. (1913).

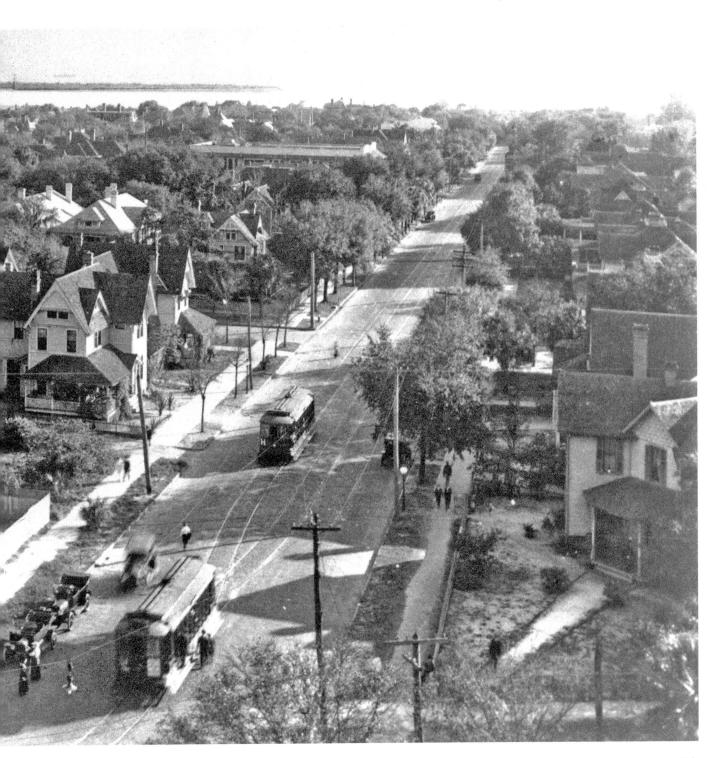

The original Hillsborough County Courthouse with its dome and minaret are seen in this September 1915 photo. The courthouse faced Franklin Street. Shown here is the intersection at Madison Street. Beyond and to the right of the courthouse is Tampa City Hall with its clock tower.

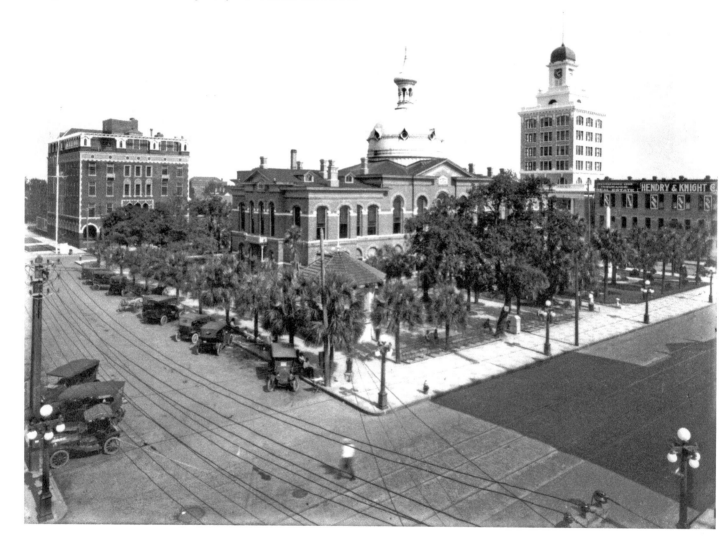

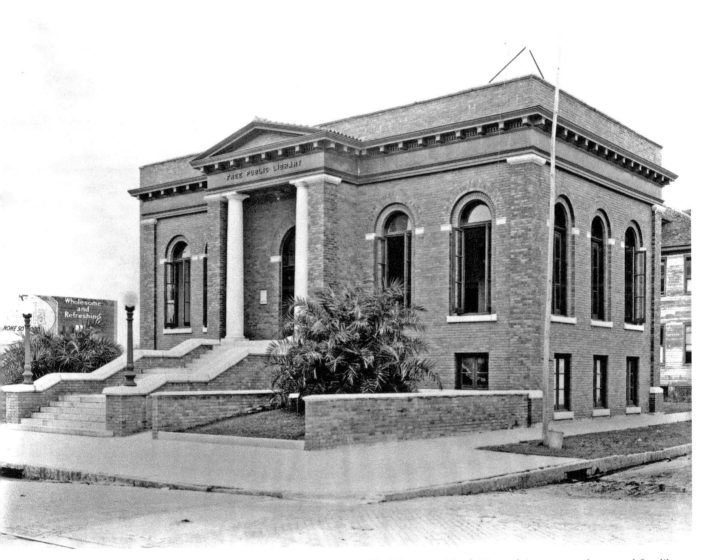

The West Tampa Public Library on North Howard Avenue was the second free library in the county. The building is pictured here around the time of its opening in 1918.

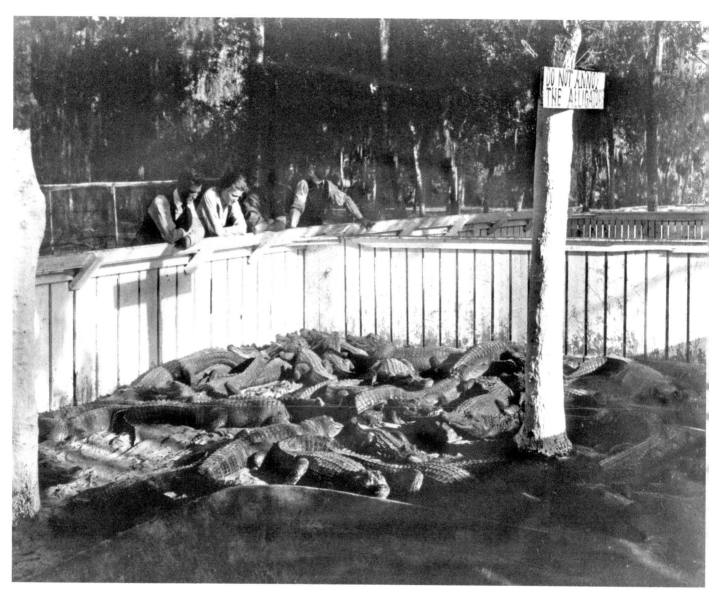

Sulphur Springs, north of early Tampa, was first developed and opened to the public by Dr J. H. Mills in 1908 as a public swimming area and amusement pavilion. It was connected to Tampa via a trolley line, built by Tampa and Sulphur Springs Traction Company. Here, a small group views captive alligators.

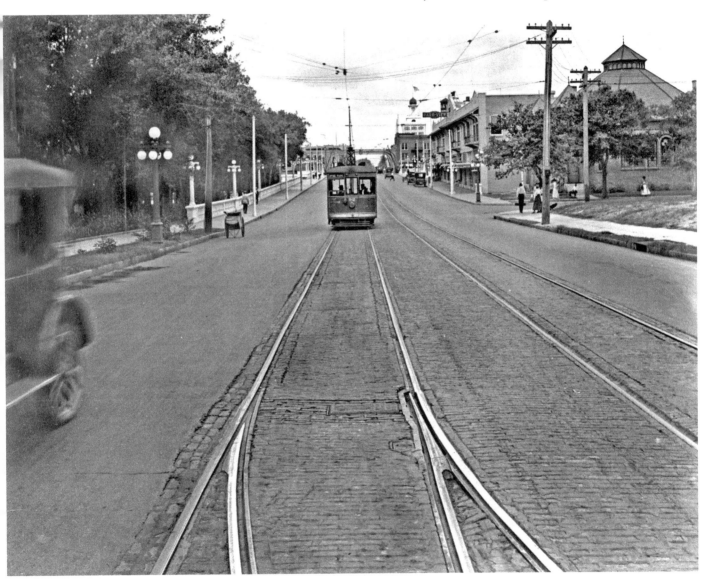

An electric street car on Lafayette Street seen from the intersection at Hyde Park Avenue, looking eastward toward down town.

A scene from the Port of Tampa in 1917, stevedores unload barrels of asphalt from the wooden hulled, masted freighter, "Hope."

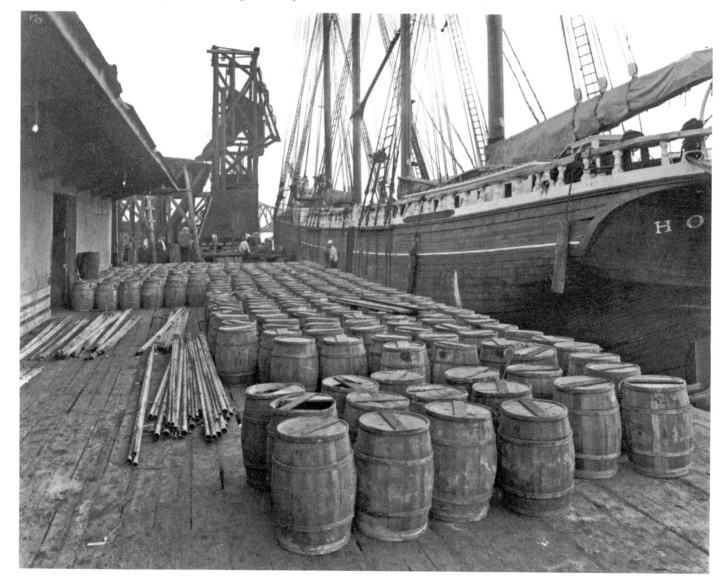

The intersection of Bay Street and Hyde Park Avenue in 1916. This view looks southwest across Hillsborough Bay with homes along Bayshore Boulevard in the distance.

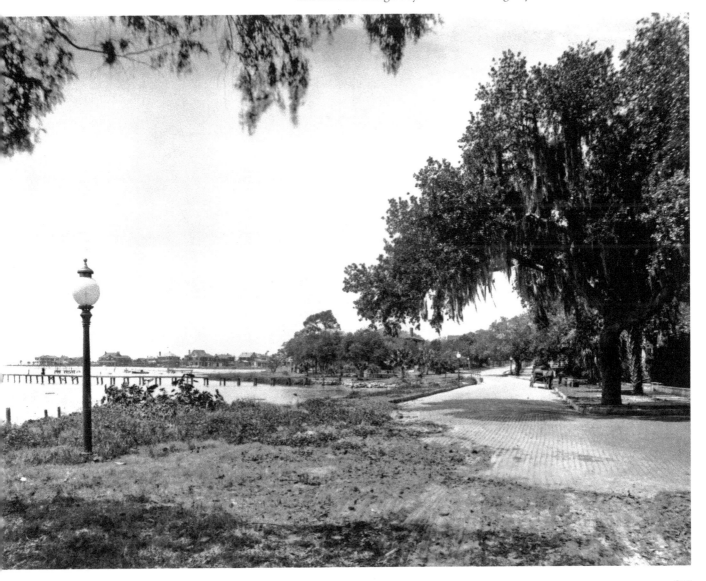

The neat, upscale neighborhood of Hyde Park. The subdivision was
created by O.H. Platt of Hyde Park, Illinois in February 1886.

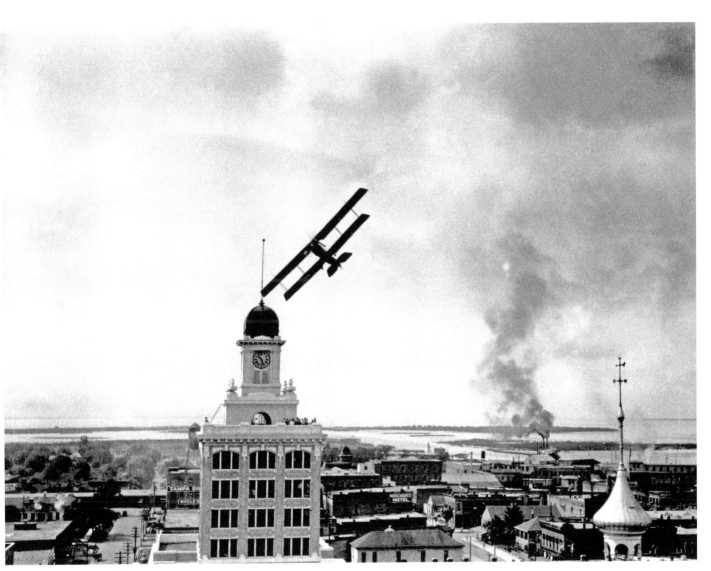

A biplane flying over City Hall. The minaret of the Hillsborough County
Courthouse is in the frame on the right. Big Grassy and Little Grassy Key,
later known as Davis Islands, are in the distance.

Tampa Heights, which began development in the 1890s, was the city's first completely residential suburb. The Tampa Heights Methodist Church, at 503 East Ross Avenue, was built in 1910 and had a congregation as large as 1,600.

This is the Hillsboro State Bank on North Collins Street in Plant City, which lies 24 miles east of Tampa. Plant City, a predominantly agricultural community, was incorporated in 1885. The city was named after Henry B. Plant.

L'Unione Italiana is a social and benefit club founded in 1894. Members were eligible for shared medical expenses and death benefits. The original club was destroyed by fire in 1915. This new building, erected in 1917, features classic and Mediterranean architectural elements.

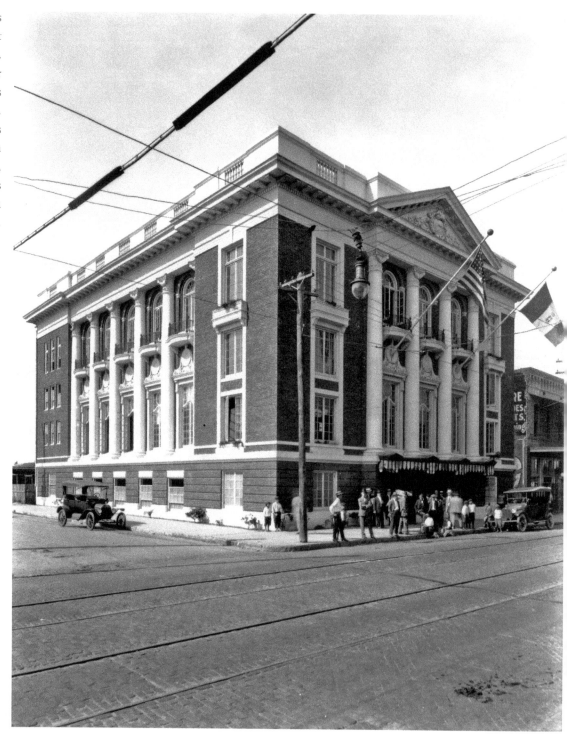

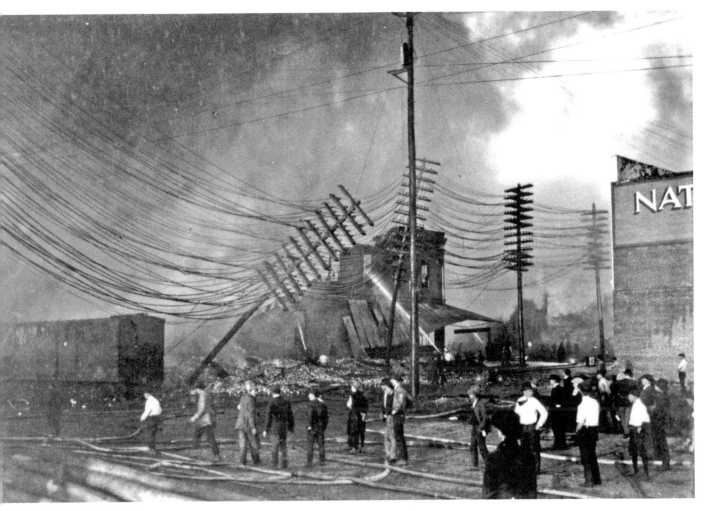

The event known as "The Great Tampa Fire," occurred on December 30, 1919, along the waterfront. This photo was taken on Washington Street, the one-time hub of commerce in Tampa. The corner of the two-story National Biscuit Company is at the right edge of the photo.

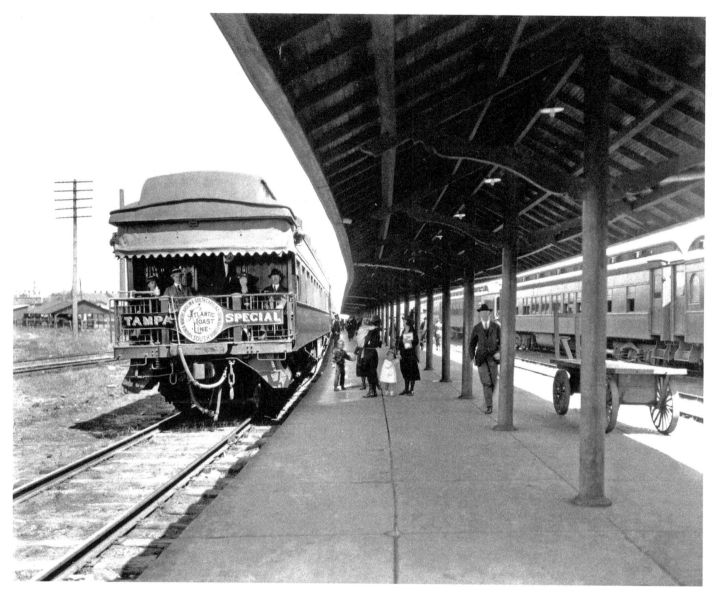

The "Tampa Special" rolling into Tampa Union Station at Nebraska Avenue and Twiggs Street. This passenger train was a part of the Atlantic Coast Line Railroad.

The Roaring Twenties, the Great Depression, and Economic Recovery

1920–1939

During the 1920s Tampa's population swelled to over 88,000. Facilities at Port Tampa City, the extensive railroads, and the shipping terminals on the downtown channels made Tampa an international shipping hub.

The sixth hurricane of the 1921 season did not directly hit Tampa but drove sufficient water into Hillsborough Bay to severely damage Bayshore Boulevard, wash out bridges over the Hillsborough River, and leave cargo ships hard aground. Ironically, the wake of that disaster brought a construction boom.

Real estate developer Dave P. Davis was able to buy Big Grassy Key and Little Grassy Key in Hillsborough Bay for $250,000 in 1924. Dredging united the islands and within a year every single-family home site was sold. Despite a plummeting real estate market the following year, Davis Islands was built and remains a desirable address.

The northern tip of Davis Islands was acquired for the 186-bed Tampa Municipal Hospital, constructed during 1926 and 1927. The facility was renamed Tampa General Hospital in 1956.

Clara Frye moved to Tampa in 1908, a time when African Americans were not admitted to existing whites-only hospitals. Recognizing the dire need, the nurse allowed surgeries to be performed in her own home. In 1923 she opened the Municipal Hospital for Negroes in a house on Lamar Street. The larger Clara Frye Hospital for Negroes was built in 1936 amid the predominantly African American section of Tampa. A plaque at Blake High School, where the hospital once stood, honors Frye's work.

Pinellas County resident George S. Gandy opened the first bridge across Old Tampa Bay in 1924. That same year 1,500 acres north of the city, acquired to grow Temple oranges, was redeveloped for homes and given the name, Temple Terrace. West Tampa became part of the city of Tampa in 1925.

The first radio station in Florida, WDAE, went on the air May 15, 1922. An aerial placed atop the Citrus Exchange Building transmitted the AM signal from a modest studio assembled from surplus military equipment.

Demand for luxurious hand-rolled cigars fell steeply with the onset of the Great Depression, foretelling great change for Ybor City. The Works Progress Administration poured money into the economy through the construction of Peter O. Knight Airport, the rebuilding and widening of Bayshore Boulevard, and completion of the second bridge over Old Tampa Bay, the Ben T. Davis Causeway. The span was later renamed for the man largely responsible for the beautification of the causeway, Courtney Campbell.

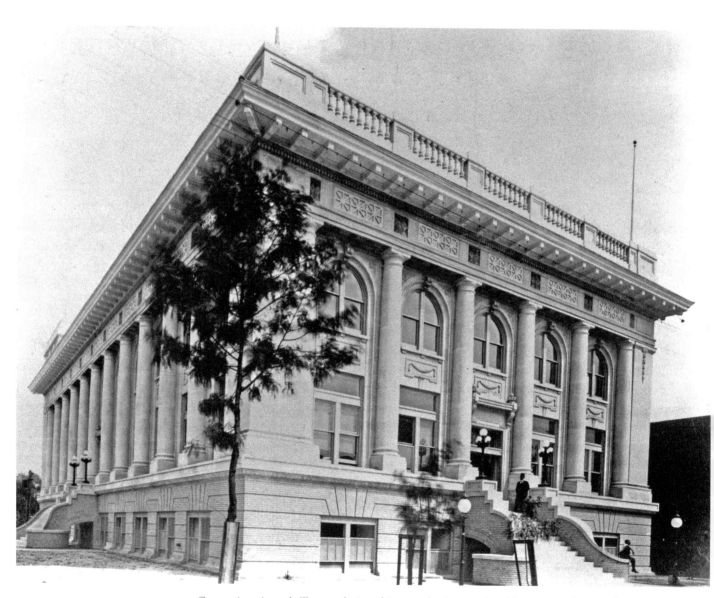

Centro Asturiano de Tampa, designed in neo-classic revival and beaux arts classic styles, is pictured here around 1920. The building was located on North Nebraska Avenue and held facilities for amusement and entertainment. In addition to being a social club, membership included health care and a death benefit.

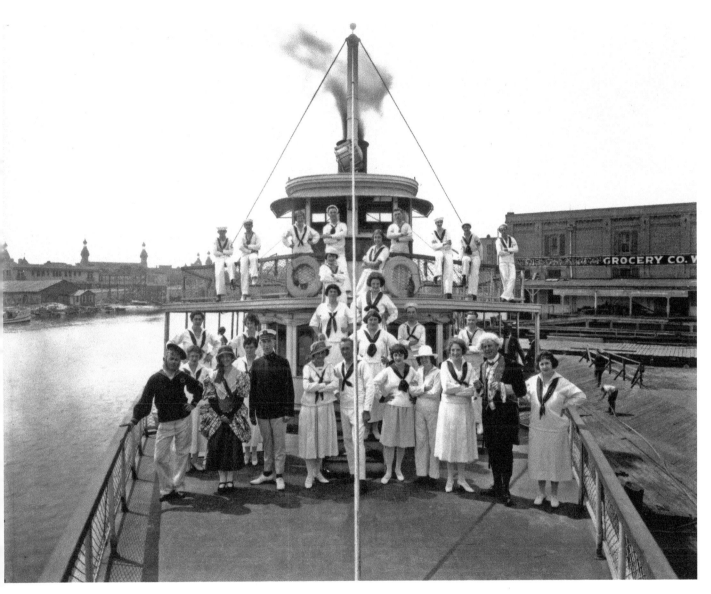

The cast from the operetta, "HMS Pinafore" aboard a steamboat on the Hillsborough River. The Tampa Bay Hotel is in the background to the left.

This is a 1920 view south on Franklin Street toward Garrison Channel and Seddon Island. The clock tower and cupola of City Hall stands out boldly on the skyline. The photo was taken from the Citizen's Bank Building.

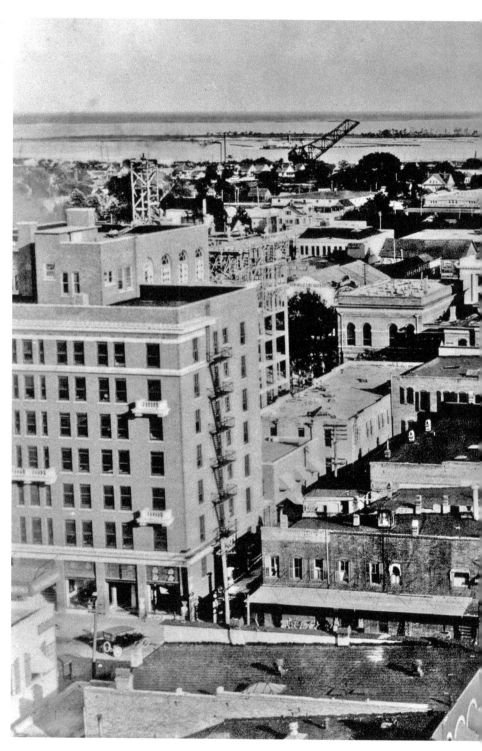

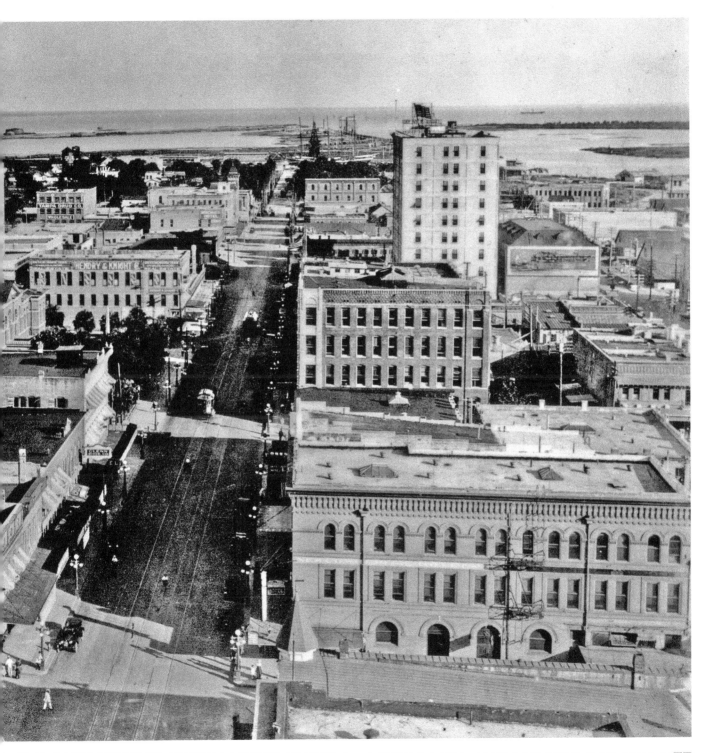

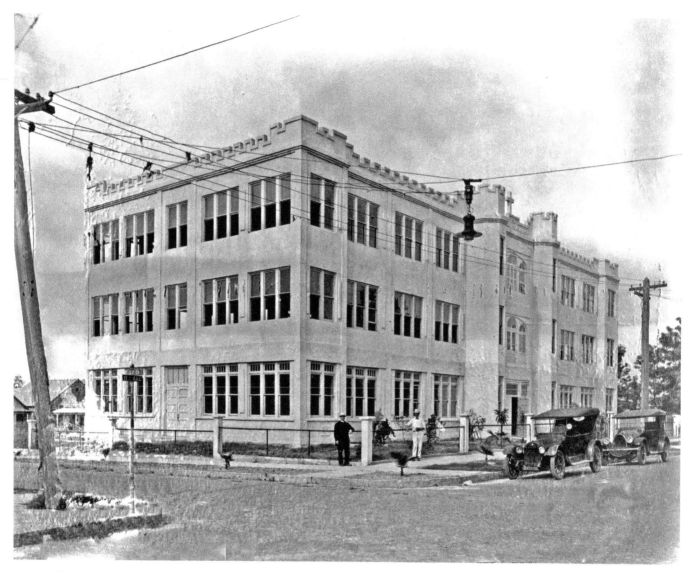

St. Joseph's Convent located at Eleventh Avenue and Eighteen Street
in Ybor City. Associated with St. Joseph's Hospital, the nuns of the
convent worked the hospital wards, providing care and comfort.

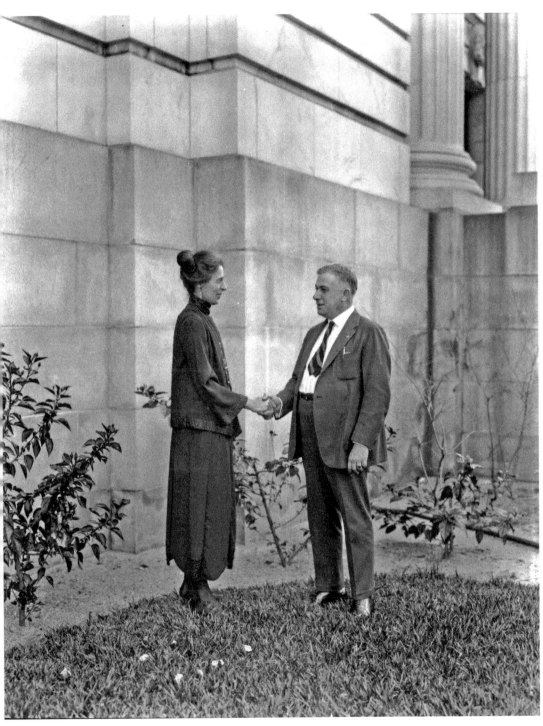

Postmistress Elizabeth Barnard with Edwin Lambright, the Assistant Editor of the Tampa Morning Tribune, on the grounds of the Federal Building, taken in January 1923.

Shot in 1921, this is a view from the Tampa Bay Hotel looking east across the Hillsborough River at the skyline. The structure on the river is a bat tower. Over the years Tampa had had bouts with malaria and yellow fever, both mosquito-borne diseases. Bat towers were built along the river because of bats' natural appetite for mosquitoes.

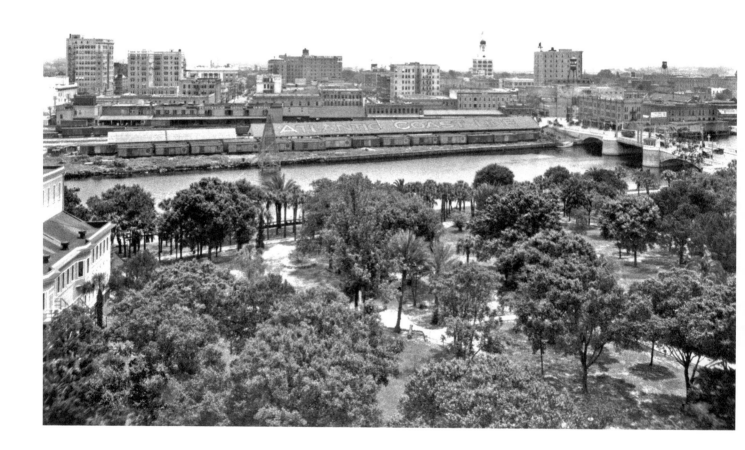

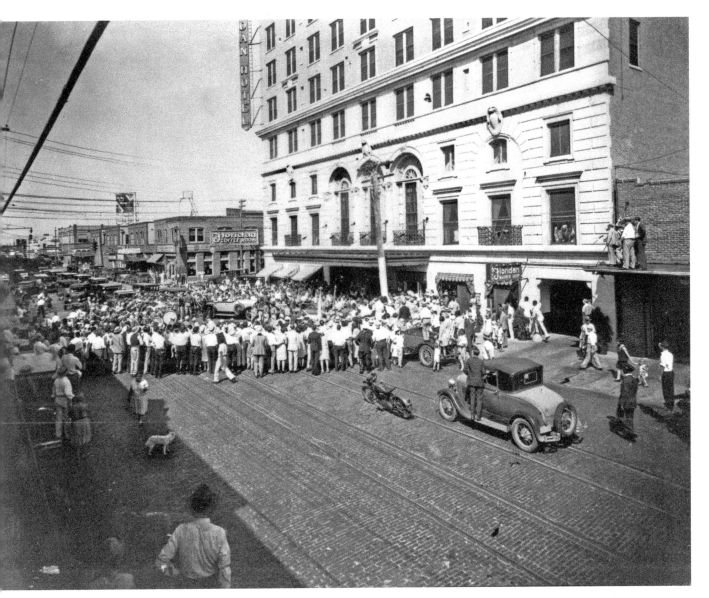

A crowd outside Floridan Hotel has the traffic on Cass Street drawn to a stop.

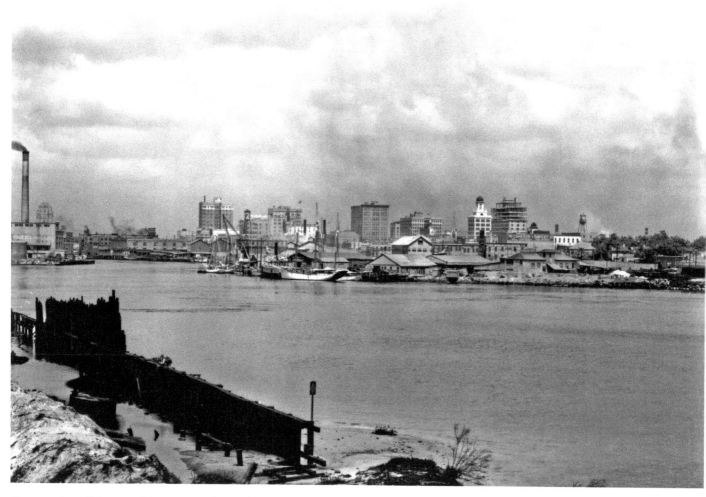

Construction of the seawall in 1925 on the northern tip of Davis Islands. Across the mouth of the Hillsborough River the domed tower of City Hall is visible.

A gathering of Boy Scouts playing baseball on a dirt field. Tents are pitched on past the backstop. The location for this 1925 photo is not known.

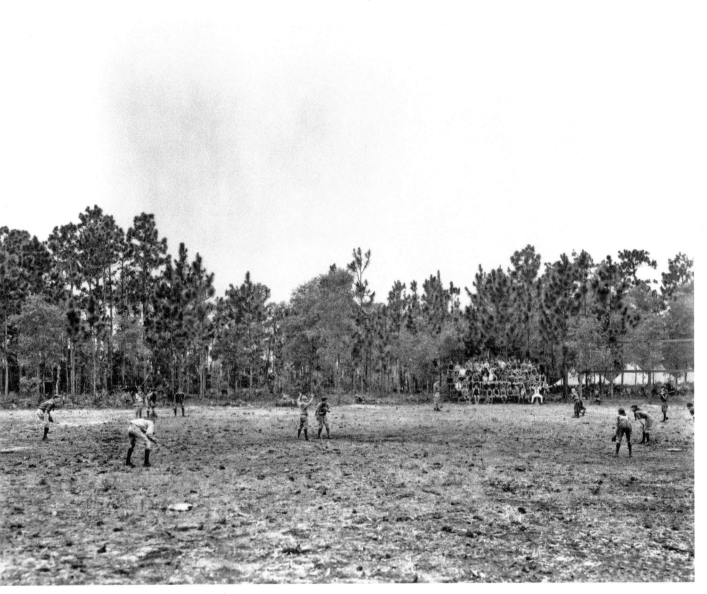

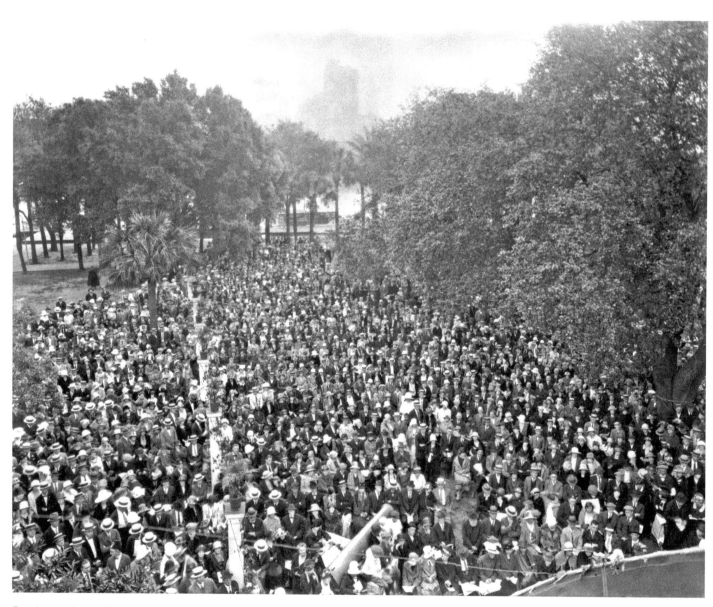

Sunrise service on Easter morning 1925. Worshipers are assembled in Plant Park adjacent to the Tampa Bay Hotel. The skyline of Tampa is barely visible through an early morning fog over the Hillsborough River.

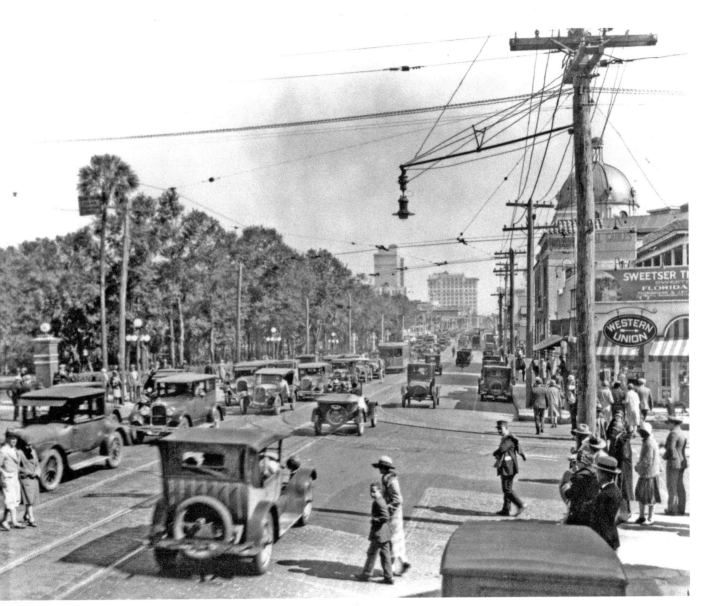

Pedestrian and automobile traffic at the intersection of Lafayette Street and Hyde Park Avenue in November 1926. To the left are the trees on the grounds of the Tampa Bay Hotel. The dome seen on the right belongs to the First Baptist Church.

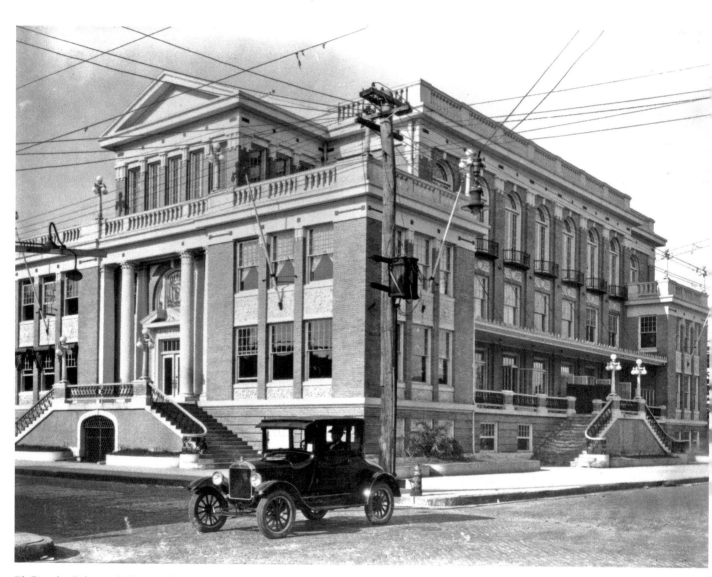

El Circulo Cubano de Tampa (the Cuban Club) as it appeared in 1926. This was a brick building with neoclassic accents located on the Avenida Republica de Cuba near Tenth Avenue in Ybor City.

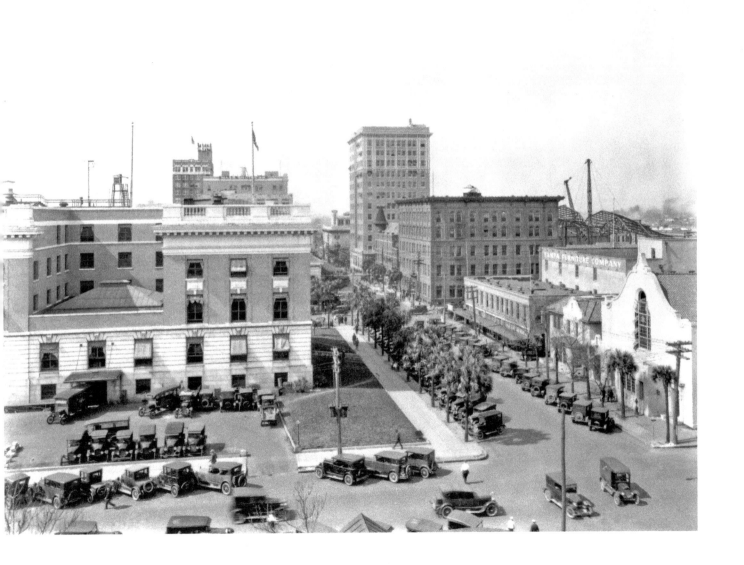

The rearview of the Federal Building. Marion Street is in the foreground, intersecting with Zack Street. February 25, 1926.

The loading dock of the Tampa Arctic Ice Company plant and its fleet of delivery trucks. The company was located at Second Avenue and Fourteenth Street in Ybor City.

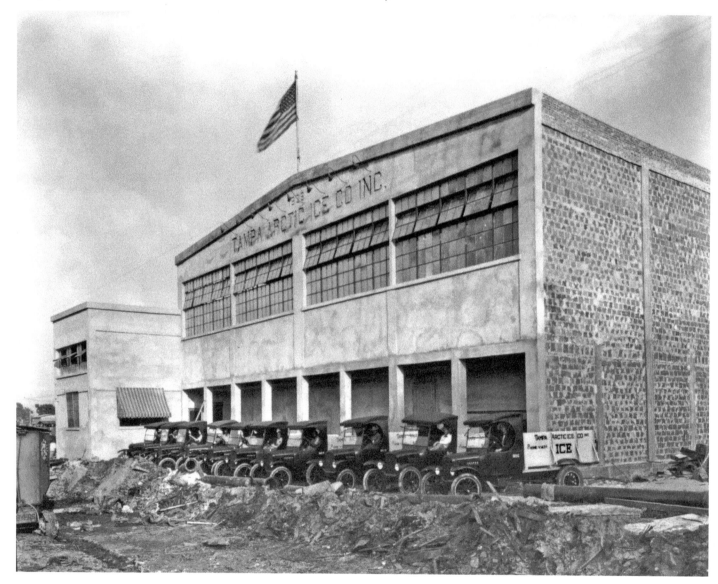

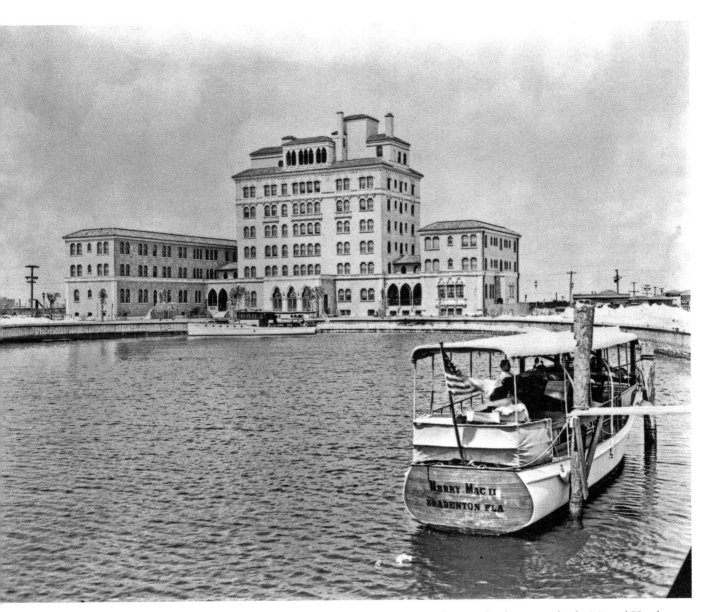

This photo from 1926 marked the second year of development of Davis Islands, as a result, the Mirasol Hotel seems to stand alone. The Mirasol is keenly position on Davis Boulevard, the main road winding through the islands, and on Hillsborough Bay, making the hotel accessible by boat. Notice that the hailing port for the wooden vessel in the foreground is Bradenton, Florida, another historic and developing port city on the Gulf Coast.

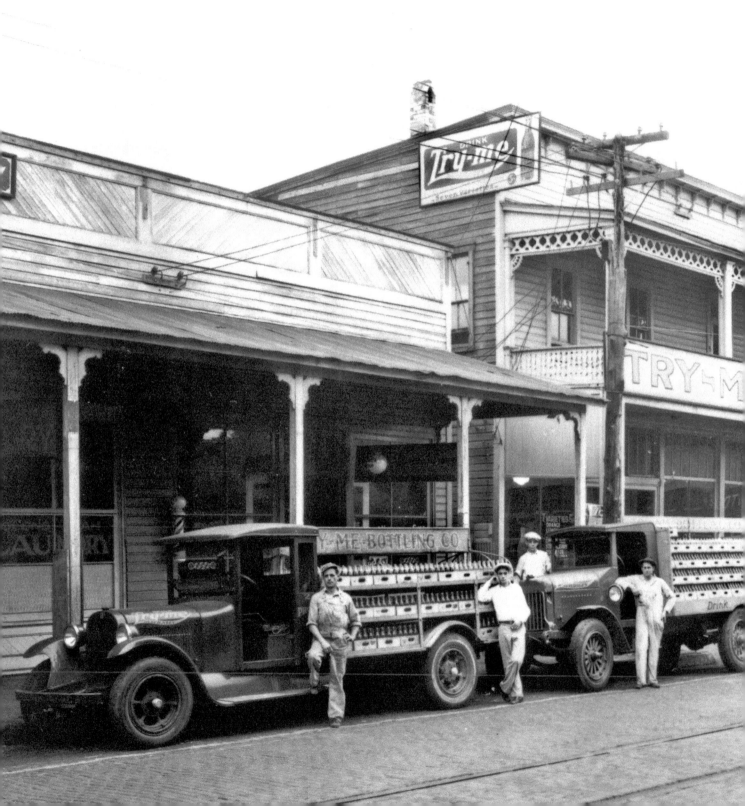

Try-Me Bottling Company on Seventh Avenue in Ybor City. Try-Me soda was produced and distributed in many southern cities.

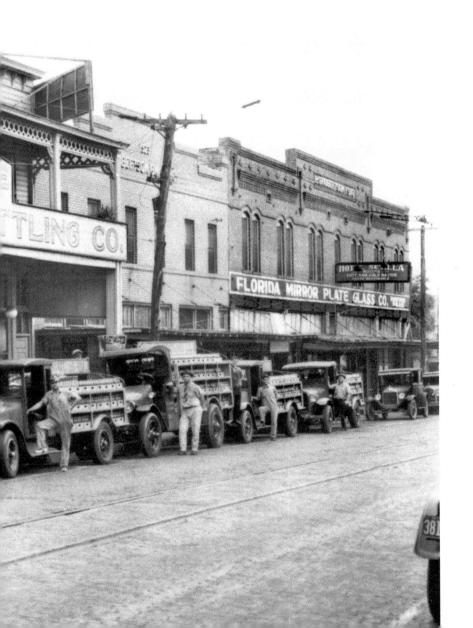

Following pages: This is a 1926 view of the Tampa skyline from the foot of Cardy Street, the lower boundary of Tony Jannus Park, looking northeast across the Hillsborough River. City Hall is quite recognizable at the far right side of the image.

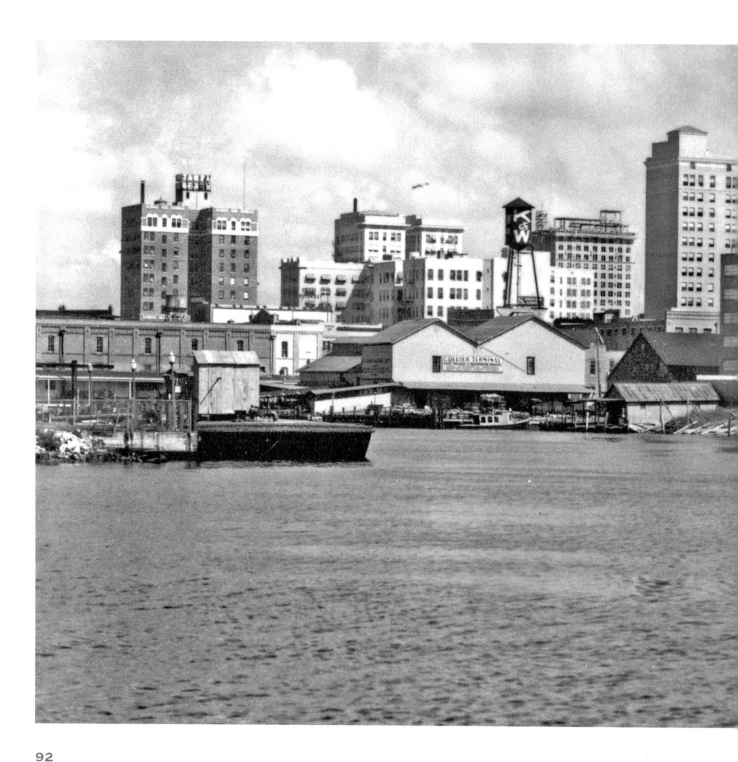

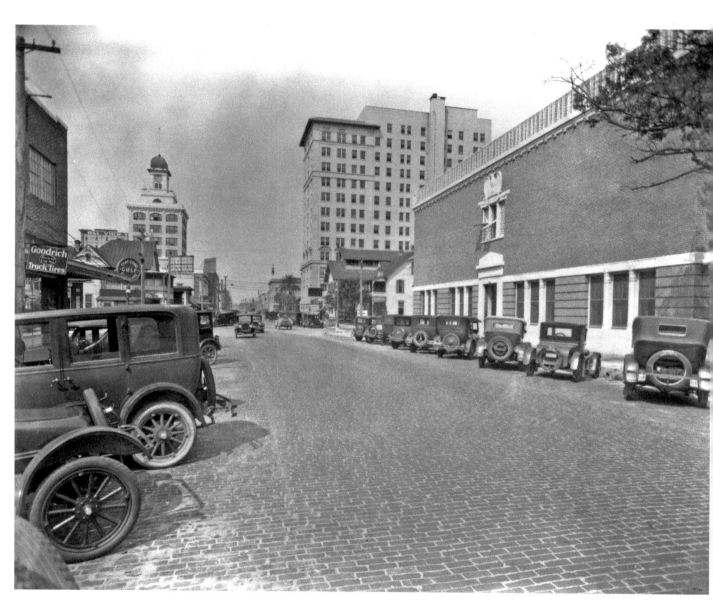

Lafayette Street near Morgan. To the right is a view of the façade of the
Masonic Hall. The Tampa Terrace Hotel rises in the center of this 1926
photo. City Hall is to the left, across the street from the hotel.

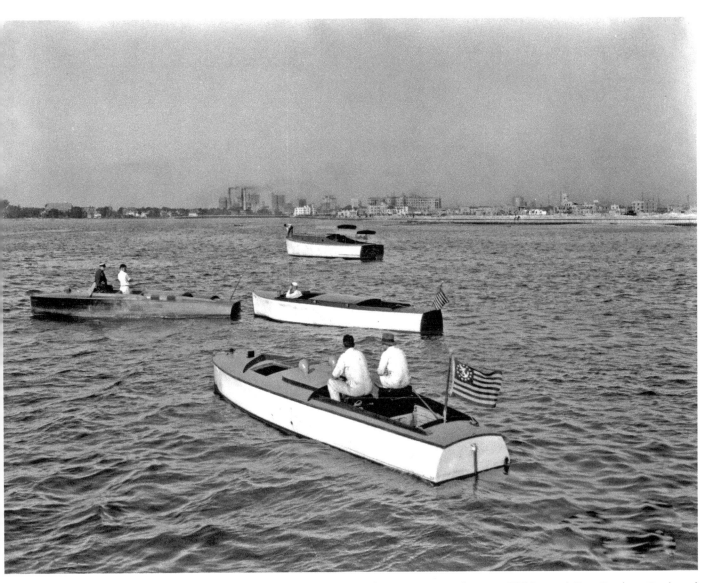

Gasoline engine powerboats on Hillsborough Bay, Bayshore Boulevard and Davis Islands are in the background. (1926)

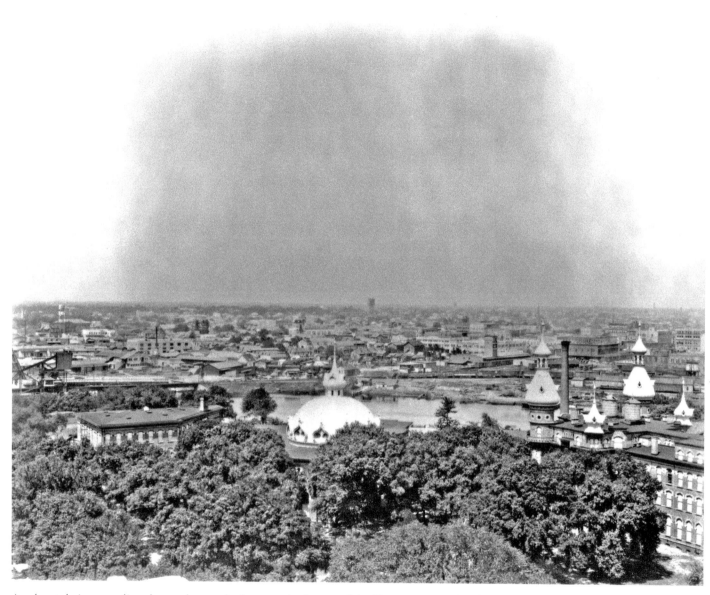

An elevated view revealing the treed grounds, domes and minarets of the Tampa Bay Hotel and looking to the northeast, across the river and the northern edge of the city. At this time the hotel belonged to the City of Tampa but had not been in use for years.

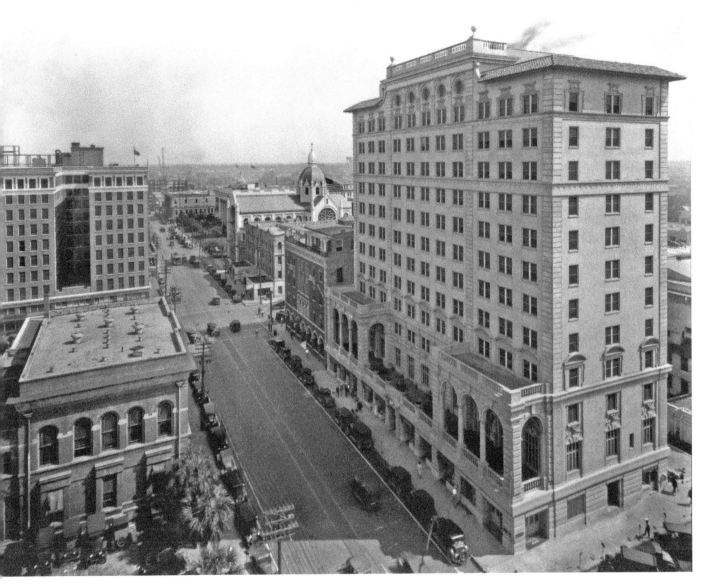

The building in the forefront is the Tampa Terrace Hotel captured here in 1926. Further down Florida Avenue the dome of Sacred Heart Catholic Church can be seen.

This 1927 photo was taken at a reunion of Confederate soldiers. This gentleman was reported to be 106 years old, making him age 40 at the time the Civil War broke out.

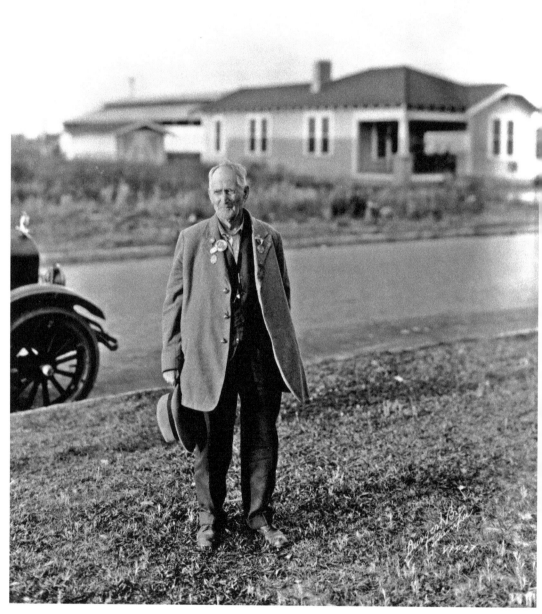

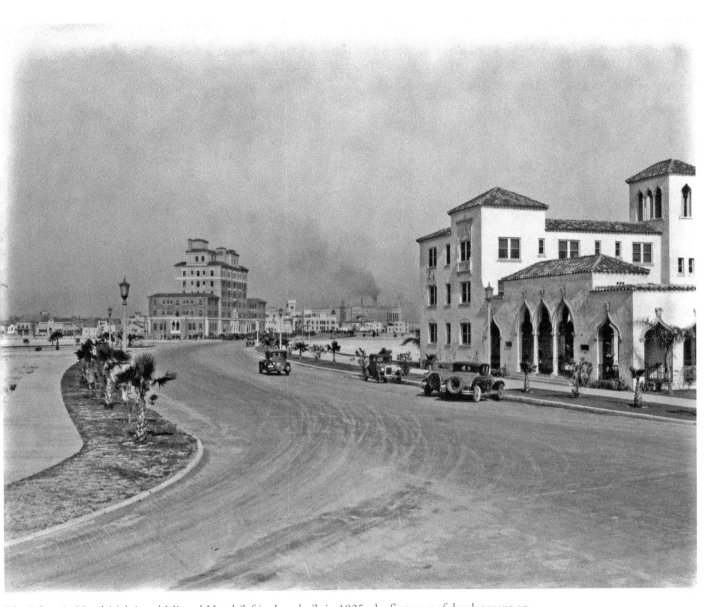

The Palmerin Hotel (right) and Mirasol Hotel (left) where built in 1925, the first year of development on Davis Islands. The grand real estate project used dredging to join and fill in two scrub-covered, marshy keys in Hillsborough Bay, just south of downtown. The following year construction would begin on the Tampa Municipal Hospital on the northern tip of the Islands.

In the mid-1920s Florida was in the midst of a real estate boom. Not only was Tampa growing rapidly, nearby communities also benefited from the growth. Here, prospective buyers from the Florida West Coast Development Corporation examine building sites at Homosassa Springs in Citrus County.

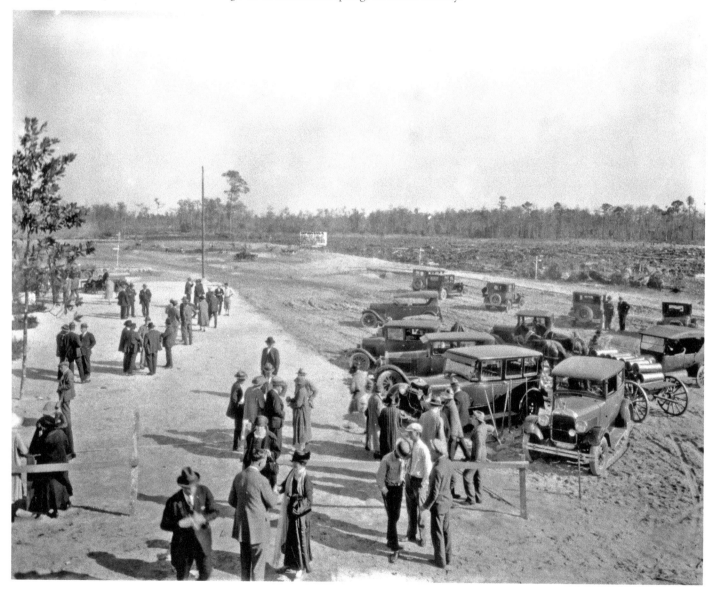

Hyde Park Motor Company which sold Chrysler automobiles was located at 1704 Grand Central Avenue (renamed John F. Kennedy Boulevard.)

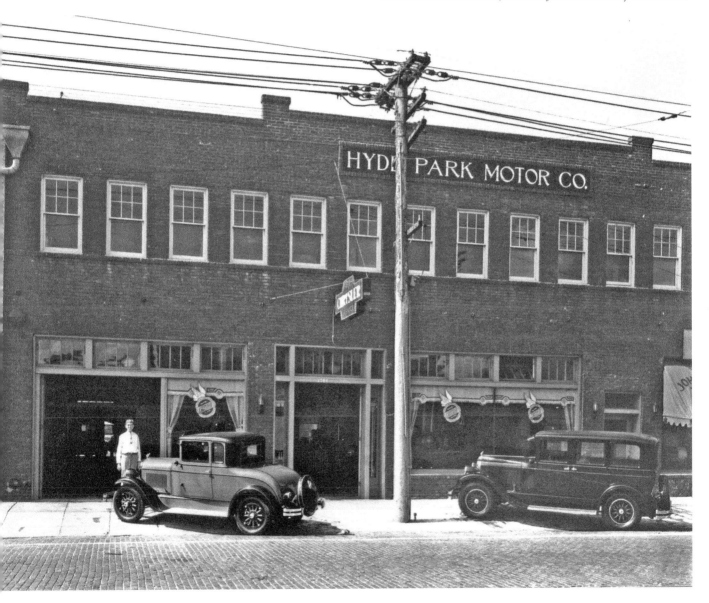

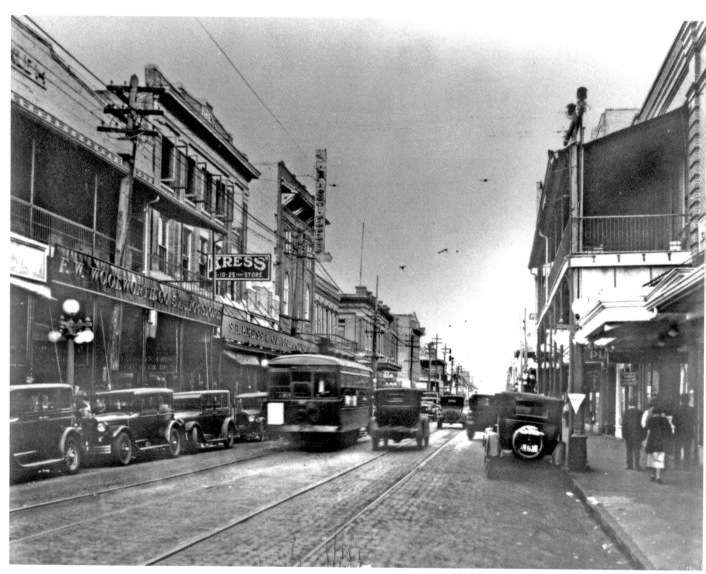

Seventh Avenue in Ybor City, the road is shared by automobiles and streetcars. S.H. Kress and W.F. Woolworth are among the stores on Ybor City's commercial avenue.

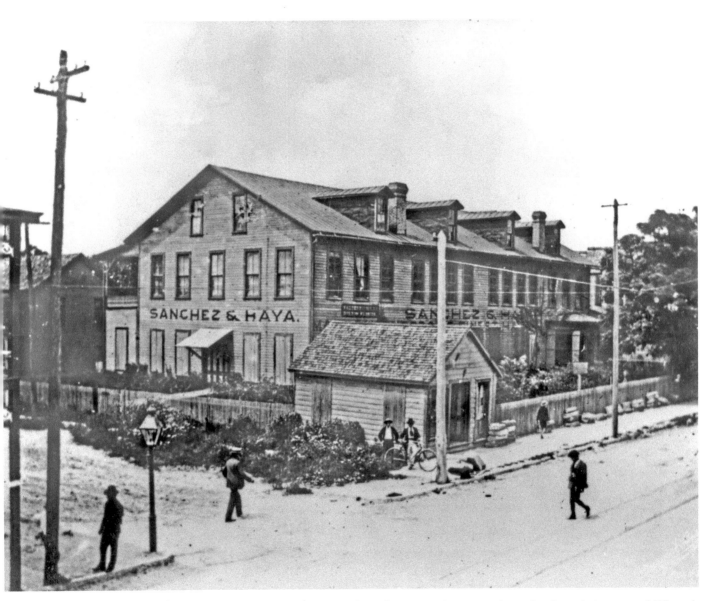

The wood-framed Sánchez y Haya Factory #1 located at Seventh Avenue and Fifteenth Street in Ybor City. Tampa's first hand-made cigar of fine Cuban tobacco was rolled here on April 13, 1886. September 9, 1927.

The 17-story, 316 room Floridan Hotel at the corner of Cass Street and Florida Avenue. At the time of its completion in 1926, it was the tallest building in Florida. The Floridan is now on the National Register of Historical Places.

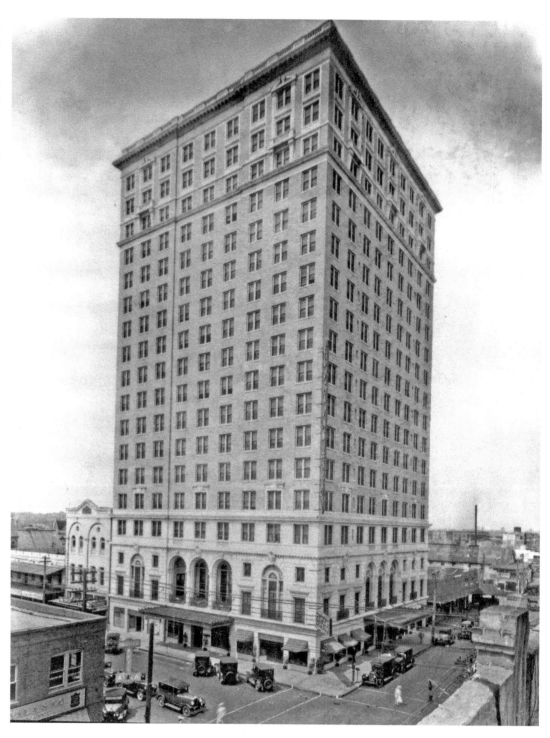

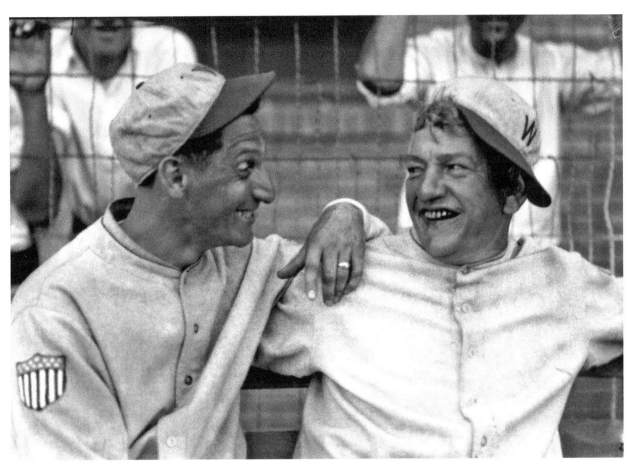

The Washington Nationals baseball team held spring training in Tampa from 1920 until 1929. This photo, taken in 1928, is reported to be of Al Bool and Nick Cullop after a good-natured boxing match, neither appears to be worse for wear.

Members of the Ad Club seated on the garden steps of the Tampa Terrace Hotel, on the southwest corner of Lafayette Street and Florida Avenue. (1928)

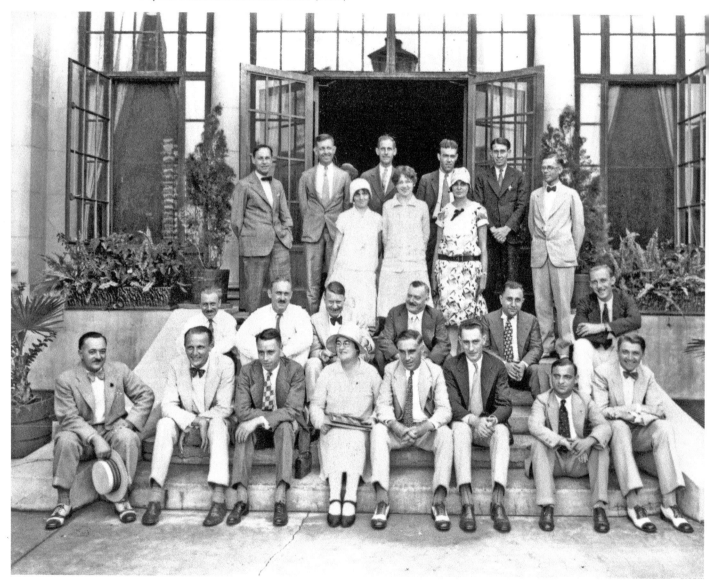

The Mecca Café on Seventh Avenue in Ybor City, seen here about a month before the stock market crash in October 1929, an economic event that would lead to dramatic changes for this company town that had been so important in the growth and development of Tampa.

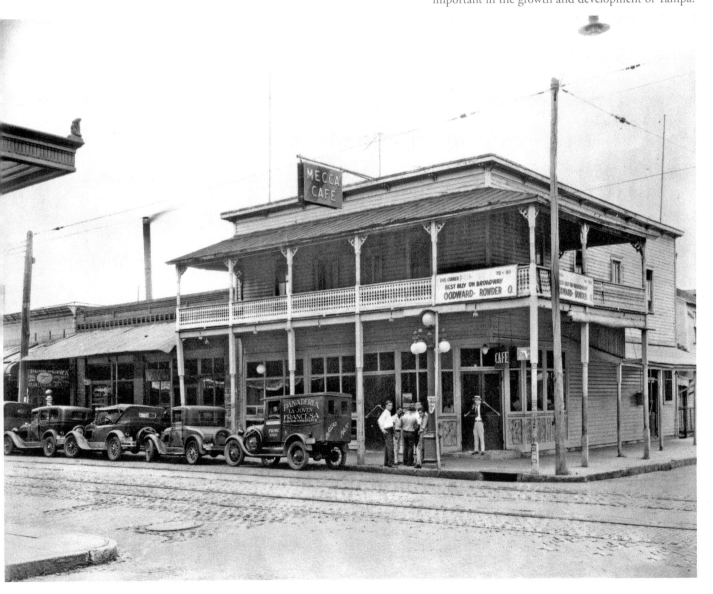

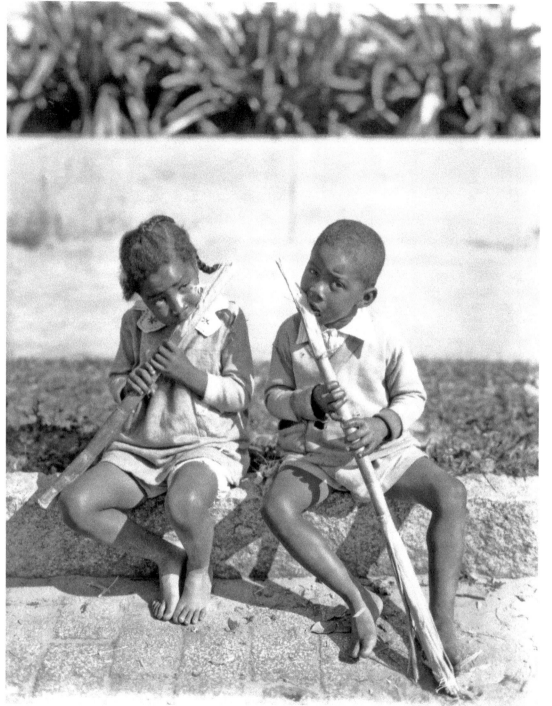

A girl and boy seated on a granite curb and enjoying sugar cane. This photo was taken in 1931.

The A. Cappello & Brother Grocery Store on West Fortune Street in the part of town once known as "Little Havana." The two-story building was a grocery downstairs and residential apartments above.

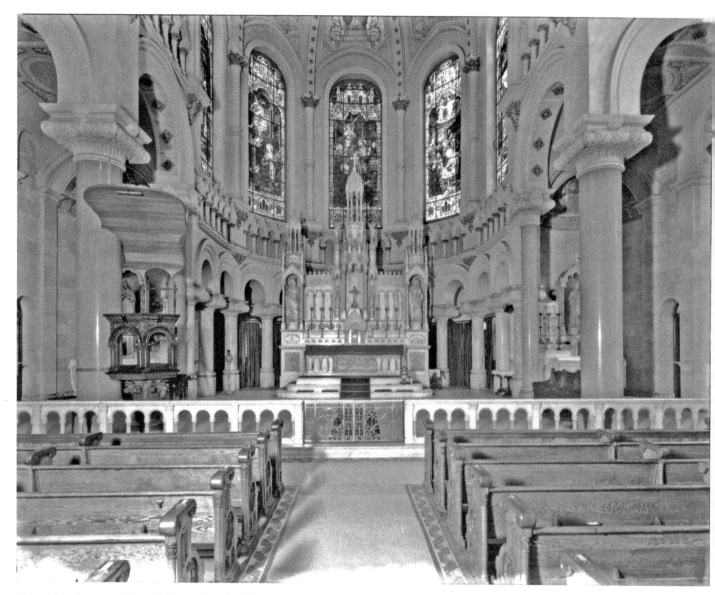

Pictured is the apse of Sacred Heart Catholic Church on Florida Avenue.
The 1931 view reveals the marble altar and magnificent stained glass
windows. Sacred Heart was built in 1905.

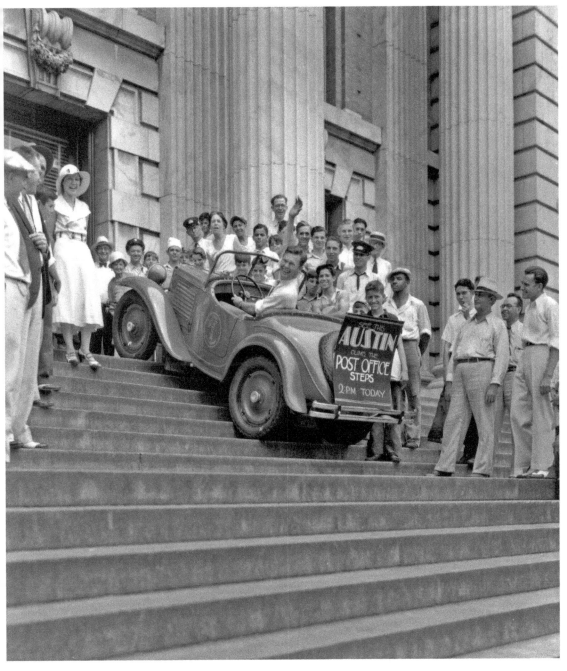

In this 1932 publicity stunt, an American Austin Roadster was driven up the steps of the Post Office on Florida Avenue.

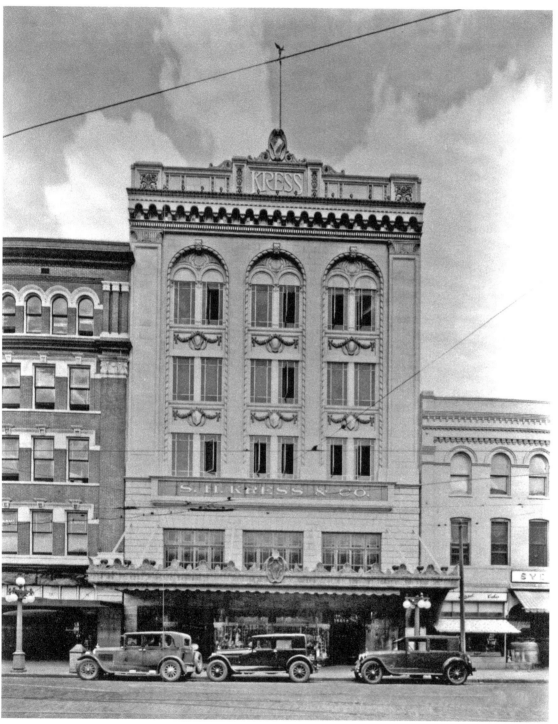

The S.H. Kress & Company between Franklin Street and Florida Avenue. The Kress store, which is on the National Register of Historic Places, has terra cotta facades and a bronze marquee. Samuel Kress, the founder of the five and dime store chain, was an art collector and took great pride in building architecturally pleasing stores.

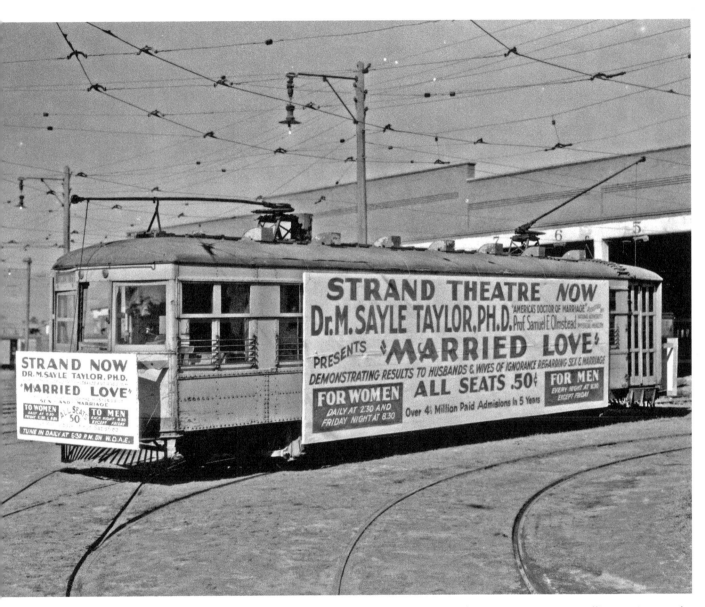

A placarded street car advertising marriage counselling seminars at the Strand Theater is pulling away from the station house. Notice that women and men attend separate sessions.

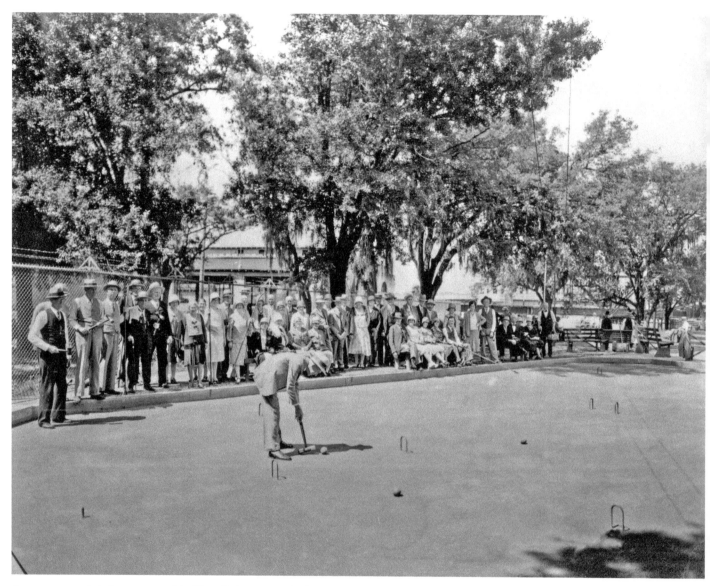

A croquet match being contested in Plant Park, next to the Tampa Bay Hotel. This photograph, taken in 1930, was shot three years before the vacant landmark hotel was reopened as the University of Tampa.

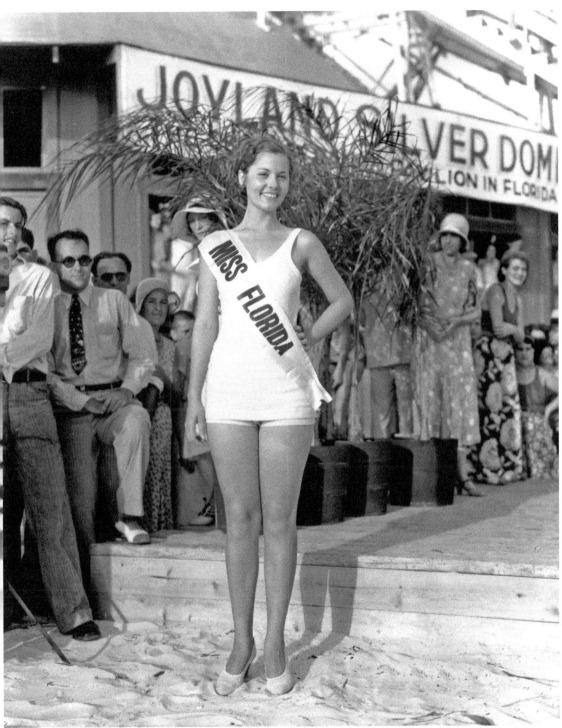

Miss Florida 1931 makes a promotional appearance at the Joyland Silver Dome on Clearwater Beach, on the Gulf Coast of Pinellas County.

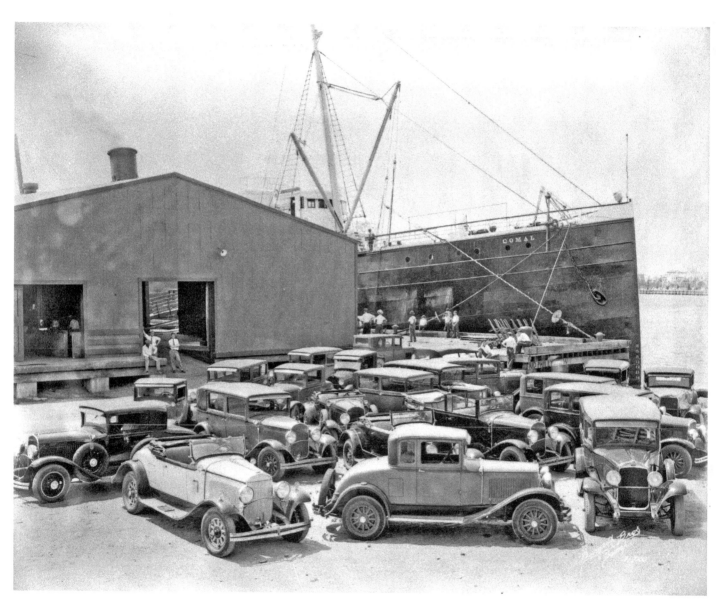

A shipment of new cars received at the Mallory Dock in the Port of Tampa in 1930. The vehicle were destined for the R. S. Evans new and used car dealership on Florida Avenue in the Hulsey Building.

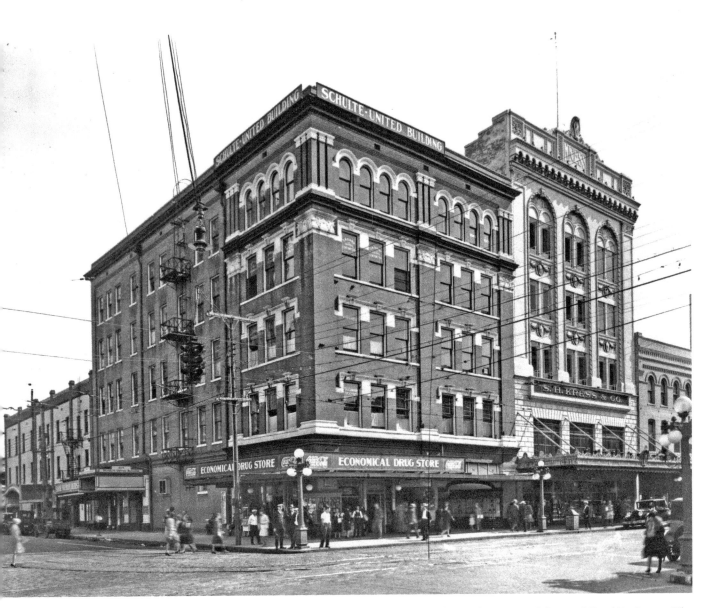

Schulte-United Building at the corner of Cass and Franklin Streets. The
Economical Drug Store occupied the ground floor of the Schulte-United.

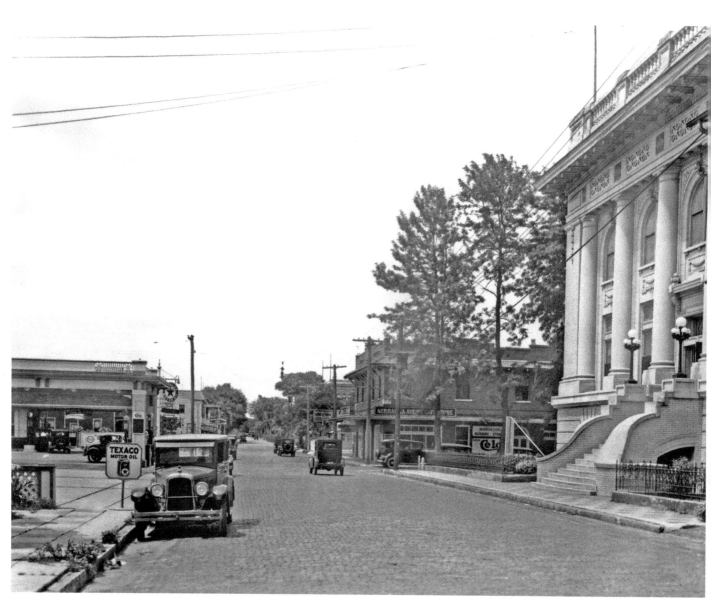

Nebraska Avenue in 1931. El Centro Asturiano is the columned building
on the right side of the photo. A Texaco service station is to the left.

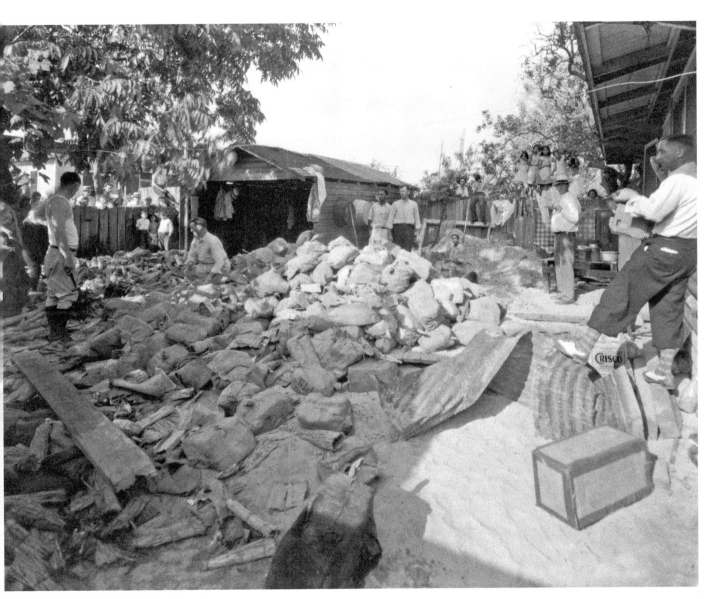

· In 1931, during Prohibition, federal authorities dig up bagged bottles of liquor in the backyard at 1014 Tenth Avenue in Ybor City.

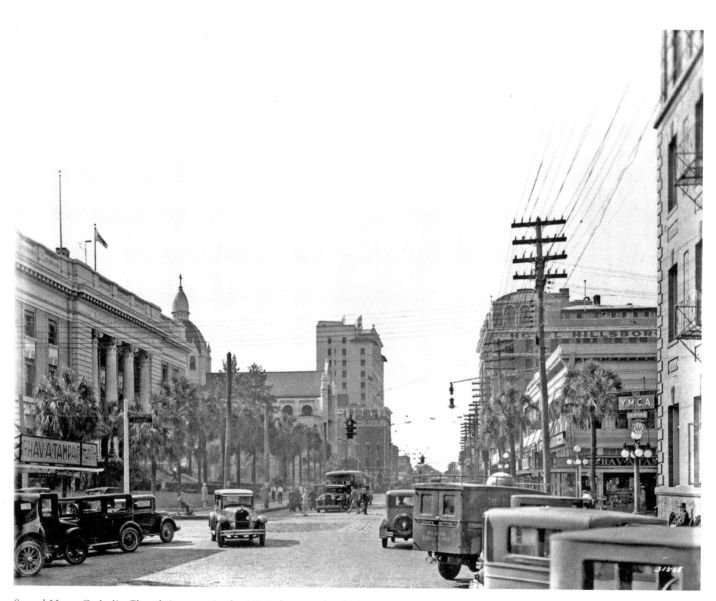

Sacred Heart Catholic Church is center in the 1930 photograph which
focuses south down Florida Avenue. The tall building beyond is the
Tampa Terrace Hotel.

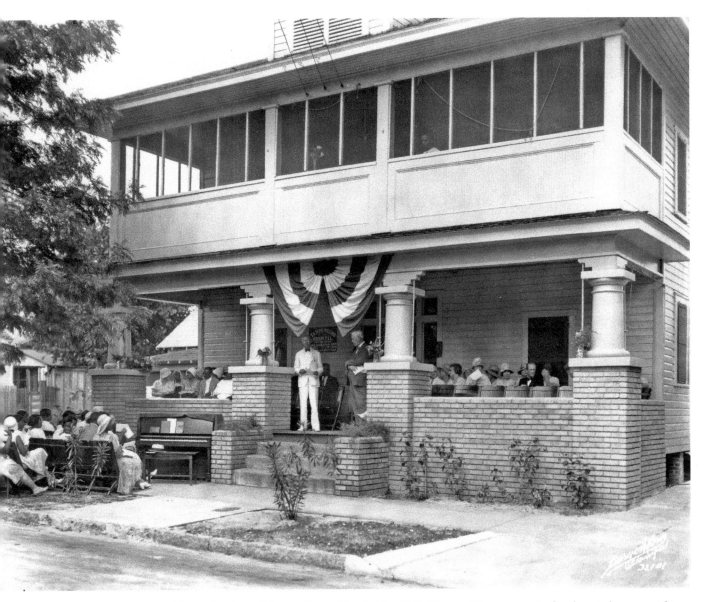

The dedication of Tampa Negro Hospital in 1923. The small house was the first hospital to treat African Americans in Tampa and was the result of the tireless efforts of Clara Frye. It is noteworthy that the guests at the ceremony are segregated, whites on the right and people of color on the left.

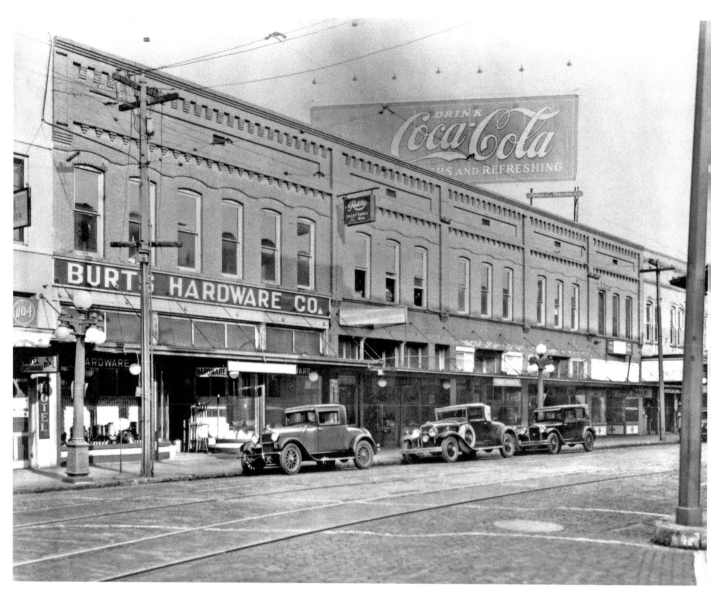

A 1930 view of the Franklin Street featuring Burt's
Hardware and Vicker's Printing Company.

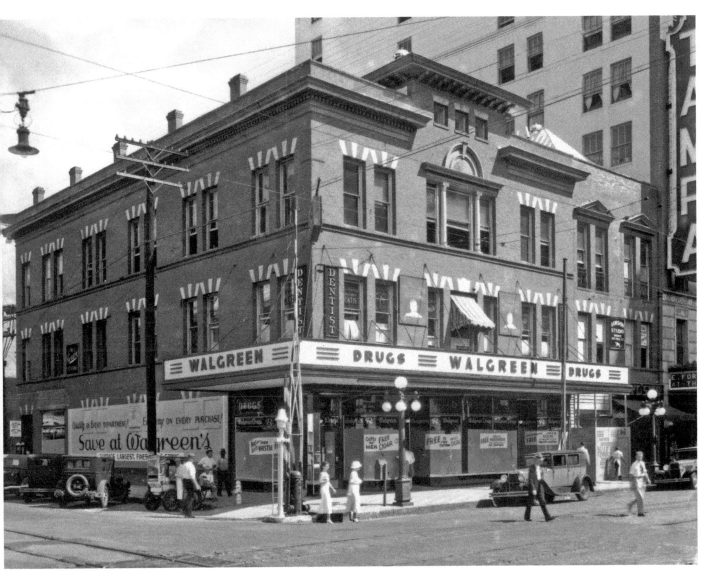

Walgreen's Drug Store at the corner of Franklin and Polk Streets. The sign for the Tampa Theatre can be seen in the extreme right edge of the photo taken in October of 1934.

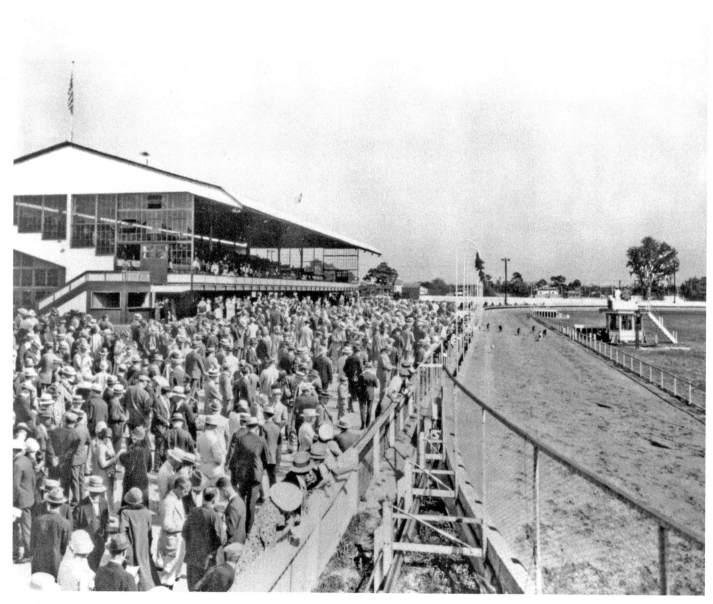

Greyhound racing at the Sulphur Springs Dog Track in 1935. The quarter-mile track opened in January 1921. The winner of the very first race was Royal Mae.

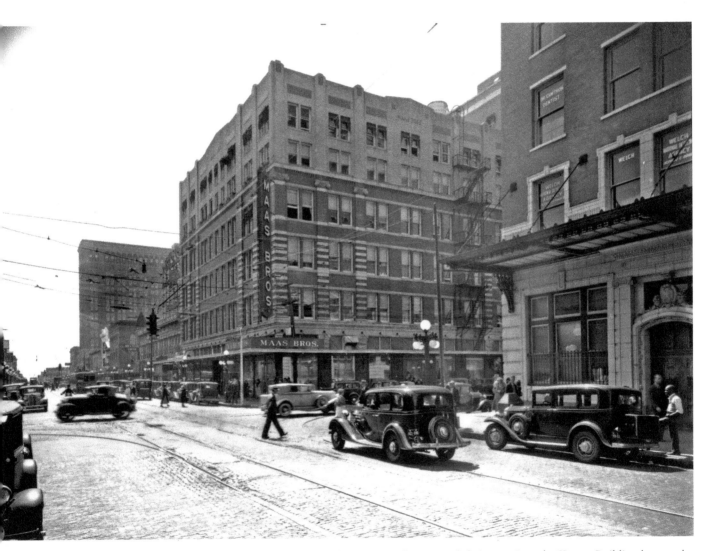

The Maas Brothers moved their store into the Krause Building here at the corner of Franklin and Zack Streets into 1898. Their store remained there until the site was taken for the American National Bank.

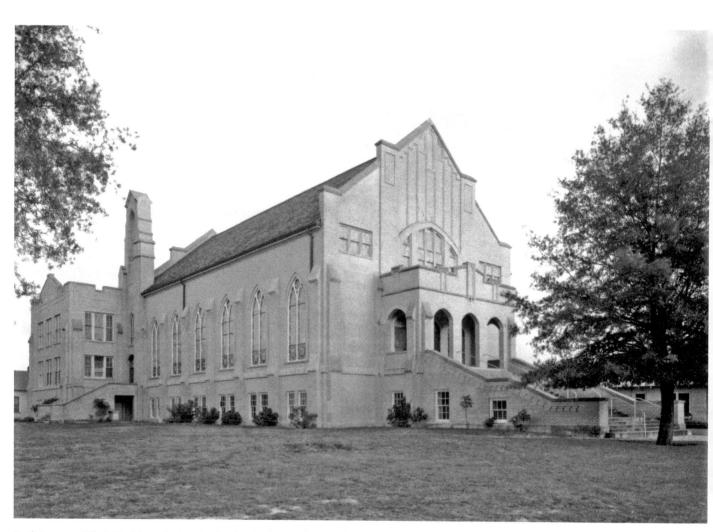

Built in a modified Gothic revival style, the Seminole Heights Methodist Church was built in 1927 and is pictured here in 1935. The church, which has been extensively restored, is located at the corner of Central Avenue and East Hanna.

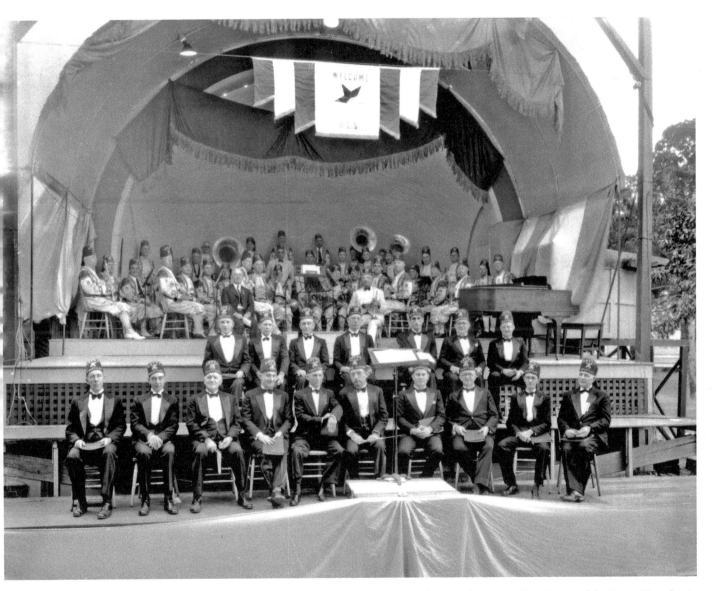

This 1934 photo features chanters and orchestra of the Egypt Temple. At that time the facility was located at 402 South Boulevard.

Agricultural fields, processing buildings, and railroad tracks near Six-Mile
Creek in eastern Hillsborough County.

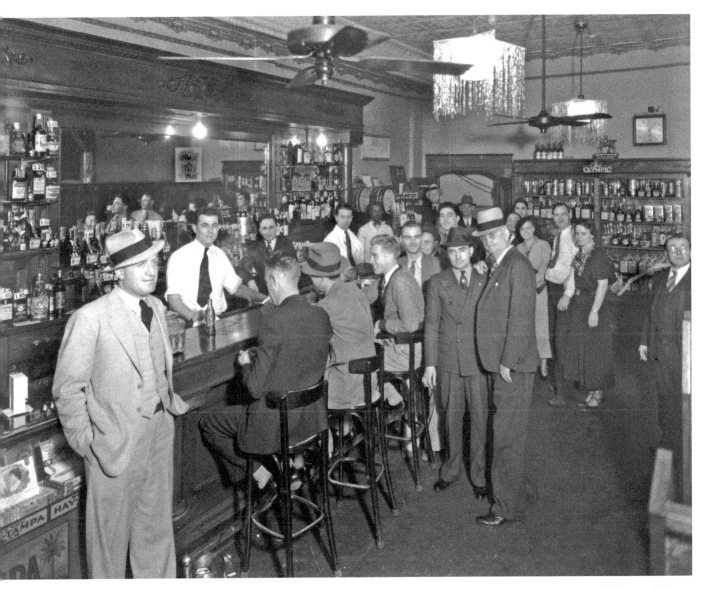

Patrons and staff of the Olympic Bar at the corner of Cass and Tampa Streets. Note the well-stocked bar in the background and the fine Tampa-rolled cigars in the left foreground of this photo taken in 1936.

The Tampa Bay Hotel, which had closed in 1905, remained unused until the University of Tampa took up residence in 1933. The photo, taken in 1936, is outside of what was the main lobby of the hotel, now known as Plant Hall.

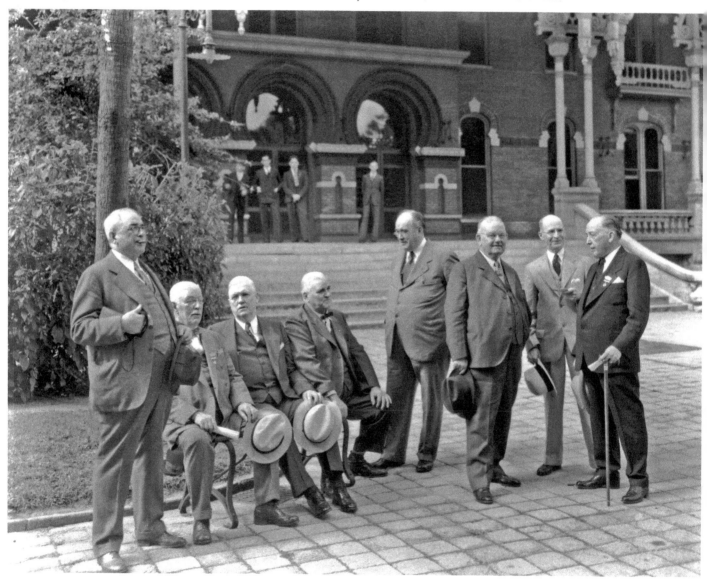

Members of el Circulo Cubano (the Cuban Club) with their families in the elegant ballroom. The Cuban Club was a massive four-story building with a wide range of amenities. This social club was formed circa 1900.

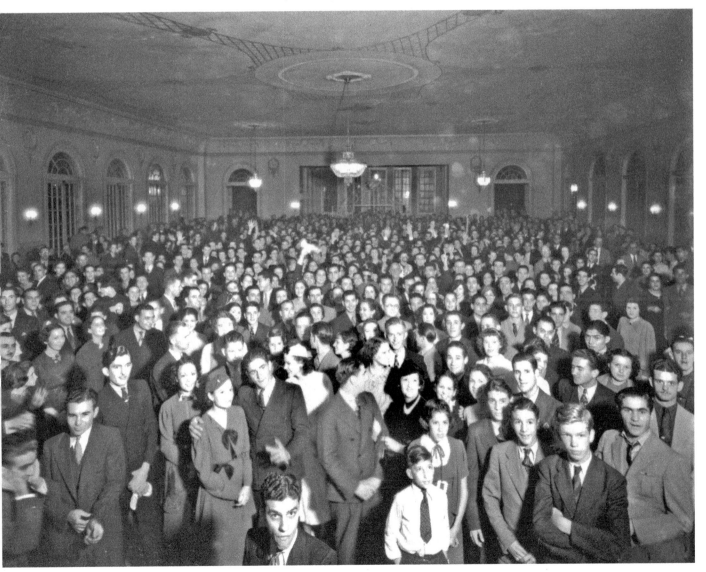

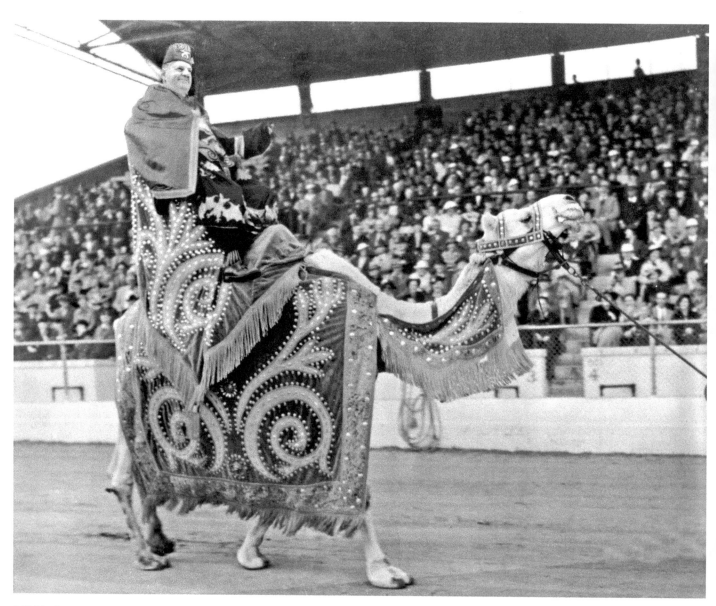

Bill Blocks, in Masonic regalia, riding a camel in a in the 1938 Gasparilla
parade at the State Fairgrounds.

Pedestrian and automobile traffic over the original bridge that connected
Davis Islands with Bayshore Boulevard.

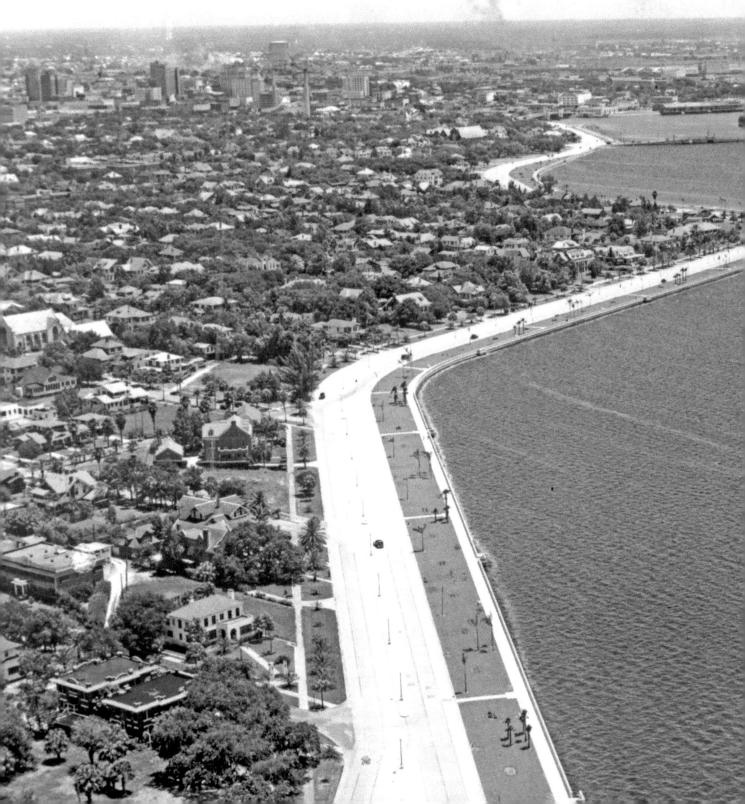

An aerial view of Bayshore Boulevard after the restoration and widen that was completed post-Depression under grants from the Works Progress Administration. Bayshore was substantially damaged by a hurricane in October 1921. The refurbished and repaired road was four lanes with a median and street lights.

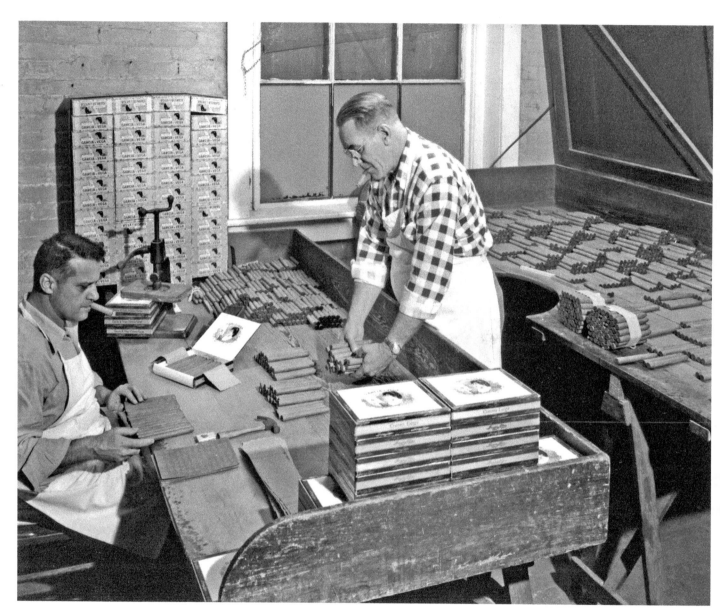

Much of the growth of Tampa is attributable to the cigar industry.
However, by 1958 the industry in Tampa held a mere fraction of its once
grand stature. Here, two workers are hand packaging Corona Largas at the
Garcia y Vega factory.

World War II and the Baby Boom

1940–1959

During World War II, Drew Field, Tampa's first airport, was converted to an army air training center. After the Japanese surrender, control of the airport was returned to the City of Tampa. The name change to Tampa International Airport was prompted when Trans Canada Airlines began flights from Tampa in 1950.

Construction on Southeast Air Base, Tampa, was completed almost eight months before the attack on Pearl Harbor. Renamed MacDill Army Air Base, the facility was used during the war for training on B-17 and B-26 aircraft. Following the war, MacDill became an operational base for the Strategic Air Command.

By 1950, Tampa's population was nearly 250,000. Despite representing 15 percent of the city, most African Americans remained in low-paying, manually intensive jobs. Racial segregation continued to be strongly enforced until the fruition of the civil-rights movement.

Tampa native Dr. Frank Adamo was appointed medical director of Centro Asturiano Hospital in 1932 and county medical director in 1937. After Pearl Harbor, Adamo joined the army. He gained worldwide fame for developing a new treatment for gangrene. First Avenue was renamed in his honor.

After hostilities against the U.S. began in 1941, Tampa's shipyards quickly retooled from building commercial vessels to warships, launching more than 100 Liberty Ships, destroyers, and escorts in support of the war effort. The combined workforces of Tampa Shipbuilding & Engineering, Hooker's Point Yard, Tampa Marine Company, and Bushnell-Lyons swelled to nearly 31,000. A much-needed economic boost was provided by this influx of workers and their families. Women earned their place in the strenuous work of the shipyards and, in doing so, forced the unions to change their membership rules.

Tampa's cigar industry never fully recovered from the Great Depression. The Latin population remained steadfastly in Ybor through the beginning of the decade of the 1940s, but, having viewed the world outside their neighborhoods, many of the children of the once-powerful cigar industry used their GI bills to fund college educations and move out. Ybor City slid into an economic and infrastructure decline.

A substantial immigration from Sicily had occurred toward the end of the nineteenth century. By 1930, 17 percent of Tampa was of Sicilian heritage. Having initially found work as cigar factory laborers, with time the Italians started their own neighborhood businesses and began pushing their children toward greater successes. In 1956 Nick Chillura Nuccio, grandson of Sicilian immigrants, became the first Latin mayor of the city.

The photographers of the Burgert family are credited on all of the images in this book. This is the Burgert Brothers studio at 209 Jackson Street in downtown Tampa as it stood in 1941.

Three generations of Burgert's made their living in photography. The family business was closed after the last the of Burgert's retired. Following years of improper storage, the negatives were discovered and subsequently purchased by the Friends of the Library in 1974. The negatives from their reflective and thoughtful photos of the beginnings and growth of west central Florida are now being cared for and restored by the Tampa-Hillsborough County Public Library.

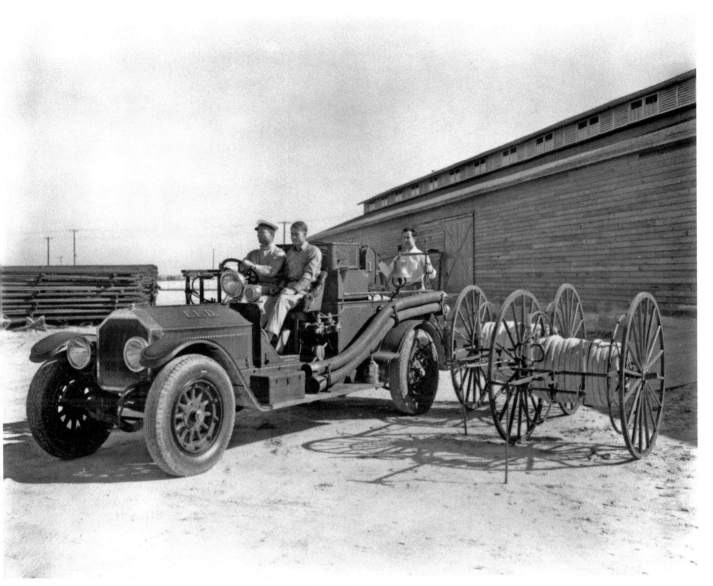

Firefighters of Tampa Fire Department ready to roll out to a blaze. Before the days of the trucks with sufficient capacity to carry all their own stores, extra equipment such as the hose carriages seen here were towed to the burning site.

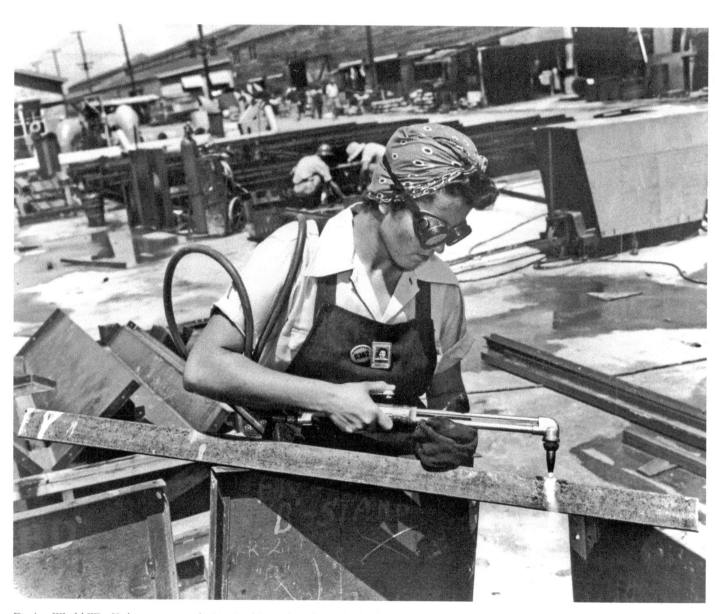

During World War II there were nearly 31,000 shipyard workers who built well over 100 warships. Though an advent in the beginning of the war, by the end of the conflict, women were common place in all manner of jobs in the yards. Along the way, union membership rules had to be changed to allow for woman in their ranks.

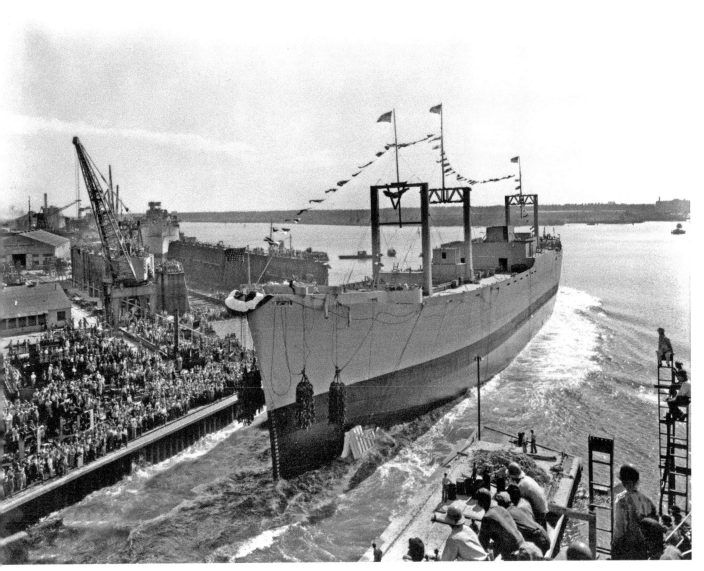

Through World War II Tampa's shipyards made significant contributions to the US efforts. This is the launch of the USS Mauna Loa from Port Tampa City in 1943. Port Tampa remained a separate city until annexed in 1961.

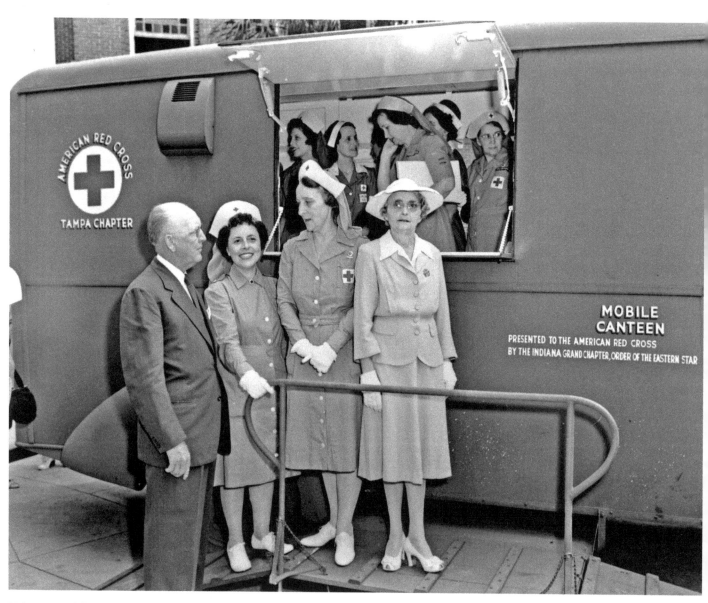

Volunteers of the Tampa Chapter of the American Red Cross inspect a
Mobile Canteen vehicle donated by a sister chapter from Indiana. (1943)

Jack Dempsey, who retired from boxing in 1927, is seen here boarding an Eastern Airlines plane at Drew Field, likely sometime after his World War II service in the Coast Guard. Dempsey once fought an exhibition in Tampa for a real estate developer of the Forest Hills subdivision.

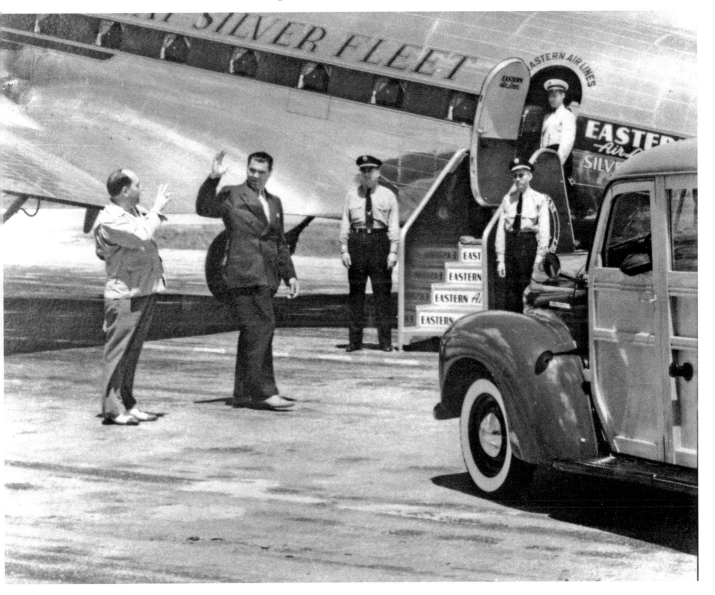

This image of the First Christian Church is from 1943. The sanctuary, located at 350 Hyde Park Avenue, was built in 1922.

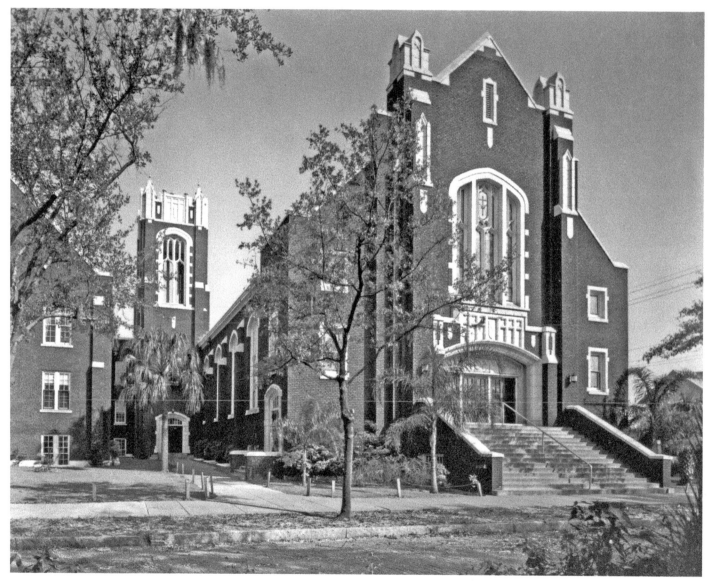

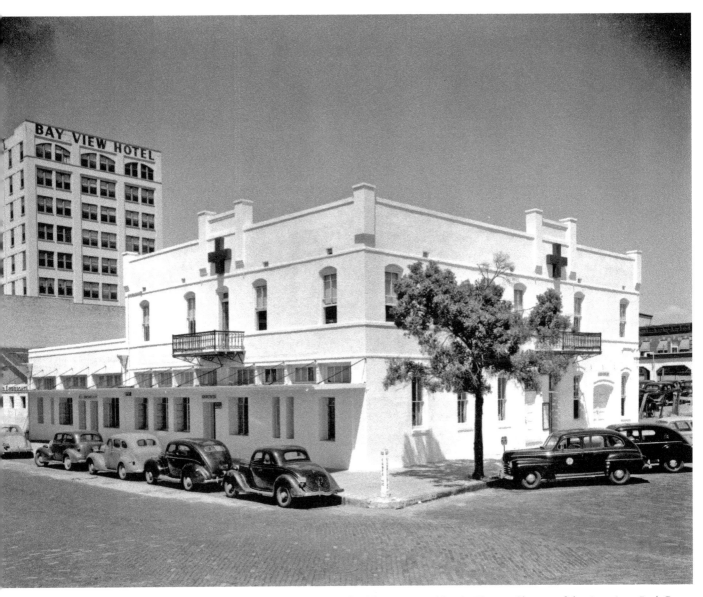

The building occupied by the Tampa Chapter of the American Red Cross.
This building was on the 200 block of Tampa Street. The brick paved
street is very noticeable in this photo from 1946.

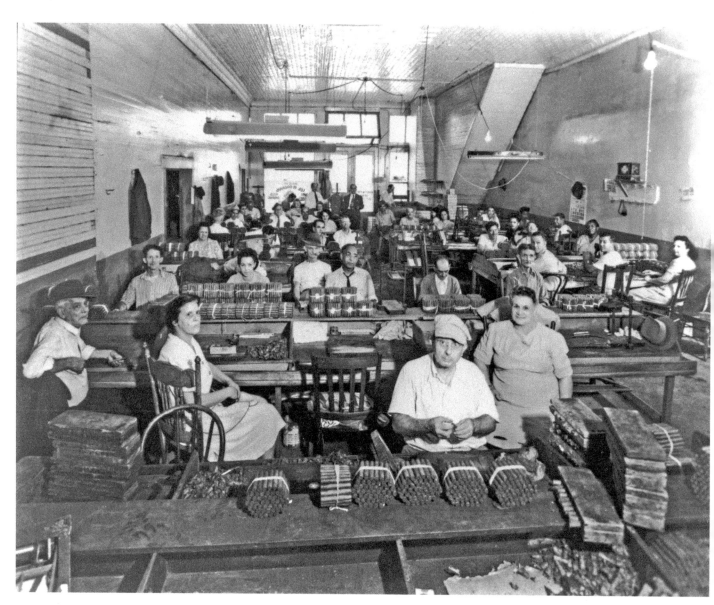

Cigar makers at their rolling tables at the Cigar Manufacturer's Association on East Lafayette Street. This photo was taken in November 1946 as the industry was becoming mechanized. Nonetheless, there is nothing so fine as a hand-rolled cigar made by a true craftsman.

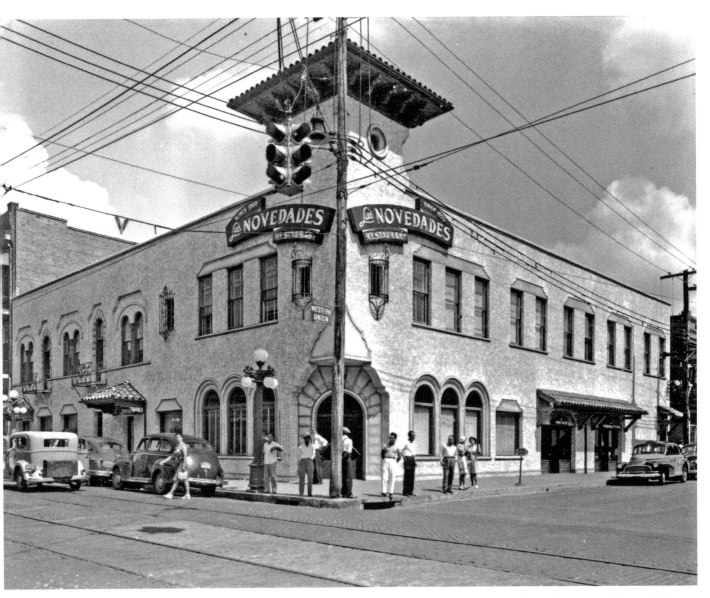

Las Novedades Restaurant was founded by Manuel "Canuto" Menendez at the corner of Seventh Avenue and Fifteenth Street. Las Novedades means, "The Novelties." This was an extremely popular place to dine, so much so that in 1898 a squad of Rough Riders rode their horses right into the dining room. They were greeted warmly. (1946)

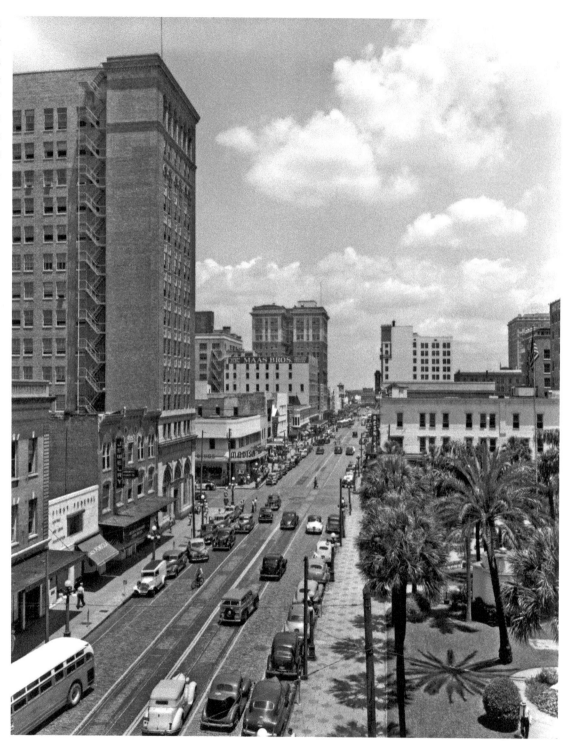

Traffic moving on Franklin Street in front of the Hillsborough County Courthouse lawn. In this 1947 photo it can be seen that bus service has begun replacing the street trolleys.

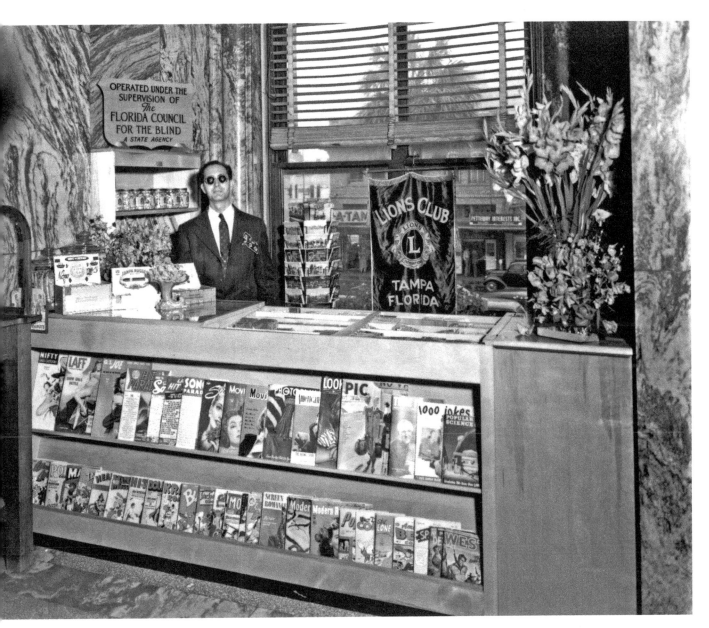

The newsstand in the Federal Building in 1946. The stand was operated by the Lions Club of Tampa in association with the Florida Council for the Blind. Notice the cigars for sale on the countertop.

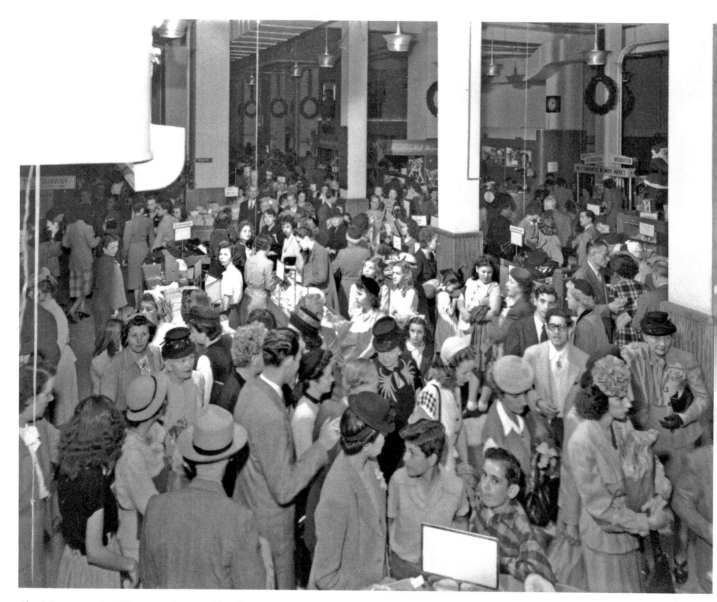

Abe Maas moved to Tampa and opened his first store, the Dry Goods
Palace, in 1886. Later that same year his brother, Isaac, joined him and
they opened the first Maas Brothers store. This is the main floor of their
downtown location in 1946.

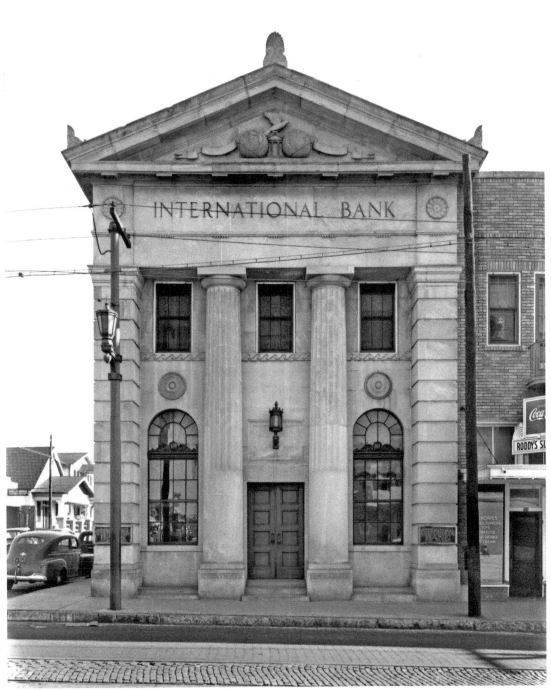

The neoclassic styling of the International Bank at the corner of West Fortune and Spring Streets in downtown Tampa.

An aerial shot taken in 1946 of Tampa Municipal Hospital. Beyond the hospital compound is the Platt Street Bridge crossing the mouth of the Hillsborough River. The landmark dome of the Hillsborough County Courthouse and the clock tower of City Hall are visible in downtown.

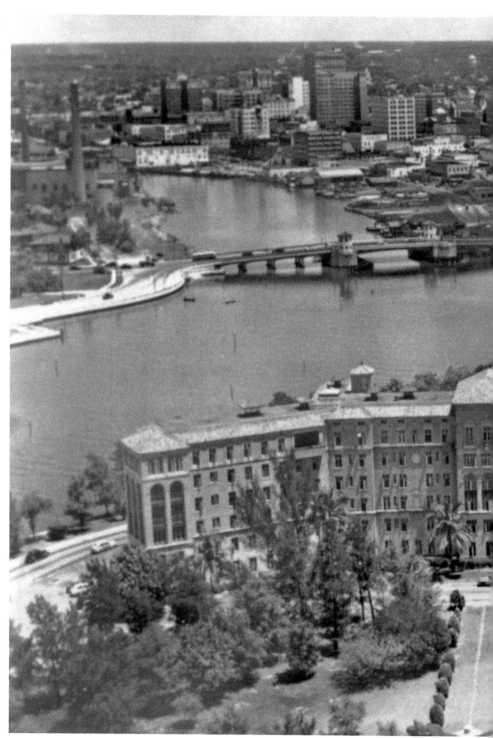

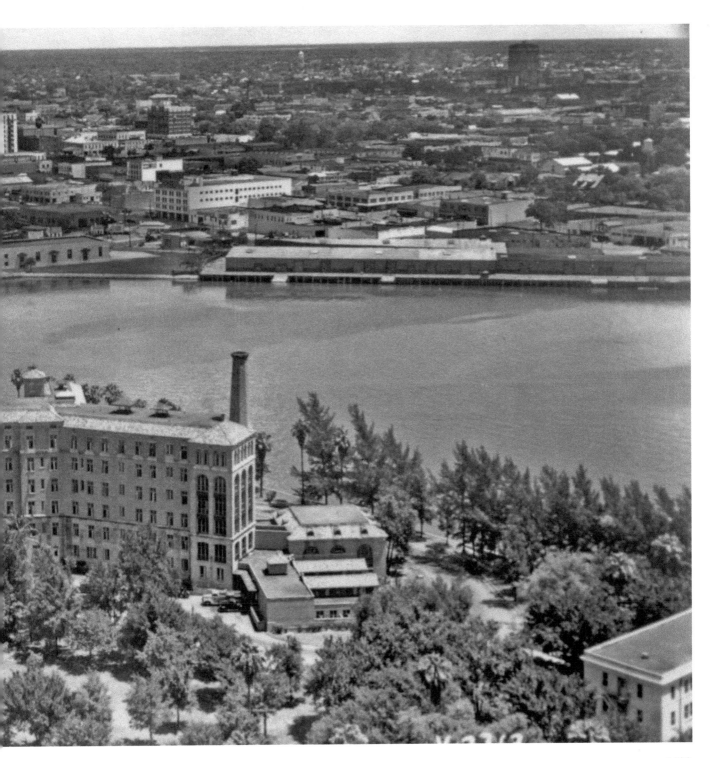

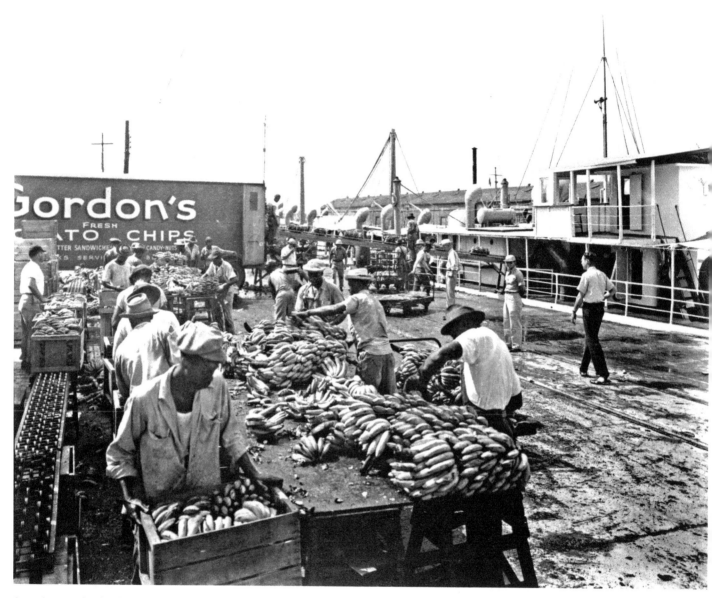

Stevedores unload a shipment of banana at the Port of Tampa. According to the photographer, many other goods passed through the port, but bananas seemed especially picturesque. (1947)

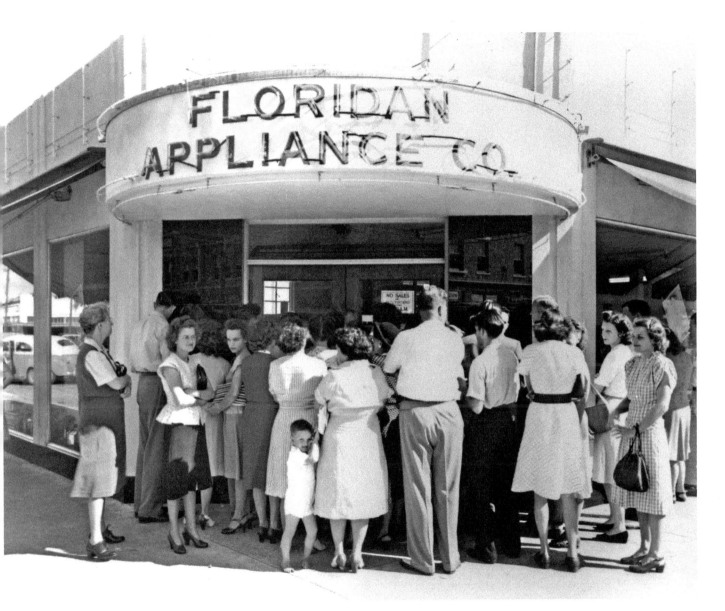

A crowd awaits the opening of the Floridan Appliance Company store on
East Cass Street. (1943)

A 1948 view of the Gulf Florida Terminal at the Ybor Channel. The
freighter, Bessemer Victory and being loaded fruit juice.

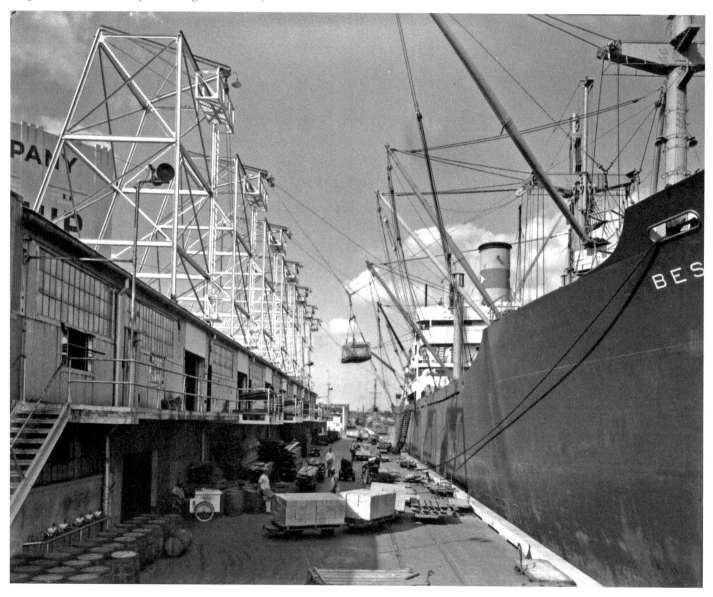

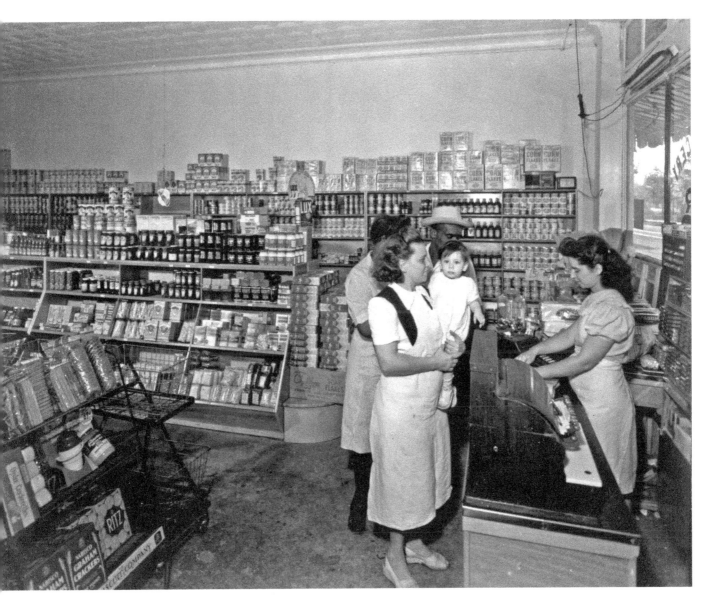

Customers and clerk in the Floridan Grocery Store on Main Street in West Tampa. The Floridan businesses were named for the principle artesian aquifer that provides water to the region.

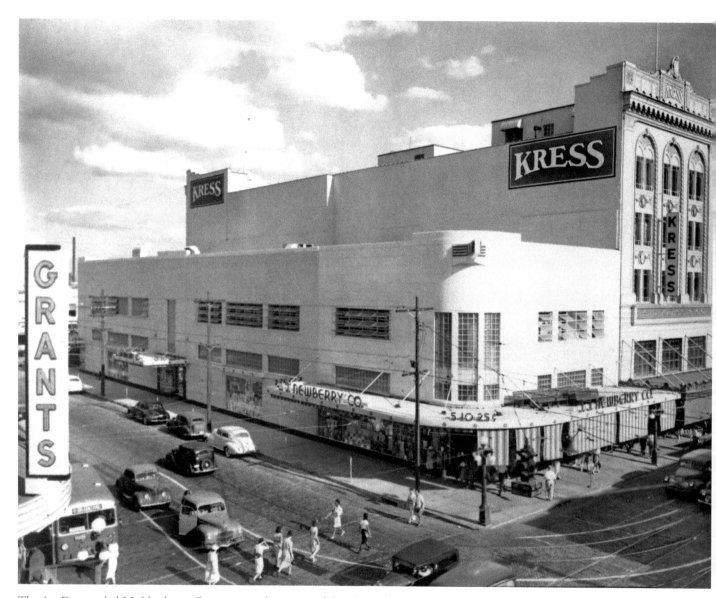

The Art Deco styled J.J. Newberry Company on the corner of Cass Street, looking south down Franklin Street. The S H Kress façade and signs are right next door.

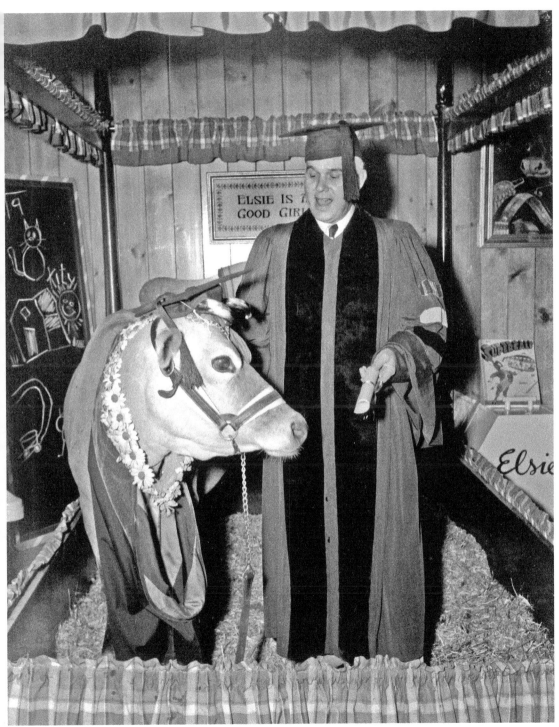

Borden Dairy Product's beloved Elsie the Cow with Dr. Elwood C Nance, president of the University of Tampa. Elsie toured the country in a specially constructed train car. Here, in her four poster canopied bed, where she often received visitors, and wearing mortarboard and hood, Elsie is being bestowed an honorary degree. Nance took leadership of the private school in 1945.

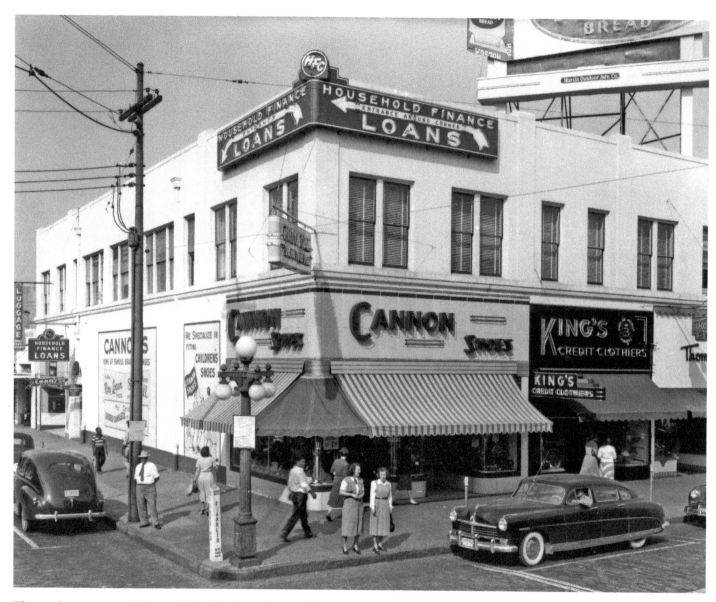

The northwest corner of Cass and Franklin Streets showing both the
Cannon and Thom McAn Shoe Stores and a Household Finance Loan
office. (1949)

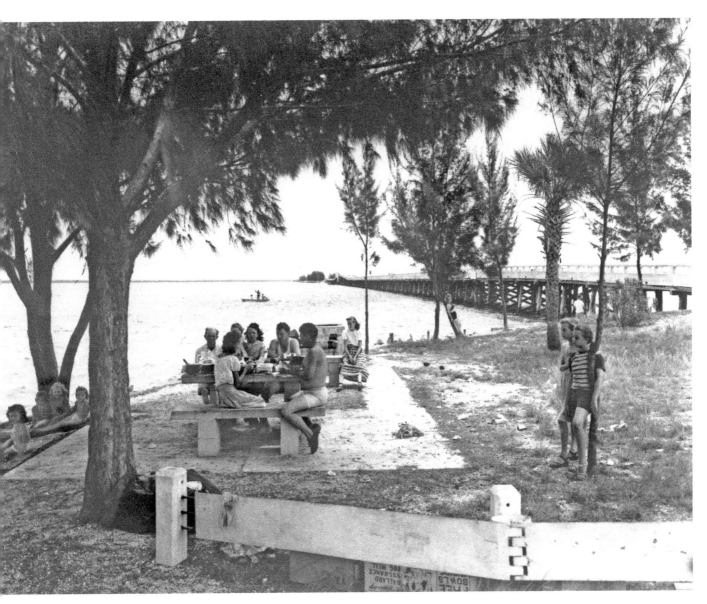

The bridge in the background spanned Old Tampa Bay from Tampa to Clearwater. The bridge was started in 1927 by Ben T. Davis but halted by an economic crash in Florida and further hampered by the Great Depression. The bridge was finished in 1934 through grants made by federal recovery programs. Beautification of the causeway followed World War II affording picnic areas and public beaches. The man receiving credit for the enhancements was Courtney Campbell. The causeway bridge now bears his name.

Vaughn Monroe, singer, trumpeter, and big band leader is seen here performing in Tampa for the benefit of the Red Cross. Singing with the Moon Maids, Vaughn was best known for his hit "Racing with the Moon." Other Vaughn hits included "There, I've Said It Again" and "Ghost Riders in the Sky."

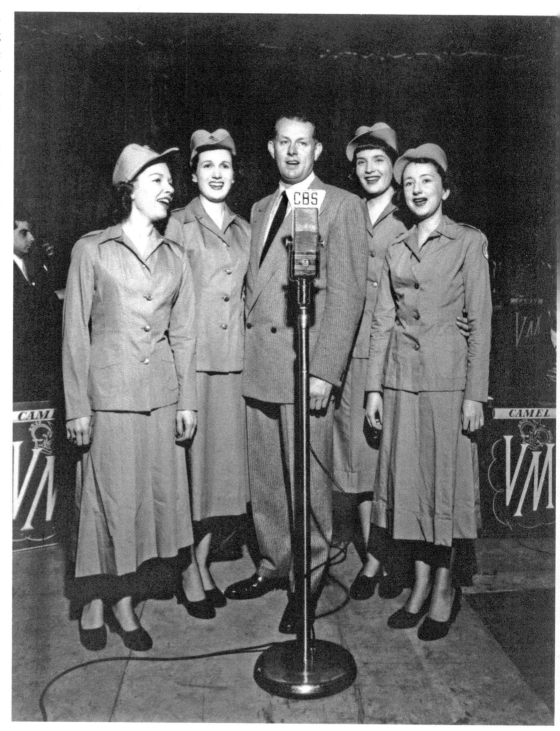

A photograph of a wedding ceremony in 1950 at the Episcopal House of Prayer on East Columbus Drive in West Tampa. In these days before air conditioning, notice how the stained glass windows pivot for ventilation.

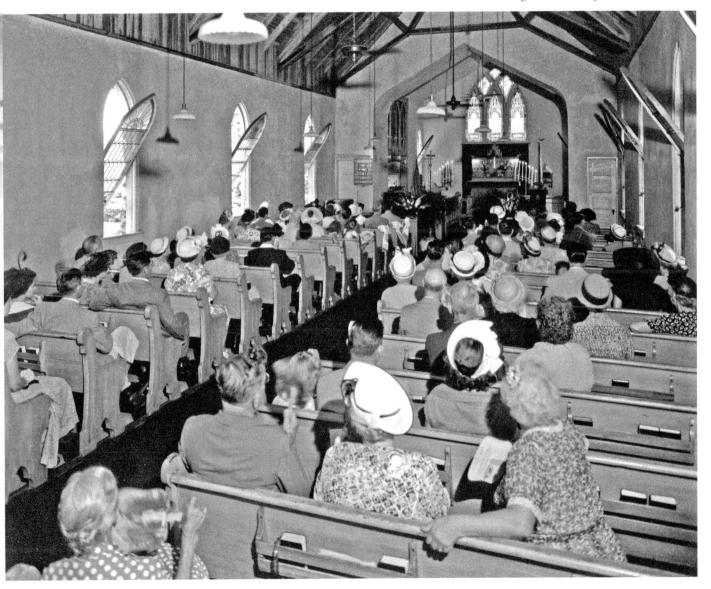

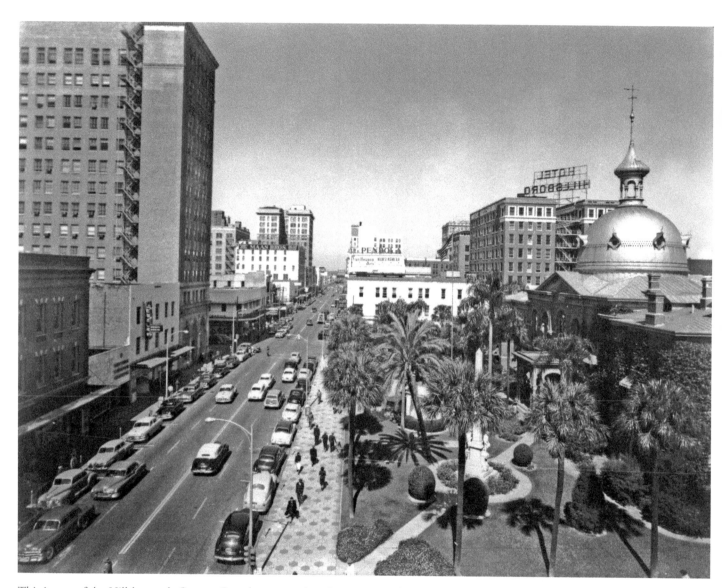

This image of the Hillsborough County Courthouse was shot the same year the new, replacement courthouse building was completed. The thoroughfare in front of the building is Franklin Street. The Civil War Memorial is seen in the diagonally cut sidewalk from the corner of Franklin and Lafayette up to the steps of the courthouse.

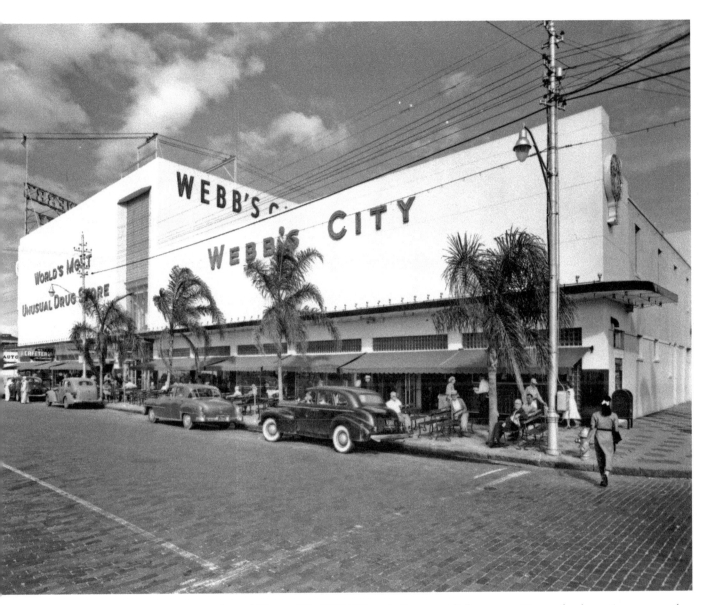

In 1925 James "Doc" Webb bought into a small drug store. During the depression era, as other stores closed down Doc Webb bought the additonal space. Eventually he had over 70 stores spaces between 2nd and 4th Avenue South and had 1,200 employees. Doc Webb's son, Jim, asserts credit for inventing the "10 Items or Less" check-out line.

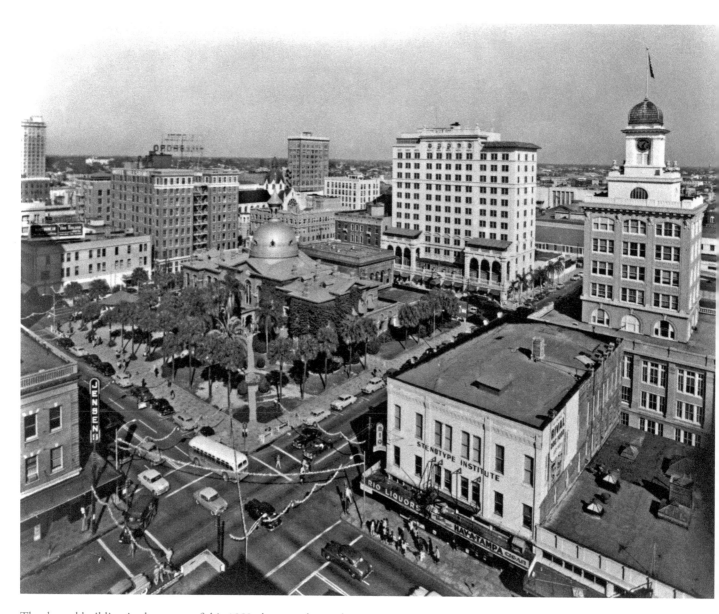

The domed building in the center of this 1952 photograph was the original Hillsborough County Courthouse, built in 1891. To the right is Tampa City Hall. Behind the courthouse is the Tampa Terrace Hotel.

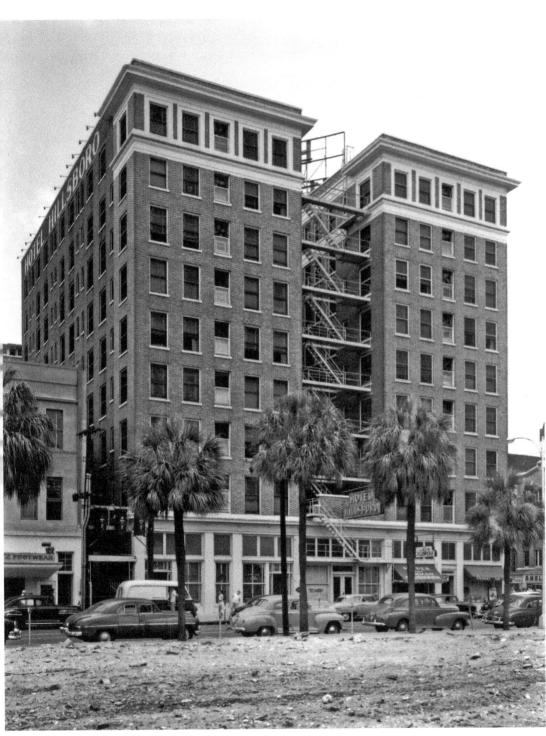

The nine-story brick
Hotel Hillsboro located on
Madison Street. Just barely
visible in this picture in the
large metal-frame, lighted
sign atop the building
which shone the name of
the hotel.

The Civil War Memorial in front of the new Hillsborough County Courthouse. The memorial was moved here in 1952 when the building was completed. The monument initially stood on the ground of the old courthouse building at Lafayette and Franklin Streets. The memorial, entitled, "Memoria In Aeterna," was a gift in 1911 from United Daughters of the Confederacy.

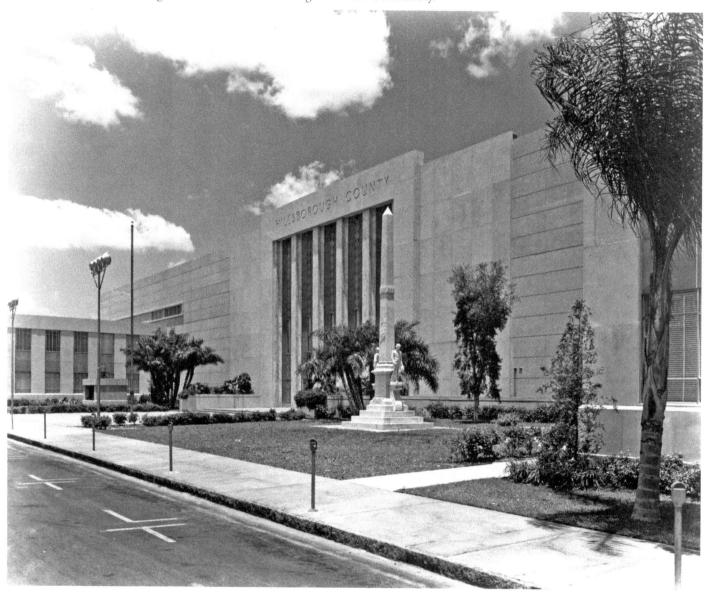

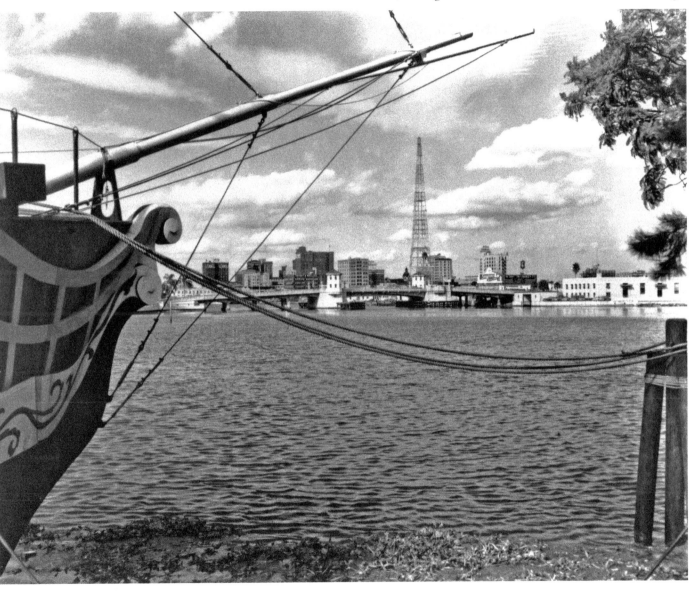

The pirate ship of Ye Mystic Krewe of Gasparilla, moored off Davis Islands, looking across the channel toward the Platt Street Bridge.

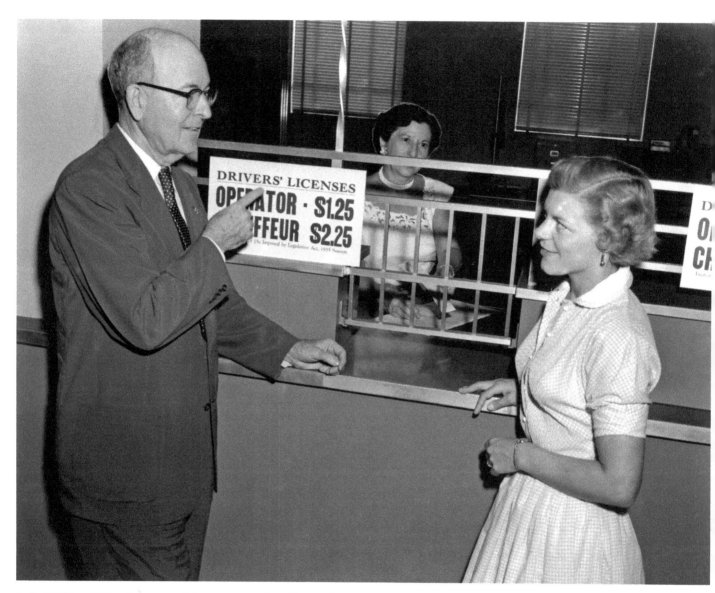

Judge William C Brooker poses with customer at Auto License Bureau.
The clerk, behind the counter in this 1955 image, looks on in her lovely
business attire.

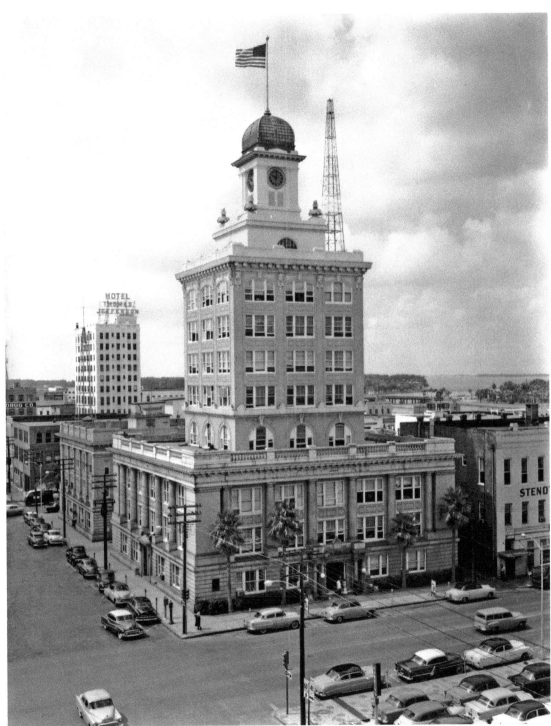

The City Hall building was constructed in 1915 of brick and granite. It sits at the corner of Lafayette (now Kennedy) and Florida Avenue. The clock tower, known as Hortense, was a donation of the W.H. Beckwith Jewelry Company.

Sol Fleishman reporting for Florida's first radio station, WDAE. Known as Salty Sol Fleishman, because of his love of fishing, he first worked at WDAE at age 11, playing records. In 1957 he transitioned to local television news at WTVT where he became Sports Director. Fleishman retired in 1974, but continued with guest appearances until 1981.

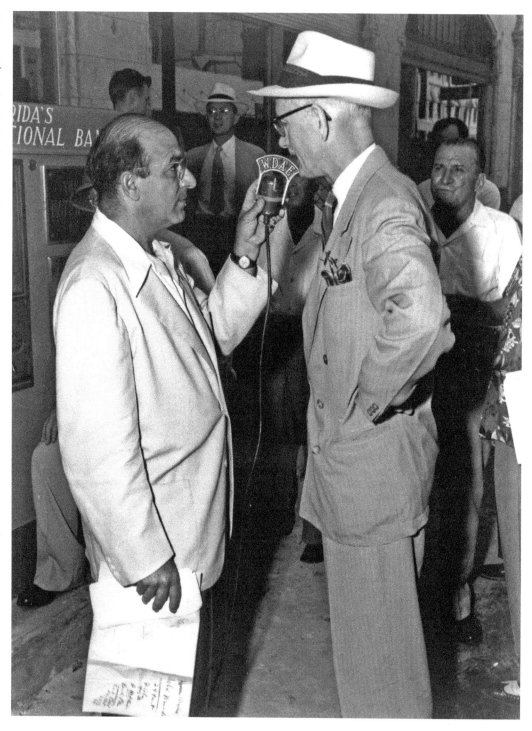

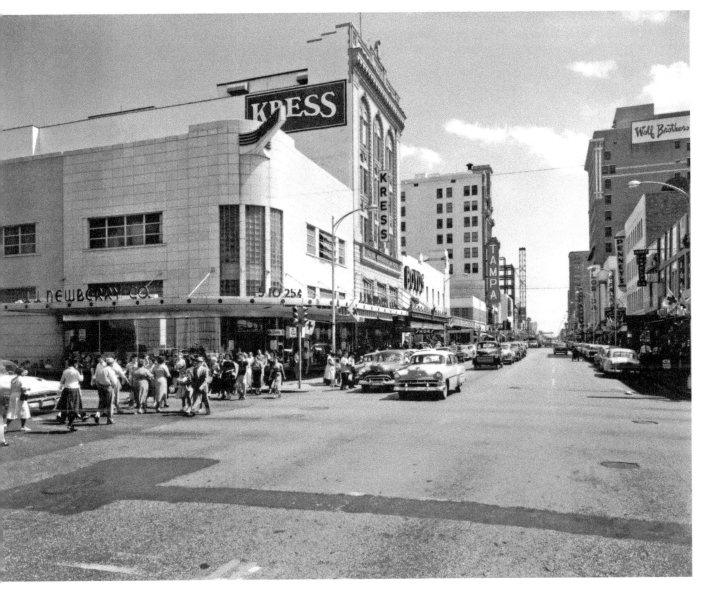

J.J. Newberry Company and S.H. Kress & Company, both five and dime stores, located in the 800 block of North Franklin viewed from Cass Street intersection.

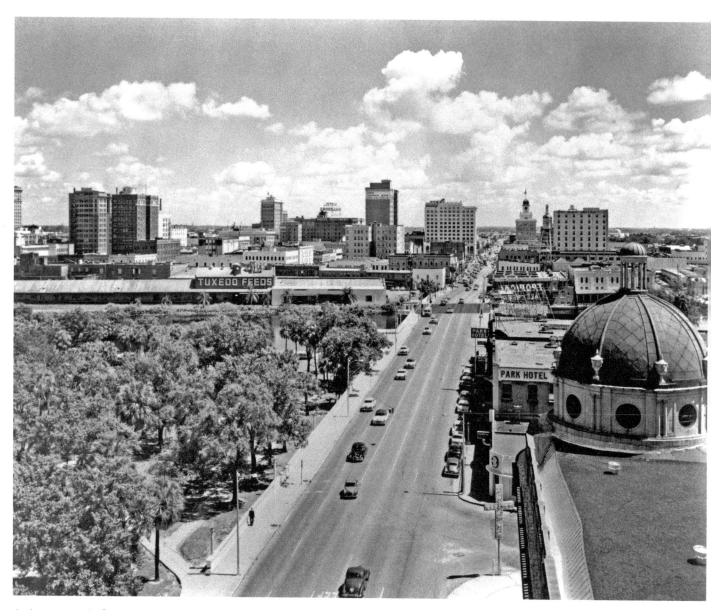

A view east on Lafayette Street. In the foreground to the left is Plant Park and to the right is the dome of the First Baptist Church. Across the river, the cupola and flag mast of City Hall is visible. The "Tuxedo Feeds" sign is on the Atlantic Coast Line Railroad warehouse along the river (1955).

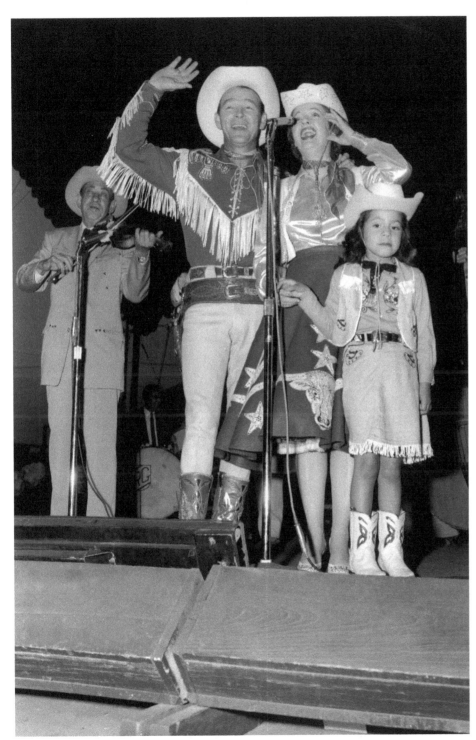

Roy Rogers, Dale Evans, and daughter performing at the Florida State Fair in 1959. Roy and Dale were both musical performers and stars of the big and small screens.

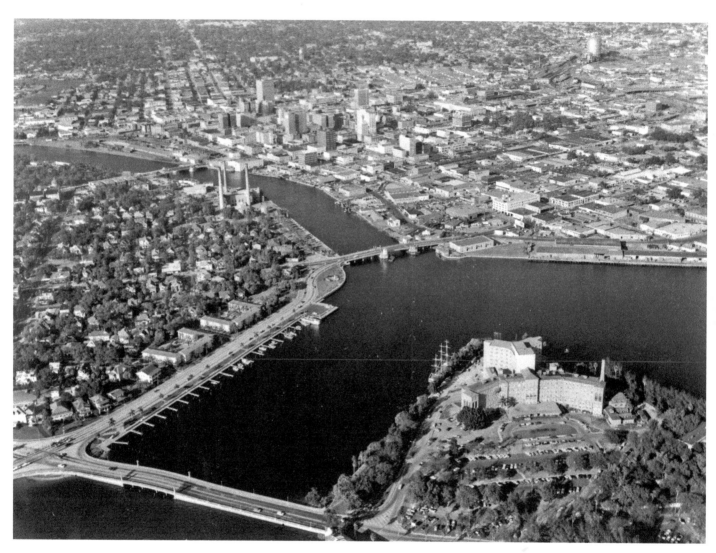

This aerial view from 1957 shows the Hillsborough River (top left) opening to Garrison and Sutton Channels. The span in the foreground is the original Davis Islands Bridge; the perpendicular road is Bayshore Boulevard. Tampa General Hospital is the large complex on the tip of Davis Islands.

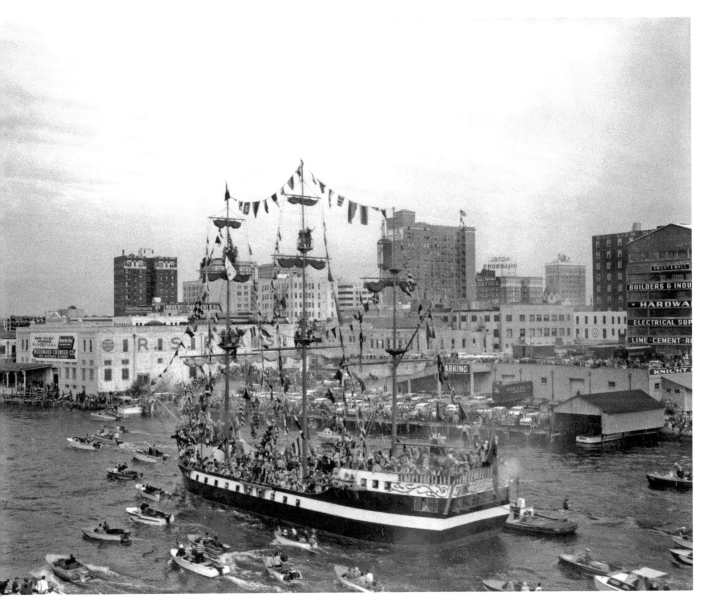

Pleasure boaters flank the pirate ship of José Gaspar as part of the annual carnival of Gasparilla. Gaspar, a former Spanish naval officer never actually invaded Tampa, but he was an actual pirate. He and he crew sailed and terrorized shipping interests along the south Florida coast in the late 18th century.

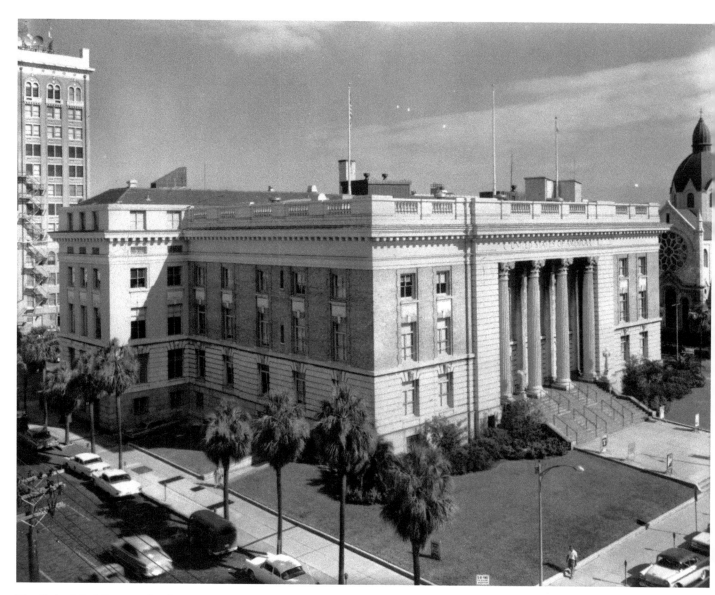

The Federal Building on Florida Avenue seen here in 1960. The tall
building to the left of the frame is the Floridan Hotel. To the far right is
Sacred Heart Catholic Church.

The Post Office shares space in the Federal Building on Marion Street. The loading dock of the Post Office is in the foreground. The taller of the two buildings on past the Federal Building in the Citizen's Bank Building.

A view from aloft across the skyline and out to Davis Islands and Hillsborough Bay. The busy thoroughfare below is Florida Avenue. Midway up on the left edge of the photo is the Federal Building. Across the photo, almost to the right edge, is the sign for the Tampa Theater on Franklin Street. (1961)

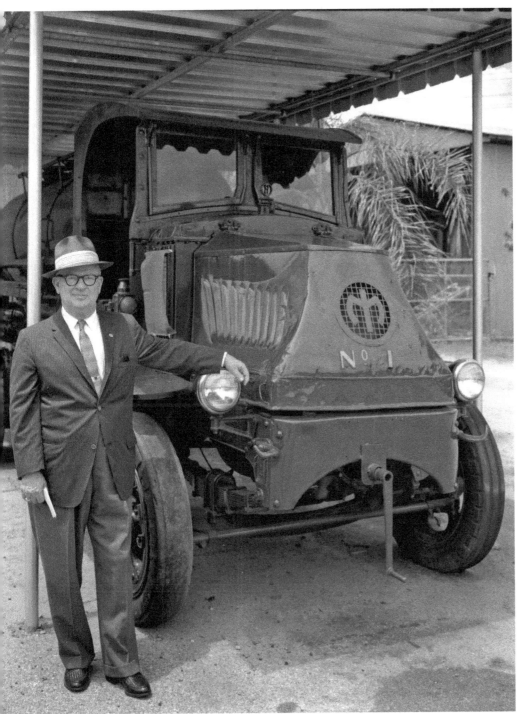

The president, treasurer and namesake of W. L. Cobb Construction Company posed in front of one of his pieces of heavy equipment. Cobb Construction was a paving company located on 22nd Street.

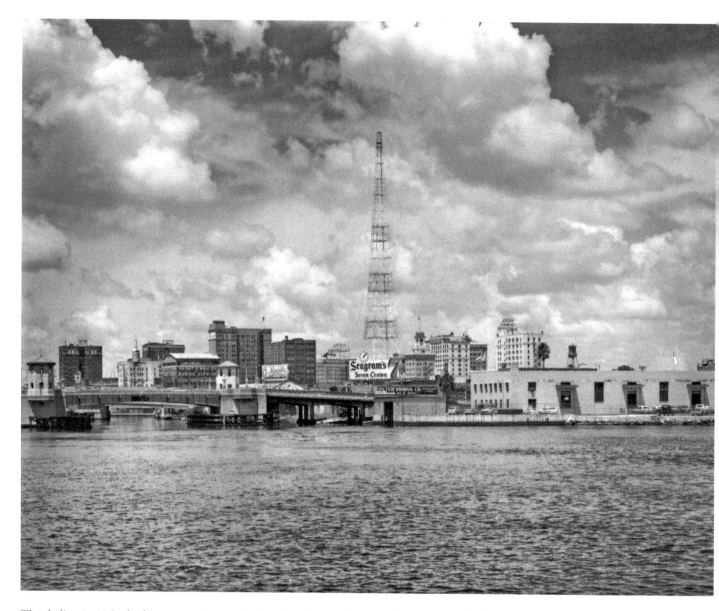

The skyline in 1960, looking across Garrison Channel at the Platt Street Bridge and toward the mouth of the Hillsborough River from the vantage of Davis Islands.

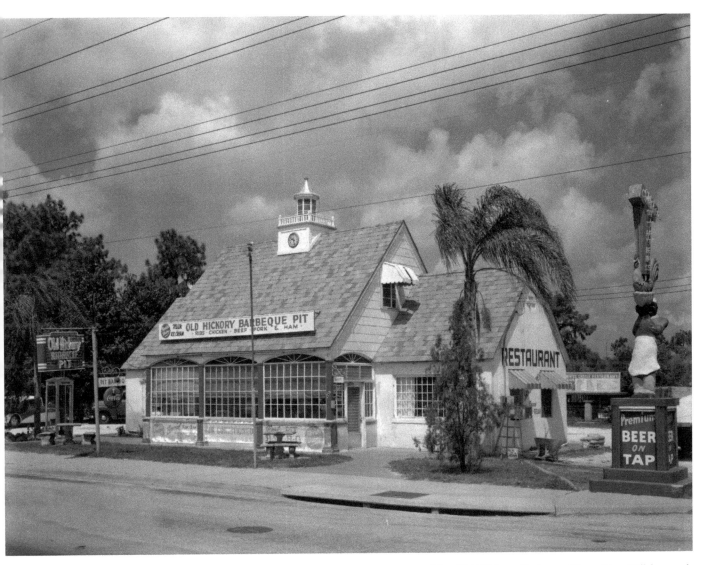

The Old Hickory Barbecue Pit on East Hillsborough
Avenue, operated by Christian Ostegaard.

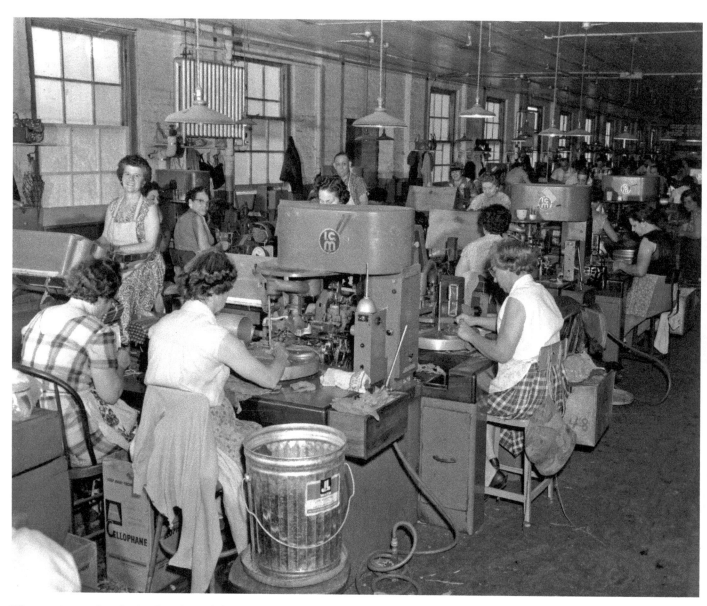

Women cigar makers in the Corral, Wodiska y Ca factory making cigars with the assistance of machines. This photo, from 1961, demonstrates changes that had been going on in the industry since the 1930s, the increased usage of machinery to accelerate cigar production. Purists would argue that there is still nothing finer than a hand-rolled cigar.

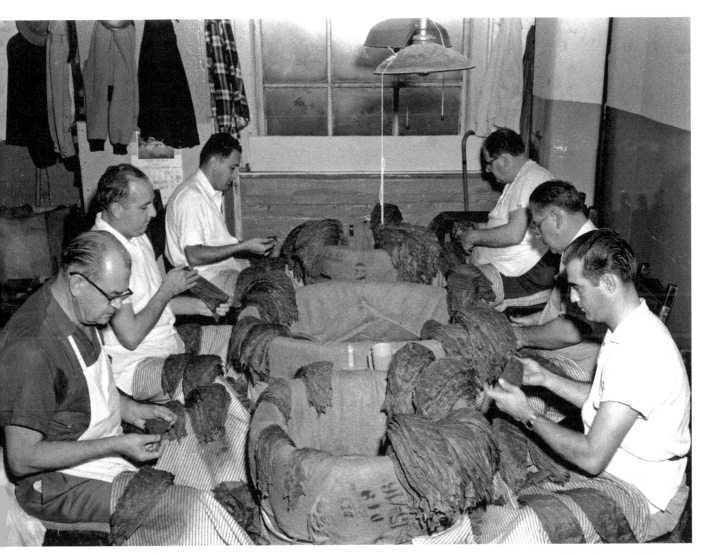

These employees of the Corral, Wodiska y Ca (and Company) are stripping Cuban tobacco leaves of the stems, the first step in making a hand-made cigar. Next the leaves are sorted by color, texture and maturity. The third step is to take filler tobacco in the palms of the hands and rolling them into shape. The shaped cigars are put into a press for 45 to 60 minutes before being placed into a final wrapper and shaped with a chaveta.

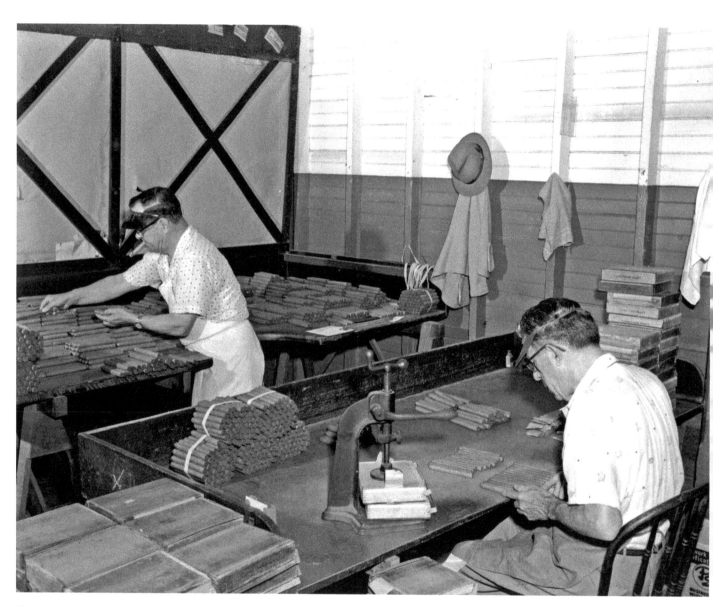

Cigar makers at the Corral, Wodiska y Ca factory rolling and packing product. The press to the left of the seated gentleman packs the tobacco firmly into the proper shape before the final outer leaf is applied. Notice that the man standing is sampling the product.

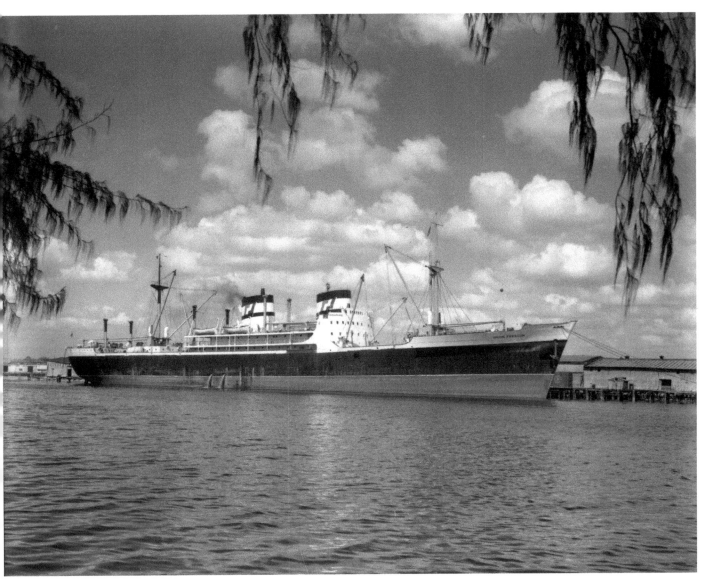

Seddon Island was developed by the Seaboard Air Line Railroad in the early 1900s as a transfer site for cargo to and from ships and railcars. Pictured here is the ship, Union Freedom, at the Block Terminal. In 1979 Seddon Island was sold to a financial services company for residential, hotel and retail development and was renamed Harbour Island in 1981.

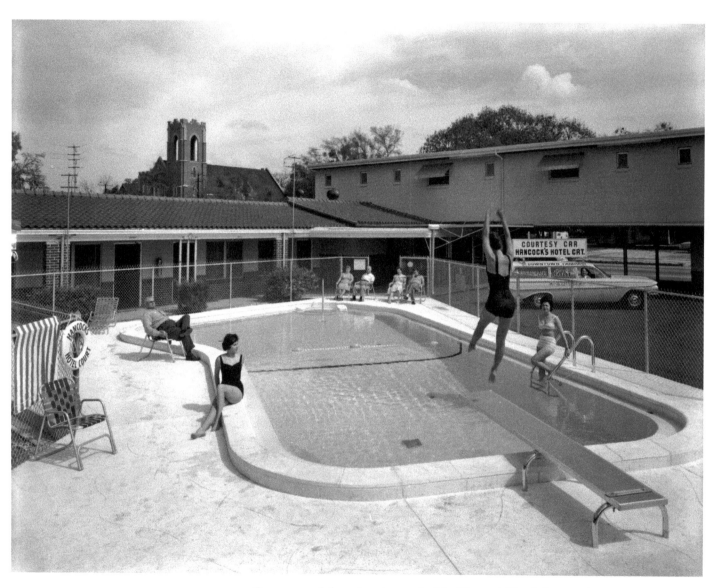

Guests around the swimming pool of the Hancock Hotel Court and Restaurant on Florida Avenue. This type of small hotel or motel was very common in the 1960s, simple in its design yet full of amenities such as the restaurant, pool, and courtesy car.

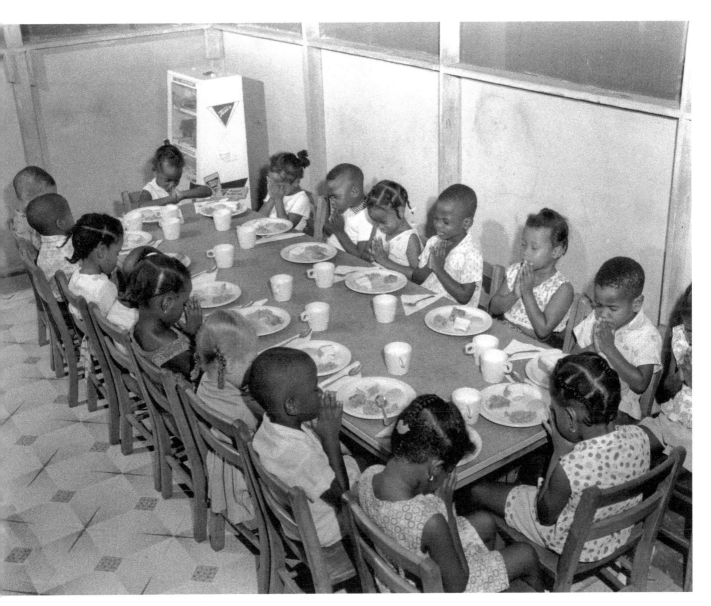

The Helping Hands Day Nursery and Kindergarten was founded in 1925 to provide care for African American children. The facility was managed and staffed by African American women. Helping Hands had facilities for 50 to 60 children and included a playground, breakfast and lunch programs, educational programs and a nursery.

Construction of the First Federal Savings and Loan Association of Tampa building on the northwest corner of Franklin and Madison Streets. This style of architecture, with significant use of glass, would dominate the skyline in years to come. The savings and loan had three other locations, one on South Dale Mabry Highway, one on East Hillsborough and one on West Hillsborough Avenue.

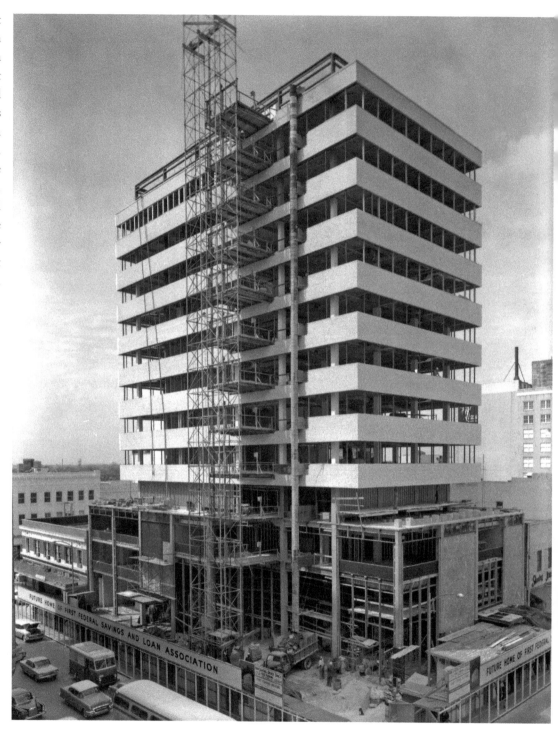

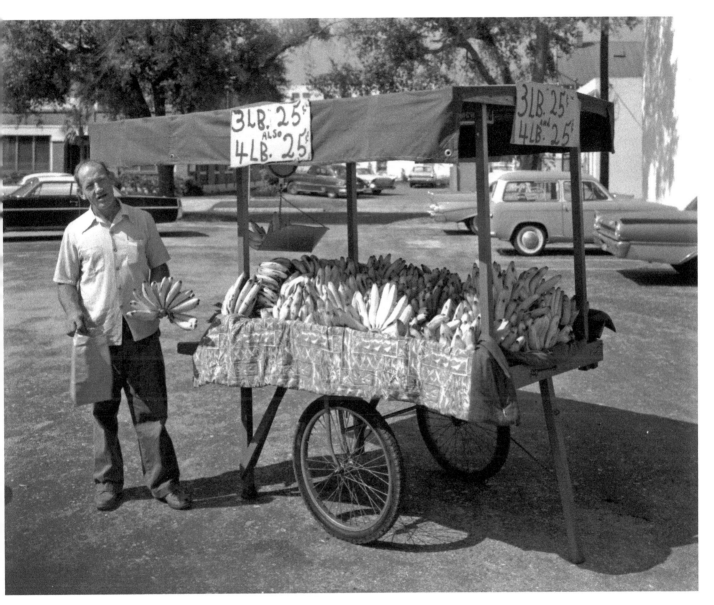

A street vendor with a special marketing approach for selling bananas.

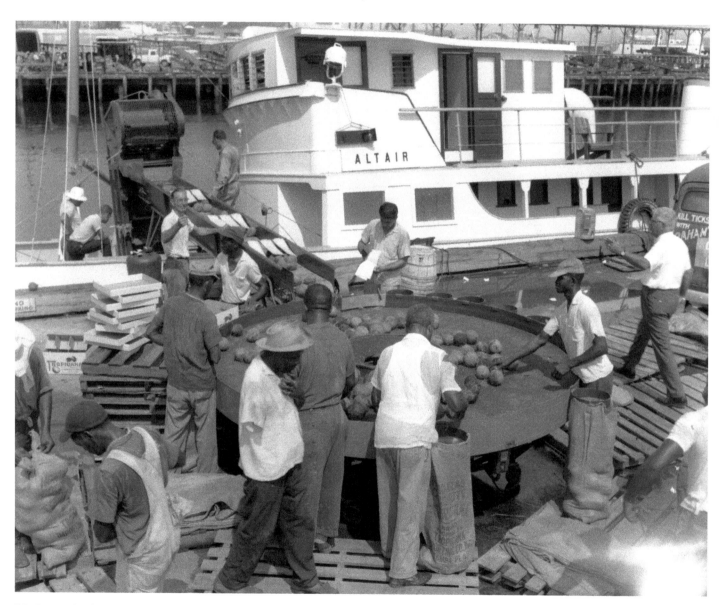

Workers unloading and sorting coconuts from the Altair in the Port of
Tampa in 1963.

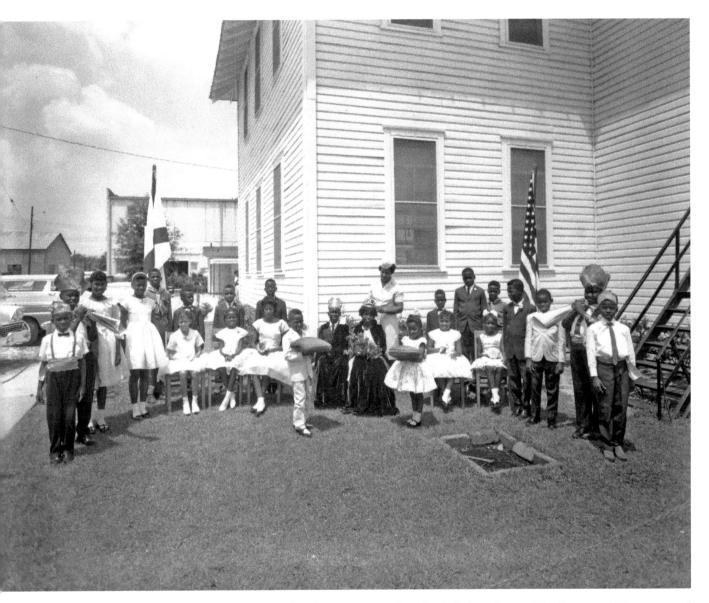

The coronation ceremony at the Dobyville Elementary School on South Dakota Avenue. The Queen and King are seated in the middle, trumpeters in festive hats, seen at either edge of the photo, are poised to herald the event. The school was raze around 1976 for the construction of the Crosstown Expressway. The expressway was later renamed the Leroy Selmon Expressway in honor of the first Tampa Bay Buccaneer inducted into the NFL Hall of Fame.

Beginning in 1900, Richard Doby began accumulating land north of Hyde Park, an area that came to be known as Dobyville. Amid this region, bound by Willow and Cass Streets and Albany and Azeele Avenues, Dobyville Elementary School was built for African American students. Pictured here are the 1963 King and Queen of the school as a part of the May Day celebration.

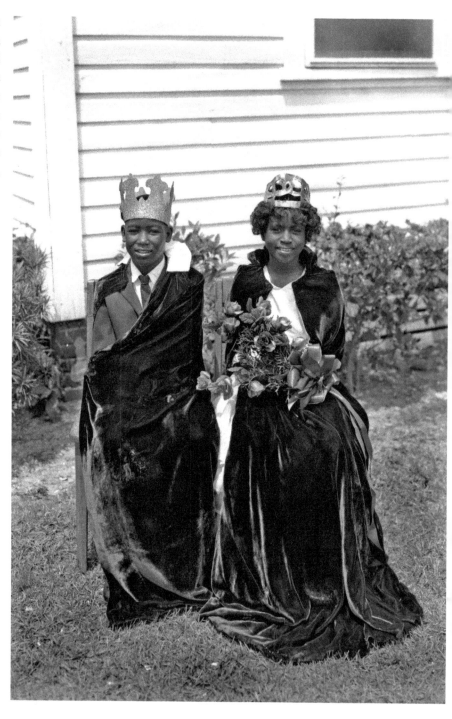

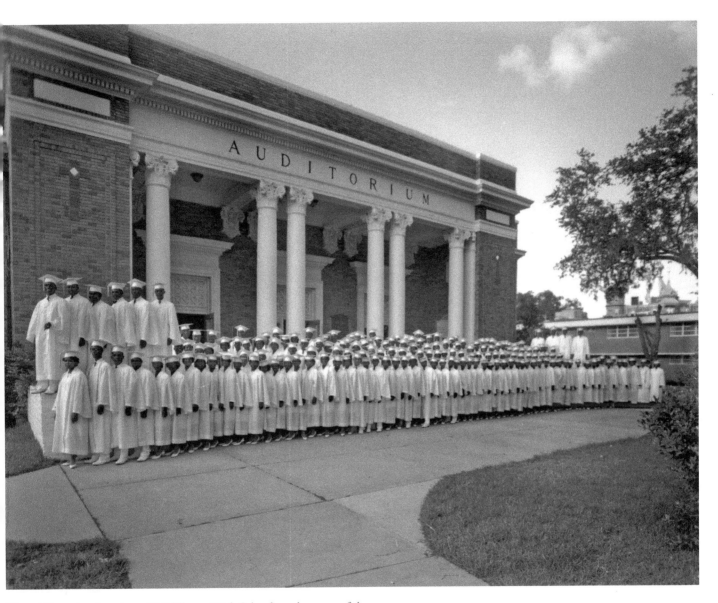

The 1963 graduating class of Middleton High School on the steps of the Donald Brenham McKay Auditorium on the campus of the University of Tampa. Middleton was an African American high school; Tampa's schools were still segregated in the early 1960s.

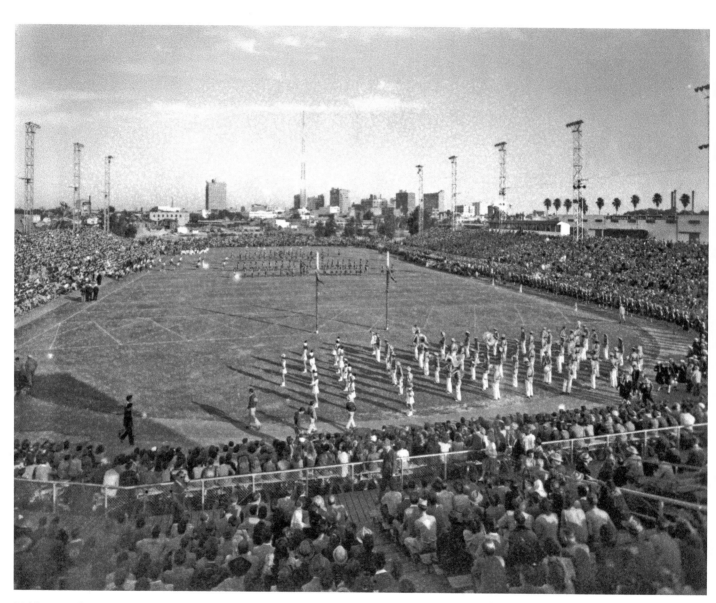

Halftime at the 1967 Plant versus Hillsborough High School football game being played at Phillips Field, the Stadium Athletic Field at the University of Tampa. The Tampa skyline is in the background, across the Hillsborough River.

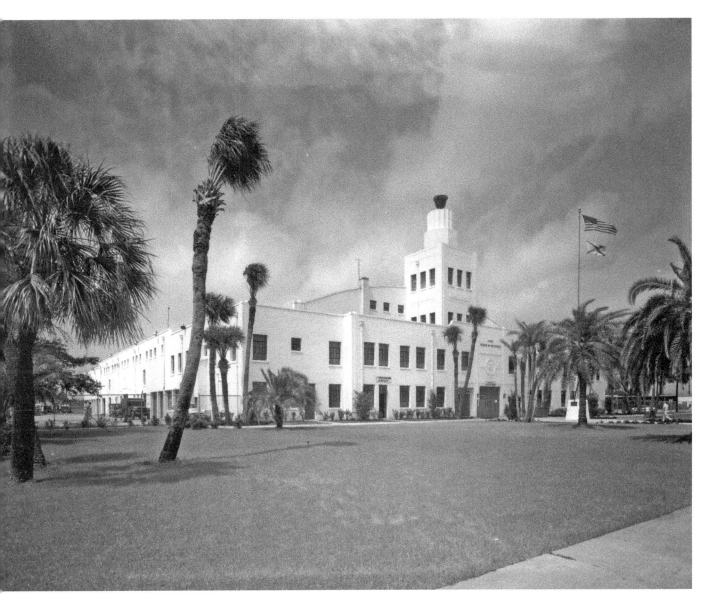

The dedication plaque reads, "Named in Honor of Homer W. Hesterly, Soldier, Patriot, and Civic Leader." The site was donated by George Nelson Benjamin for use as a West Tampa public park. The location was used as a staging area and encampment by the Rough Riders in advance of the invasion of Cuba in 1898. Construction of the 116th Field Artillery Armory was begun in 1934. The Art Deco styled building featured here was completed in 1941 with WPA funding. The first commander of the facility was Colonel Hesterly. The armory was renamed for Colonel Hesterly after his death in 1957.

Notes on the Photographs

These notes, listed by page number, attempt to include all aspects known of the photographs. Each of the photographs is identified by the page number, photograph's title or description, photographer and collection, archive, and call or box number when applicable. Although every attempt was made to collect all available data, in some cases complete data was unavailable due to the age and condition of some of the photographs and records.

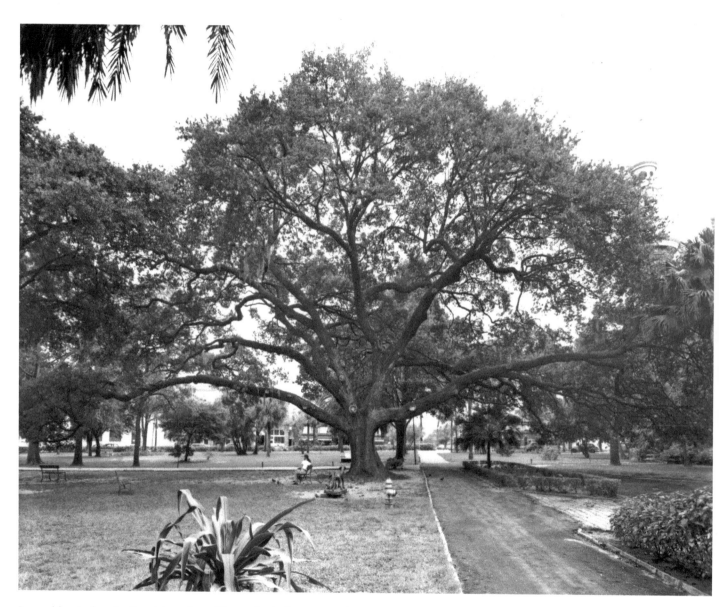

Legend has it that the Spanish explorer Hernando de Soto met with native Indians under this tree in Plant Park, making it over 500 years old at the time this photo was taken in 1946. Just in front of the tree is a bronze statue, "Au Coup de Fusil," by Maurice de Nouvilliers, brought here from Europe by Henry Plant when he decorated the grounds of his Tampa Bay Hotel.

HISTORIC PHOTOS OF
TAMPA

By the late nineteenth century, the city of Tampa was a vibrant, cultural center. Through the early twentieth century, two World Wars, and into the modern era, Tampa has continued to grow and prosper by overcoming adversity and maintaining the strong independent culture of its citizens.

This volume, *Historic Photos of Tampa,* captures this journey through still photography from the Burgett Brothers Photographic Archives held at the Tampa–Hillsborough County Public Library. From the late 1800s, the Depression era, and to the building of a modern metropolis, *Historic Photos of Tampa* follows life, government, education, and events throughout Tampa's rich history.

The book captures unique and rare scenes through the lens of hundreds of historic photographs. Published in striking black and white, the images communicate historic events and everyday life of two centuries of people building a unique and prosperous city.

Ralph Brower first moved to Tampa in 1964 and has lived there the better part of his life. He earned a bachelor of arts from the University of Alabama and a master of business administration from Saint Leo University. He has spent time as a writer, an artist, and a woodworker.

He has been employed in the property and casualty industry for more than twenty years; roles have included researcher, analyst, and composer of technical manuals and procedures. Ralph and his wife, Sue, share their home with a beloved beagle. They live in Tampa.

WWW.TURNERPUBLISHING.COM

CPSIA information can be obtained
at www.ICGtesting.com
Printed in the USA
LVHW070750190723
752748LV00008B/49